A HISTORY OF
BACK CREEK

A HISTORY OF
BACK CREEK

BENT MOUNTAIN, POAGES MILL,
CAVE SPRING AND STARKEY

NELSON HARRIS

THE
History
PRESS

Published by The History Press
Charleston, SC
www.historypress.net

Front cover, top: Ballard Martin family, circa 1900. *Courtesy of David Harris; bottom: Early Spring,* 1954, by Harriet French Turner. *Courtesy of the Eleanor D. Wilson Museum, Hollins University, Roanoke, Virginia. Photographed by Art Sellers.*
Back cover, top: Poage store and warehouse, circa 1910. *Courtesy of Debra Christley; middle:* John P. Austin, 1958. *Courtesy of Sheri Poff; bottom*: Cave Spring/Route 221, 2017. *Photo by Art Sellers.*

First published 2018

Manufactured in the United States

ISBN 9781625859709

Library of Congress Control Number: 2017955904

Notice: The information in this book is true and complete to the best of our knowledge. It is offered without guarantee on the part of the author or The History Press. The author and The History Press disclaim all liability in connection with the use of this book.

In honor and memory of my Back Creek aunts and uncles—Cornelia, Christine, Vinson, Francis, Lorene, Nelson, O.C. Jr.—and their youngest sibling (my mother), Gaynelle.

CONTENTS

PREFACE

The history of southwestern Roanoke County is personal for me. From early settlers along Back Creek being my maternal ancestors (Martin, Poage, Harris, Sloan, Hayes and Grisso), to my mother having grown up on her parents' farm on Martins Creek Road, to my having begun my pastoral ministry some thirty years ago by serving a church at Bent Mountain, I have a deep appreciation for the history of this region. It is with much satisfaction that I contribute to preserving and celebrating that history with this book.

Since Europeans first settled along the banks of Back Creek in the 1740s to the present, southwest Roanoke County's history is as fluid and contoured as the creek itself. Where once log cabins dotted Virginia's frontier, one now navigates the sprawling suburbs. Between those eras are stories of Scots-Irish homesteaders, Confederate deserters, enterprising orchardists, NASCAR races at Starkey, a highway built by convicts, religious revivals, one-room schoolhouses, the country stores, a few murders and much more. Court documents, archival newspaper accounts and longtime residents have been invaluable sources for this comprehensive history. I have learned about doctors on horseback, a forgotten railroad, midwives, baseball teams, switchboards and swimming holes, to name a few elements that shaped the social and economic life of the Bent Mountain and Back Creek region.

The difficulty with writing history is deciding what to include and, to borrow a filmmaking phrase, what to leave on the cutting-room floor. Much has been condensed to provide a broad historic overview spanning

two centuries. Hopefully, I have captured the essentials. In inviting the community to become engaged in this project, I was amazed at the interest and response. While limited to 100 images for this book, I scanned more than 350 photographs. All image scans, used here or not, have been donated to the Virginia Room of the Roanoke Main Library for preservation and future research.

History is quintessentially human. It's conflicted, inspiring, humorous and, at points, disturbing. This history is not immune to those traits. As you read, may you learn about and appreciate what was.

—Nelson Harris
Roanoke, Virginia
June 2017

ACKNOWLEDGEMENTS

M any persons provided assistance in this history project. Where possible, I have tried to give credit within the text itself. However, I do wish to express appreciation to those individuals who provided encouragement, advice, research and recollections.

To my "Back Creek History Group" that met regularly with me for three years providing guidance, information and leads, I am indebted. That group consisted of the following: Genevieve Henderson, Charles Hofer, Gordon and Marie Saul, Russ and Jane Grisso, Lawrence and Betty Martin, Ralph Henry, Walter Henry, Molly Koon, Danny Kittinger, Lorene Preas, Lynne Mowles, Tim Hash, Joyce Turman and Dana DeWitt.

Others who provided information, assistance and/or photographs were George and Mary Ann Conner, Alice Hunt, Lewis Paige, Patsy Ford, Mauvieleen Altis, Lou Emma Richards, Bill Bowman, Tim Harvey, John Hildebrand, Ellen Phillips, Darlene Smithwick, Holles Charlton, David Harris, Joan Carver, Sheri Poff, Debra Christley, Don Debusk, Grandle Meador, Carole Hawkins, Martha Brizendine, Judy Reed, Lois Overstreet, Philip Thompson, Wil Robinson, Joy Bird, John Murphy, Teresa Lavinder, Hugh Springer, Fred Cox, Ed Frost, John Long, Arnold Horsley, Harold Hamlett, Marilyn Holland, Glenn Reed, Hazel Brown, Lorie Murray, Bob Stauffer, Hugh and Dolores Simpson, Bailey DuBois, Angela Roberson, Philip Thompson, Sandra Kelley, Pamela Clark, Bobby Woods, Ruth Fornes, Glenna Wimmer, John and Sue (Conner) Poff, Charlotte Austin, Shelby Davis, Michael Poff, Albert H. Poff Jr., Macie Conner, Sammy

ACKNOWLEDGEMENTS

Holt, Kat Jacobs, Kevin Kelleher, Alonzo "Kitt" Kittinger, Cindy Windel, Gladys King, Laura Finnell Hall, Frances Ferguson, Frank Stone, Charles Young and Joy Medley-Atkins.

If any individual was omitted from the above list, it was unintended. My apologies.

EARLY HISTORY, 1740–1860

W hen Robert Poage II settled along Back Creek at what is today's Poages Mill section, he was alone. Having received a land grant of one hundred acres in 1747, Poage homesteaded at "the Ford" on the creek. Poage would not get neighbors for at least two years, when John Mason and his brother-in-law, James McKeachy, homesteaded in 1750. Poage had settled along what early maps called the "Traders Path," a path that intersected with the Carolina Road near present-day South Roanoke and went southwest to Bent Mountain and into far southwestern Virginia. Mason was near Cave Spring.

Poage and Mason were pioneers on the Virginia frontier. Geographical points had different names then. The Roanoke River was known as Goose Creek and at some places as Staunton River; Roanoke was Great Lick; Buck Mountain was Back Mountain; and the Roanoke Valley was still part of sprawling Augusta County. The Virginia frontier contained more forts than towns. There was Fort Lewis (near present-day Salem), Fort Vause (Blacksburg area), Fort Frederick (near Christiansburg) and Fort Chiswell. Most of these forts were established in the mid-1750s, after Poage and Mason had settled at Back Creek.

Robert Poage had come from Beverly Manor (Augusta County) and initially prospected along Catawba Creek. Poage would become a significant figure in the homesteading movement that eventually populated southwest Roanoke County. John Mason died in 1760, and his property went to his four sons, John, William, Joseph and James, all of whom helped develop

the region. Robert Poage served in a variety of positions during his lifetime, beginning as a road commissioner and then as justice of the peace, a position he held until late in life. Poage died in 1787, and his estate, both real and personal, was divided among William, Robert and John. To his daughters and their husbands, Poage left monetary sums.

During this same period, there may have been other settlers to Bent Mountain and Back Creek. James Heckman, an elderly resident of Franklin County in 1912, shared that year the reminiscences told to him in his childhood by his grandfather that four men came from Pennsylvania on a hunting and trading expedition in the mid-1700s. Their last names were Heckman, Willett, Martin and Webster, and they followed the "Great Trail" into Virginia. Webster's brother-in-law, Samuel Billups, had preceded them by a year or two. The men found the land so fertile with game and streams that, upon their return to Pennsylvania, they moved their families into the section—except Heckman, who continued into Franklin County. While Heckman's account cannot be verified, the names of Willett, Martin and Webster appear in early land records but not prior to Poage and Mason.

Later settlers came to Back Creek with homesteaders who also traveled along the Carolina Road. Two companies came through the area in the mid-eighteenth century. Captain Lewis' Company helped homestead the Back Creek section, while Captain Martin's Company settled Bent Mountain. Those with Captain Martin included the following: William Aldredge, Mary Allen, Nicholas Alley, Sherod Bebe, Robert Beaver, John Bell, Isaac Chadwicks, Joseph Cole, Daniel Conner, Christopher Cooper, James Cooper, Henry Dawes, Paul Dawes, William Dawes, William Dorman, Andrew Ferguson, Rosanna Garrett, John Green, John Hale, Thomas Harmon, Jonathan Harrison, John Hayes, John Henderson, Henry Hite, John Huff, Benjamin Huff, Leonard Huff, Philipp Huff, David Iddings, James Iddings, John Jones, Marcus Likins, William Likins, John Long, Thomas Luttrell, James King, John King, Josiah Martin, John McClelon, John McCullock, John Murphy, Hercules Ogle, James Richardson, Jacob Robins, George Shuffe, Jeremiah Stover, William Strauss, Thomas Scott, William Terry, Mary Williams, Joshua Wilson and Samuel Wilson. Among the homesteaders were eight unnamed slaves. Some homesteaders planted roots, and the surnames are still present in the section today. Others, however, resided for a season and kept moving, usually south.

In the Lewis Company were the names William Brown, James Cagey (Keagy), Thomas Cook, John Eager, Christian Frantz, Jacob Gest (Garst), William Greenlee, Thomas Harrison, Jacob Long, Peter Kinder, Philip

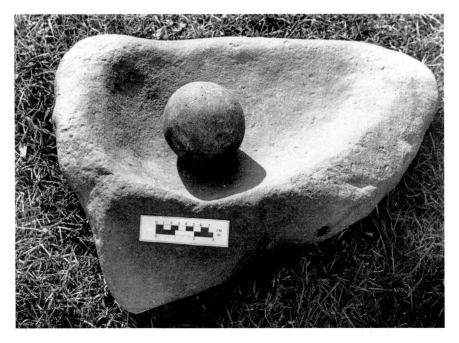

Native American mortar and grinding stone, undated. This artifact was unearthed near Cave Spring, indicating the pre-Colonial presence of Native Americans in the Back Creek section. *Courtesy of Roanoke County.*

Love, Samuel Love, William Love, James Neely, Jacob Short, Humphrey Smith and David Stewart.

To trace the beginnings of the earliest European settlers and pioneers in the Back Creek section of Roanoke County is a difficult task. Given that Roanoke County was formed from Botetourt County in 1838, and Botetourt from Augusta County in 1770, means examining the earliest and often confusing records of the two mother counties to gain some sense of early landowners. Several have tried, and this book relies upon their yeoman efforts.

The most comprehensive effort to document the earliest land grants was by I.M. Warren in 1942 with the Work Projects Administration (WPA). A map was produced of original land grants and other early surveys. An individual was given a land grant for a variety of reasons, usually as a reward for military or frontier service and for homesteading purposes; it did not mean the landowner actually settled on the grant. The grant often was sold so that the grantee could acquire property somewhere else. Thus, one cannot assume the all land grantees were the earliest settlers, though a few were.

The process of granting land came as the result of three critical developments that occurred almost simultaneously. First, land granting in western Pennsylvania had effectively ended, meaning immigrants had to purchase land that was rapidly increasing in value. Second, the "dark frost" that plagued Northern Ireland in the winter of 1739–40 had created a large influx of Scots-Irish, such that this group became dominant in the Shenandoah Valley. Third, Virginia's colonial governor, William Gooch, opened the Virginia frontier in 1730 and was making large tracts available for individual settlement.

The Virginia frontier, inclusive of present-day Roanoke County, initially had an informal manner of homesteading and land "rights." There was the "corn right," which entitled the planter to approximately one hundred acres of land for each acre he had planted. There was the "tomahawk right," in which a land grant was established by deadening a few trees, marking one's initials on the trees and thereby establishing a boundary line. Finally, there was the "cabin right," based on a settler having built a log cabin on a tract of land he claimed—akin to squatter's rights. All of this necessitated the Virginia colony establishing counties with clerks who received and recorded more formal surveys documenting grants and purchases of land. A few of the earliest settlers in the Back Creek region, mostly Scots-Irish and Germans, probably exercised these informal, folk "rights," but by the mid- to late eighteenth century, the grants and boundaries were being legally recorded in Augusta County.

Based on the WPA research, early land grants for the Bent Mountain area were as follows, with the year and acreage provided: Andrew Lewis (1822, 88 acres), Robert Harvey (1800, 265 acres), Arthur Cooper (1787, 160 acres), Thomas Baldwin (year unknown, 193 acres), John Mills (1767, 325 acres), John Huff (1783, 66 acres), Jesse Wilson (1787, 265 acres), John Henry (1782, 150 acres), John Mills (1761, 1,050 acres), Obediah Reynolds (1795, 150 acres) and Godfrey Hamilton (1791, 180 acres).

On and around Lost Mountain, we find grants to Louis Martin (1836, 200 acres), Gilbert Marshall (1773, 160 acres), Alexander Harkness (1785, 250 acres), Francis Smith (1820, 1711 acres), David Snyder (1781, 188 acres), Henry Snyder (1812, 150 acres) and Robert Beavers (1747, 140 acres).

At the base of Bent Mountain and extending east toward and encompassing the Poages Mill area, grants were provided to John Poage (1780, 155 acres), John Snyder (1783, 460 acres), James Melon (1783, 650 acres), Edward Billups (1794, 555 acres), James Blair (1791, 192 acres), Thomas Ferguson (1819, 110 acres), Samuel Flora (1787, 200 acres),

Martin-Simpson family, circa 1910. The Martins' ancestors settled at the base of Bent Mountain, purchasing land along Martins Creek in the early 1800s. *Courtesy of Joyce Turman.*

Godfrey Hamilton (1797, 325 acres), John Hartman (1802, 540 acres), James McGavock (1754, 104 acres), James Melton (1782, 230 acres), John Pickleheimer (1797, 8 acres), James Mason (1768, 250 acres) and Robert Poage (1747, 150 acres).

In the Cave Spring area, grantees included Francis McIlhaney (1783, 200 acres), John Hartman (1800, 265 acres), James Simpson (1782, 364 acres), Ludlow Simpson (1823, 50 acres), James Templeton (1770, 139 acres), John Hayes (1793, 1,054 acres) and John Henry (1781, 445 acres).

In the Buck Mountain and Starkey region were James Cagey (1767, 95 acres), Robert Harvey (1805, 350 acres) and Andrew Tedford (1794, 350 acres).

These early grantees sold, willed and traded their lands frequently.

For those who did homestead, their dwellings were primitive, and farms consisted of just a few cleared acres. A description of the earliest homes in the region was described by the WPA writers in their 1942 book *Roanoke*.

The original log cabins had puncheon or earthen floors and one bedroom. Bunks, pallets, and trundle beds accommodated both family and overnight guests. Stores were kept at the rear in what was called a "press room." Because there were no closets, clothes were hung on wooden pegs around the walls. Cooking utensils were of copper, iron and earthenware; and most of

the dishes were pewter, with possibly a few of stone china that had been brought from the Old Country. Besides the water bucket there was always a dipper made from a gourd. Bread was mixed in wooden bowls, and corn cakes were baked in the ashes on the hearth.

As more settlement occurred, geographic points began to be named. Twelve O'Clock Knob was so named due to the sun being directly over its point at noon as one looked toward the mountains from Salem. Back Creek may have derived its name from its being in the area of Back Mountain (later called Buck Mountain). Poages Mill reflected the presence of the 1840s-era mill that had been constructed along Back Creek by the Poage family. Cave Spring had a spring that provided a popular watering hole for livestock between Bent Mountain and Roanoke. Some later tried to claim that the spring's water had medicinal value. What is today called Starkey was previously Farland and originally Speedwell, after the large Harvey home and estate in that area. Many assume Poor Mountain was named due to poor soil conditions on its slopes, but early maps have it spelled "Poore," with some historians stating it was named after an officer in General Andrew Lewis's company. Lost Mountain's name may have stemmed from its being overshadowed by the larger mountains that surround it. The name Mason's Knob most likely came from John Mason, as he and his descendants settled near its base. What has perplexed historians most is the origin of Bent Mountain's name. Some suggest the mountain was named by frontier surveyors Charles and William Bent. The Bent brothers did surveying in Kansas and Colorado; however, no court records exist documenting any such surveying by them in the Roanoke Valley. Andrew Lewis, the earliest large landowner on the mountain, had Bent Plantation, but records seem to indicate the plantation was named for the mountain, not vice versa. The theory for the origin of Bent Mountain's name that has the most currency is that the mountain was named due to its geography. The mountain's ridge forms a U-shaped curve. Thus, the mountain is "bent."

Critical to the development of homesteads and trade for the Back Creek area was a road. The Traders Path, which Robert Poage had settled alongside in 1748 and others had used, was not sufficient to meet such needs. The first documented effort at road building came on November 10, 1772, when John Bowman was appointed by Botetourt County to survey a road from the "Long Lick to the Gap of the Mountain" in the Back Creek section. Three days later, Poage, Leonard Huff and James McKeachy were to survey a road from "Tosh's Ford to the Top of Bent Mountain"; Huff, Joseph Willis and

William Bell were to continue the same road from Bent Mountain to William Bell's Mill on the Little River. (Tosh's Ford was near where the Franklin Road Bridge in Roanoke crosses the Roanoke River.) According to court documents, the road was completed in May 1773. John Bowman and Philip Love were authorized to divide the tithables (taxes) from the petitioners for their maintenance of the road.

On December 11, 1783, Andrew Lewis and James Neely were appointed surveyors for the portion of the road that went from Tosh's to the top of Bent Mountain; Robert Poage, William Neely and William Walton handled the tithables.

On October 12, 1784, Godfrey Hamilton was appointed surveyor for a road from the Bedford County line to the "head of Buck Mountain near the Indian graves." On September 9, 1794, Joseph Mason was appointed surveyor for a road that went from Jacob Vineyard's homestead at Harvey's Furnace (present-day Starkey area) to the county line near Jacob Nofsinger's homestead. These earliest road surveys are difficult to map given the lack of firm reference points (e.g., "Indian graves"), but the level of activity recorded demonstrates the amount of homesteading that was occurring during the colonial period.

Two men from the Back Creek section—David Willett and Lewis Harvey—were granted licenses to operate taverns, called ordinaries, in Botetourt County in the 1780s. The Willett ordinary may have been at the foot of Bent Mountain, and the Harvey ordinary was probably near what is today Starkey.

During this early period of settlement of the Back Creek and Bent Mountain sections, the largest landowner was Colonel Andrew Lewis of Bent Mountain. Lewis, fourth son of General Andrew Lewis of American Revolution fame, had been granted some twenty thousand acres. The first home reputed to have been built on Bent Mountain was Lewis' home, Longwood. The Lewis grant encompassed most of Bent Mountain and extended deep into Floyd County. Lewis was married twice and from these unions had three children who lived to adulthood: Margaret, Catherine and Thomas. With a family, he moved from Longwood into his larger home, Bent House. It was here that he and his first wife, Agatha Madison, entertained many well-known guests. Given that Agatha was a cousin to President James Madison, their guest list was notable and included John Randolph, "Light Horse" Harry Lee, Louis Phillipi and his brothers Count de Mountpensier and Count Beaugolis. When Bent House was destroyed by fire, the Lewis family moved back into Longwood. Lewis was well connected,

and documents that survived him showed correspondence to Longwood from Patrick Henry and Thomas Jefferson. Lewis spent his adult life at Bent Mountain, dying at Longwood in 1844. (Longwood burned in the 1920s.)

After the death of Andrew Lewis, his heirs (two daughters) began to sell off large tracts of their father's estate. With this came more families to the area, as two wealthy men from Pittsylvania County, Joseph M. Terry and John Dabney Coles, purchased much of the land and began settling their holdings with tenant farmers from Pittsylvania County. A descendant of Terry, Grace Terry Moncure, wrote of her ancestor's investment. "Both Terry and Coles moved white families to Bent Mountain as tenants, with contracts for clearing, building and crop-raising. This new ground, loose fertile loam, was well suited for tobacco, and it became the cash crop. An overseer managed these settlements as well as separate clearings made by colored families brought from the lower plantations."

Moncure described in detail the tobacco production on her grandfather's estates.

> Wherever a field was planted, a log barn was raised for the curing and storage of tobacco until it was ready to be packed in hogsheads. The staves for these were riven from oak or chestnut and securely bound by hoops of stout hickory to withstand the long haul over the roughest of roads to the nearest market—Lynchburg and occasionally Danville. The landscape became dotted with tobacco barns, usually about twenty-five-feet square and a full story taller than the cabin dwellings. Sometimes these were double size, double and triple pens. They were splendidly built structures, roofed on log rafters with hand driven boards. Boards were from three to four inches in width and usually of oak or chestnut.
>
> The freshly-cut tobacco was bunched and tied on five-foot sticks, packed from joist to adjoining joist, until each barn was filled through to its upper tiers....There were horizontal flues running from outside walls three feet into the barn...the fire was kept going day and night until the leaf was properly cured.
>
> During this important curing process there were day and night shifts to keep up the steady heat and regulate it properly. For no matter how fine the crop may have been when cut, its quality and the price obtained on the market was decided there within those barns where the curing was done.

Moncure remembered growing up as a child on Bent Mountain in the 1890s and still seeing the remnants of her grandfather's tobacco enterprise.

"I can recall the fields with tobacco barns on Bent Mountain—37 of them. Later, when tobacco was no longer a main crop they were utilized for storage purposes, or as a shelter for sheep and cattle, with hay lofts above."

The story of John D. Coles is interesting. Coles, born in 1779 in Halifax County, Virginia, would ride sixty miles from his estate in Chatham in Pittsylvania County to check on his tobacco fields on Bent Mountain and to visit with the overseer. According to Moncure, he had a cabin near the overseer's home where he would stay during those visits; his servants lodged nearby. On one such trip in the summer of 1848, Coles became ill. After a week at Bent Mountain, Coles chose to make the journey back to Chatham and see his doctor. When he reached home, his fever spiked and he never recovered. He died on August 28 at the age of forty-eight from typhoid. Joseph Terry, Coles' son-in-law, continued to manage the Coles property at Bent Mountain for several years until Coles' grandson John Coles Terry was of age to assume the responsibilities.

The tobacco economy imported to the area by Coles and Terry remained viable for decades. On a map of Roanoke County dated 1861, a tobacco warehouse was located near the intersection of present-day Martins Creek Road and Route 221. The author's great-great-grandfather Vincent Simpson was one of the tenant farmers likely hired by Coles and Terry from Pittsylvania County to relocate to Bent Mountain and work. He lived in Copper Hill at that time. Simpson never left the tobacco business and was operating a tobacco warehouse in Washington County, Virginia, at the time of his death in 1880.

From the early to mid-nineteenth century, tobacco was a main crop grown by Roanoke County farmers, not just by the Coles and Terry tenants on Bent Mountain. An analysis of the agricultural census for Roanoke County shows that in 1860 the median acreage of a farm was 185 acres, with 100 acres being usable land. Median yield for farms was 150 bushels of corn, 10 bushels of Irish potatoes and 1,000 pounds of tobacco. Other grain crops included wheat, oats, rye and barley, but those were minor in comparison. While tobacco was a relatively new crop for southwest Roanoke County compared to its history of being grown in the Virginia Piedmont, it was a main source of income for many farmers. In addition to crops, the average Roanoke County farmer in 1860 had three horses, four beef cattle, three milk cows, thirteen hogs and about a dozen sheep.

As settlement and the agrarian economy grew in southwest Roanoke County, citizens began to organize for the formation of a turnpike company, a popular and effective endeavor at the time, to provide a more

accessible road. The Jacksonville and Bent Mountain Turnpike Company was presented to the Virginia General Assembly in 1832, with legislation encouraging the company's formation being passed on February 11 of that year. According to legislative records, the turnpike company proposed raising $10,000 in capital through the sale of stock at $25 per share. The stock company would construct a turnpike road from Jacksonville in Floyd County to an intersection with another turnpike road at or near Cave Spring by way of Bent Mountain. Those authorized to open the company were David Kitterman, Thomas Franklin, Harvey Deskins, Joseph Howard, James Leseure, John Helms, Tazewell Haden and Peter Geurrant (all from Floyd); David Sloan, Andrew Reynolds, Joseph Pritchard, David Willett and John Poage (all in the Cave Spring area); George Langhorne, Peter Kefauver, Armistead Neale, Elijah McClanahan and William Noffsinger (Big Lick); and Frederick Johnston, Bernard Pelzer, Charles Snider, Powell Huff and George Shanks (Salem). Investors from Big Lick and Salem participated due to their interests in the turnpike making connections with turnpikes that would lead to their respective communities.

The conditions for a turnpike company becoming organized were set forth in an 1832 ordinance adopted by the Virginia legislature. When 120 shares had been subscribed, the company could incorporate. The legislation called for the road to be no less than fifteen and no more than thirty feet wide, and the grade at no point was to exceed three and one-half degrees. Further, the state's board of public works would subscribe 240 shares, or three-fifths of the stock. The turnpike company was also given permission to build side roads and "summer roads" off the turnpike for short lengths.

In 1849, the organizers had sold sufficient stock that the Jacksonville and Bent Mountain Turnpike Company became recognized and work could commence. The commissioners met at the home of Daniel Sowder in Floyd on August 10 that year and named Dr. T. Headen as chairman and Andrew Reynolds as secretary. The 120 shares sold had come from the following areas: Floyd (55 shares), Cave Spring (23 shares) and Salem (42 shares). A month later, the commissioners met again at Sowder's home and elected a board of directors. Voting by ballot, those present elected Colonel Joseph Howard, David Kitterman, Fleming Lester, William Ferguson, Joseph Pritchard and Nathaniel Burwell. Howard was the unanimous choice to serve as company president.

A month later, on October 24, the board of directors decided to hire a Mr. Reynolds to engineer a location for the road for a payment of $250. The

roadbed that Reynolds chose followed in many ways the Traders Path, which moved along the contours of Back Creek.

The income and expenses of the turnpike company were reported to the board of public works on September 1, 1853. The number of private shares sold eventually totaled 148 for $3,700.00; the state's shares totaled $5,550.00. The vast majority of funds were used for road making, and those paid were T.G. Shelor, Joseph Pritchard, Benjamin Deyerle and Owen Price. Thomas Bawlding was paid $50.00 for fencing, James Anthony $60.00 for engineering and Thomas Shelor $30.00 for surveying. There were other minor expenditures such that the closing balance for the company at the time of the report was $96.21.

By 1858, the state released its fiscal interest in the turnpike company, meaning that the road was sufficiently completed. Thus, in a decade, the leading businessmen of the area had accomplished a major and necessary undertaking.

By the mid-1800s, mail service began on a regular basis to the Back Creek section, as evidenced by mail routes being posted in various newspapers across the state. One such list was in the *Jeffersonian Republican* of January 27, 1859, advertising for persons to bid for contracts to deliver the mail. The route through the southwest county was described as follows: "From Salem, by Cave Spring, Bent Mountain, Copper Hill, Simpsons, and Little River, to Floyd Courthouse, 46 miles once a week and back. Leave Salem Saturday at 5 a.m., arrive at Floyd Courthouse at 8 p.m. Leave Floyd Courthouse Friday at 5 a.m., arrive at Salem by 8 p.m." This same route, inclusive of arrival days and times, appeared again in the *Norfolk Post* on September 27, 1865, suggesting this mail route was used for a long period of time in the area and during the period of the Civil War. The specific points mentioned in the route probably meant the locations of post offices of varying classes.

With a turnpike, postal offices, a healthy tobacco market and the construction of a few schools and churches, the Bent Mountain and Back Creek sections had become established communities economically and socially. The Civil War, however, would fracture that life along racial, economic and religious lines.

THE CIVIL WAR, 1860–1870

O n November 15, 1860, Governor John Letcher of Virginia issued a proclamation calling the general assembly into special session on January 7, 1861, in order that the representatives of the people of the commonwealth might consider recent affairs, namely the election of President Abraham Lincoln, which had resulted in an affront to the "constitutional rights and interests" of a large portion of the southern states. When the assembly convened, Letcher acknowledged the popular call for a special state convention to determine the future course of Virginia relative to the growing secession movement throughout the South.

Both chambers of the general assembly quickly moved to have a convention called. Within eight days of being convened, the general assembly had reported out a bill "to provide for electing members of a convention and to convene the same." Specifically, the act called for the election of 152 delegates to be held in early February and for a separate poll, at the same time, "to take the sense of the qualified voters as to whether any action of said convention dissolving our connection with the Federal Union, or changing the organic law of the state, shall be submitted to the people for ratification or rejection."

All of this meant that Roanoke County, like the rest of the state, would conduct a twofold election within the coming weeks. First, Roanoke County voters would have to chose a delegate to represent them at what would become commonly known as the Secession Convention. Second, those same voters would be polled as to the question of possibly referring the matter of

secession back to the voters at some future date, or not referring (which was to say that secession was not an acceptable option).

The election was held in Roanoke County on February 4. Two candidates sought to serve as the county's delegate. George P. Tayloe was the "union candidate for convention," and William Watts was the "disunion candidate for convention." The Cave Spring area voted overwhelmingly for the union candidate. Elijah Poage, whose store served as a polling place for Cave Spring, recorded in his business journal that Tayloe had received 207 votes to Watts' 45. Tayloe was elected by the county to serve as its delegate. If the Cave Spring tally was indicative of the county at large, the margin may have been significant.

The Back Creek and Bent Mountain sections may have had Union sympathies, as few residents owned slaves or depended upon them for their livelihood. The predominance of the Brethren religion, a denomination that adamantly opposed slavery, may have also been a factor.

When Abraham Lincoln ran as the Republican candidate for president, however, he did not receive a single vote in Roanoke County. Thus, sentiments had turned against federal authority by the time of the presidential election. Families in southwest Roanoke County had many sons and fathers who went to war, among them two brothers, Elmore and Otey Martin, sons of Abraham Martin, who lived along Martins Creek at the foot of Bent Mountain.

Elmore Martin wrote to his parents, Abraham and Margaret, on December 11, 1861, from a camp in Fairfax County, Virginia, where he was serving with the Twenty-Eighth Virginia Infantry. He wrote about members of the regiment being court-martialed for attempting to kill one of the regiment's officers. All were shot about a quarter mile outside the camp. Of interest to this history, however, are Elmore's references to friends and neighbors serving from the Back Creek area. "I received a letter from Rufus Hauley today. He is in Lynchburg yet he says he thinks he will get back to camp in a few days. Turel left and went to the hospital in a few days after Turner was down here, and I haven't heard from him since. Newton is in camp but not well yet. Matthew Yoppe has got a discharge so I understand a few days ago. Kiry Yoppe is well. I saw him about five minutes ago." The letter concluded with thoughts about home, girls, crops and the general boredom of camp life.

In the spring of 1862, Martin was with the Twenty-Eighth in Henrico County, Virginia, when he penned another letter. He wrote about the death of George Deyerle from Roanoke County. "We lost one of our men

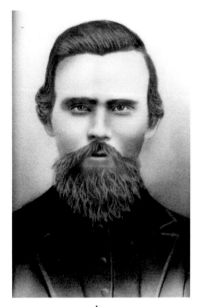

Elmore Martin, circa 1865. Martin wrote home about the boys from Back Creek during the Civil War. He did not survive. *Author's collection.*

today. George Deyrely [*sic*] was taken sick this morning after roll call and is now a corpse. He died after supper about ten o'clock. He went to the spring this morning and washed." Martin's letter suggests how quickly death from disease could consume a man. Later in the letter, he notes that other men from the Back Creek section were healthy. "All of the rest of the boys is well, but Newton is in Richmond." (Newton was Newton Hawley.) Martin relished news from home, wanting to know "how all the girls is and how Rabe is wheather [*sic*] he is well or not and how uncle Stephen Martin is doing wheather he is at home or not and how his little children is....I wrote uncle Phillip last week." (Uncle Phillip would have been Phillip Shartzer.) "We can get bread and onions and fish and coffee for one dollar per pound," he noted as he closed the letter to his parents.

Elmore Martin wrote home again two months later, on July 26, from a camp near Richmond. By this time, he was ill, though feeling better. Desperation for good food and fresh water permeated the letter. "I would be willing to give one thousand dollars to be at home one month so I could get good water and something that I could eat, for I am getting so poor and so weak....[I]f you have a chance send me some onions and other vegetables such as you have or can get. I have some dried apples and get some pies baked when we want them." Martin closed his brief letter with "Remain your affectionate son til death. All the back creek boys is well."

Martin died of disease at the Confederate hospital in Staunton, Virginia, the following year.

As the war dragged on, people fell on desperate times. Men began to desert their regiments, often roaming the mountains and roadways, robbing and stealing to stay alive and escape Confederates looking for them. Desertion was punishable by death, and the Confederate army became increasingly prone to apply that punishment. In short, Virginians began to turn on one another. One such incident occurred on Bent Mountain.

On Sunday, November 3, 1862, Colonel John R. Peyton, in search of a deserter, was ambushed and killed by Union loyalists. Loyalty to the Union was a growing movement in neighboring Floyd and Montgomery Counties. In fact, Union sympathy was so strong that President Jefferson Davis had the counties referenced by name in a memo to him from his secretary of war. Peyton's family purchased a coffin from Elijah Poage at Cave Spring. Poage recorded in his ledger the following: "J.R. Peyton was shot in the breast and killed dead…near the top of Bent Mountain…near to the lower end of Hodge's field and dragged about 80 yards down the mountain and left to the mercies of his friends. Died at age 65 years. Received payment in full on the above account through the hands of John Ferguson, Jr., from Howard Peyton of Montgomery County."

John Rowzee Peyton was a native of Montgomery County who moved to Raleigh County, West Virginia, in 1845. Weighing three hundred pounds, Peyton was well liked by his neighbors and successful as a farmer. Peyton had survived the Battle of First Manassas. According to a 1937 interview of Nathan Powell, Peyton had dined at the home of David Willett (Powell's residence at the time of the interview), where a meeting was held to discuss the hunt for local Confederate deserters. That home was located on the south side of Route 221, just beyond the present-day Apple Grove Lane intersection. (The house was razed in 2014.) Following the dinner, Peyton left and was ambushed by Stover.

A Peyton descendant wrote a detailed account of the tavern incident:

> *At the same table there were three Confederate deserters, who, however, were not known as such. Fearing Peyton would ascertain who they were and return to the army they formed a resolution to murder him. Leaving the dinner table they concerted their plan and hastened to the mountain top. Here they concealed themselves in a thicket and awaited the arrival of their victim, of whose purpose to cross the mountain that day they were advised. When Captain Peyton arrived near the top of the mountain, the miscreants fired from ambush upon him. His body was pierced with bullets and he fell dead from upon his horse. One of his assassins named Stofer [sic] was tried, convicted, and executed in Salem in 1863, the others escaped.*

Leading the investigation into the killing was Colonel Andrew Jackson Deyerle, a war veteran on furlough in Salem for wounds he had received at the battle at Cedar Mountain. Deyerle began by interrogating a local farmer, Henry Owens, who was jailed at Salem for habitually deserting the

Fifty-Fourth Virginia Infantry, even escaping one capture by leaping from a moving train. Owens informed Deyerle of the whereabouts of James Stover, Owens's brother-in-law, who was believed to have been involved in the Peyton slaying. By helping Deyerle, Owens was spared being hanged.

Owen's information proved correct, as Deyerle was able to apprehend Stover hiding in the springhouse on the Owens farm, though two others suspected of being part of the ambush, one named Baker, were never captured.

Stover was tried for the crime of killing Peyton and was convicted by a Salem jury on June 17, 1863, with a sentence of death by hanging. Two months later, on August 14, Stover's sentence was carried out. An eyewitness to the event wrote years later that Main Street east of the courthouse was lined with a somber crowd of people who fell in behind a wagon surrounded by twelve armed guards and bearing Stover, seated on his coffin, as it moved up the hill. In a thick grove of trees across the road from today's Oakey Field, Stover died. That grove would become known as Stover's Woods.

While perched on his coffin as he was transported from the jail to the gallows, Stover had been made to wear the noose around his neck. He was accompanied by Reverend Lindsay Blanton, a local Presbyterian minister. Just before Stover was hanged, Blanton offered a prayer, and the jailer, James Huff, asked again of Stover if he had killed Peyton. The condemned man only replied, "My gun did." With that, Huff pulled the lever that dropped the floor beneath Stover and, in the words of one witness, "launched Stover into eternity to meet his maker." Accounts diverge in the descriptions of Stover's last moments. One said he wore a hood; another said the crowd could see Stover's face in the throes of death. Whatever the case, the hanging was the last carried out in Salem before a gawking public; all others would be private. Deyerle's son Charles later wrote that the scene was a "horrid spectacle," and he lamented the cheers by many in the crowd as Stover's neck snapped.

On the day Stover was hanged, Lewis Stover obtained from Elijah Poage the coffin needed for burial, just as Peyton's family had done ten months earlier.

The killing of Peyton by Union loyalists prompted an angry letter from Copper Hill resident Tazewell Price to Governor Letcher. Price wrote that Peyton was shot dead from his horse in the middle of the day and further claimed that the home of a witness to the ambush had been torched, presumably by the same band of men that had killed Peyton. Price begged Letcher for protection of the citizenry by a "force sufficient

to scour the mountain" in order to put a stop to "robbery, theft and attempts to murder various citizens." Price further asserted that the home guard was not sufficient to search out and arrest the "traitors"; Floyd County citizens were thus "alarmed to such an extent that they don't believe their lives are safe."

Sentiments were so divided, particularly in the Bent Mountain section, that Confederate deserters sought refuge in the adjoining Bottom Creek gorge area, even building small cabins to wait out the war. First Lieutenant John Coles of the Thirty-Eighth Virginia Infantry, a prominent landowner in the Bent Mountain community, had his home burned by deserters during the war. Grace Moncoure, who grew up in Bent Mountain, recalled in 1967 her days as a child in the 1890s, seeing what she called "squatters' cabins" on her ancestral property. "On the Coles-Terry lands were two cabins, rumored to have been built by deserters from the Confederate army…they were unoccupied when I remember them, but most interesting samples of the crudest of abodes. In their structure was neither an inch of metal, nor a piece of glass, nor any sawed timber. They were rock underpinned, clay daubed, with log pens, log sills and joists, supporting floors of split logs with the flat side up." Given the stories and records that emerged after the war, it is certain that deserters sought refuge in the gorges and valleys of Bent Mountain and the adjoining counties.

BY 1864, THE WAR'S consequences were being felt. Economic hardships forced many Back Creek families into poverty, as supplies became limited, currency worthless and prices beyond means. Catherine King of Bent Mountain wrote to her son Joseph on April 23: "Some of the people in the neighborhood are very bad off for provisions, corn is scarce, and twenty dollars per bushel, flour three hundred dollars per barrel, and money of very little account."

Southwest Roanoke County did encounter the presence of Union troops in April 1865. The Fifteenth Pennsylvania Cavalry had been operating in the New River Valley and followed the road from Jacksonville in Floyd County to Bent Mountain, where it camped overnight. The unit then continued through the Back Creek section on its way to Salem. The presence of the Union soldiers ultimately resulted in the surrender of Salem to the Federal troops.

Learning of the fall of Richmond, leading residents of Salem planned to surrender their town to the next advancing Federal force. One should note

this decision was most likely in response to a desire to protect Salem from looting and burning rather than a strong conviction to return to the Union.

The opportunity for surrender arrived quickly. The Fifteenth Pennsylvania, under the command of Major William Wagner, had been operating east of Christiansburg in early April. Wagner's cavalry included 6 officers and some 240 men. Needing to move farther east, the Fifteenth Pennsylvania arrived in Jacksonville, Floyd County, on April 4. The citizens of Jacksonville quickly surrendered their town, and the Fifteenth continued toward Bent Mountain. Marching in a pouring rain and for nearly twenty hours, they finally encamped atop Bent Mountain in the early hours of Tuesday, April 5. By noon, Company B under Captain George W. Hildebrand was headed down the mountain and into the Back Creek section. By 2:00 p.m., Company B was on the outskirts of Salem, where they were met by Dr. David Bittle of Roanoke College, Reverend Samuel Register of the Methodist Church and physician Dr. John Alexander, who offered the surrender of the town. Bittle later wrote, "All things were as silent and awful as when the stars fell in 1832."

In summarizing the Fifteenth Pennsylvania's activities in the Roanoke Valley of April 4 and 5, Major William Wagner submitted the following detailed report to his commanding officer, Lieutenant Colonel Charles Betts:

I moved with my command from your camp near Jacksonville, Va., at 6 o'clock p.m., to operate on the Virginia & East Tennessee Railroad, east of Salem marched across Bent Mountain over a most wretched road and reached Salem at 2 o'clock p.m., of the 5th. The place had been evacuated by the enemy six hours and all public stores removed; moving on toward Big Lick, I found a destroyed six of the enemy's wagons, loaded with forage, which they had abandoned on the road; passed Big Lick Station, from which a train hurriedly took its departure but five minutes previous, carrying away all the public stores; reached the railroad bridge across Tinker's Creek at 7 o'clock p.m., fired the structure and immediately moved on down the road to Buford's Station [Montvale], at which place I went into camp at 3 o'clock a.m. of the 6th. All the government stores at Bonsack's Station, which I had passed, had been moved the previous evening.

The late Charlie Lavinder of Back Creek recalled a story told by his grandmother of the Union troops moving down Bent Mountain toward Salem. The soldiers went over Twelve O'Clock Knob along the road that went by his grandmother's childhood home on what is today Canyon Road.

Lavinder said his grandmother had been told that Union troops ate any children they could find, so she secured herself by hiding in the chimney as they passed.

With the war over, men began returning home; some were literally unrecognizable to their families. Disease, hunger and the physical demands of war had taken their toll. In the 1930s, Pattie Hawley told of her family's story. Her father, Jacob Shaver of Starkey, walked back to his parents' farm. "He had been reported dead, but sick and weakened he returned home. The family was so scared they almost ran away."

Iva May Christley reported in a WPA interview in 1932 a similar experience encountered by William Ferguson. During the war, Ferguson had contracted smallpox. "He had changed so much that he was not recognizable. He was a horrible sight and was thought to be a ghost."

Many Back Creek families remained divided by the Civil War. Thomas Martin in a 1932 interview spoke about his own ancestors. "During the War Between the States, the Martins on both sides of the house were divided between the Confederacy and the North, and as a result many bitter fights and feuds took place on this part of the county and exist to this day in some small way." The interviewer noted that Thomas Martin was a "hot Confederate sympathizer." Among the descendants of David Martin, an early Back Creek settler, were two grandsons who died during the war serving the Confederacy and one grandson who was named Ulysses after the Union general. Charlie Altis of Back Creek was also interviewed in 1932 and made a similar comment. "The Grubb and Webster families were divided over the Civil War resulting in family fistfights especially on election day."

Many from southwest Roanoke County served in the Civil War, among them the following:

Tazwell Starkey, private, Company D, 5th Virginia Cavalry
Kyle S. Wertz
Francis M. Willett, private, Company A, 36th Virginia Infantry
John Wertz, private, Company E, 36th Virginia Infantry
Jacob Shaver, private, Company I, 28th Virginia Infantry
Otey T. Martin, private, Company E, 28th Virginia Infantry; died from measles at Confederate hospital near Culpeper Courthouse on July 6, 1861
Elmore W. Martin, private, Company E, 28th Virginia Infantry; died at Confederate hospital in Staunton, Virginia, in November 1863

Robert Harvey Jr.

William H. Ferguson, *private, Company G, 28th Virginia Infantry*

Joseph R. King

Edward Short, *private, 9th Virginia Cavalry*

John Dabney, *private, Company I, 28th Virginia Infantry*

John Coles, *first lieutenant, Company H, 38th Virginia Infantry*

Dewitt C. Booth, *captain, Company D, 58th Virginia Infantry*

Jordan Woodrum

William J. Baldwin, *corporal, Company I, 28th Virginia Infantry*

Samuel H. Willett, *32nd Virginia Regiment*

Preston E. Simpson

William B. Atkins, *22nd Virginia Regiment*

James W. Turner, *Company F, 2nd Battalion, Virginia Reserves*

Benjamin S. Muse, *private, Company E, 36th Virginia Infantry*

Charles W. Muse, *private, Company A, 157th Regiment, Virginia Militia;
died at Confederate hospital in Princeton, West Virginia, on May 17,
1863; buried in Muse Cemetery on Roselawn Road*

Andrew J. Muse, *private, Company A, 36th Virginia Infantry; killed at the
Battle of Kernstown, Virginia, on July 25, 1864*

James W. Muse, *died at a Confederate hospital in Louisiana in 1863*

John R. Muse, *private, Company E, 42nd Virginia Infantry; died at the
Battle of Cedar Mountain, Virginia, on August 10, 1862*

Henry Hayes

Thomas J. Webster, *private, Company F, 25th Virginia Cavalry*

Ballard P. Martin, *private, Company E, 36th Virginia Infantry*

David A. Poage, *private, Company K, 36th Virginia Infantry*

Jacob D. Sloan, *corporal, Company A, 36th Virginia Infantry*

Matthew Yopp, *private, Company E, 28th Virginia Infantry*

Joseph M. Terry, *captain, Company H, 38th Virginia Infantry*

Carey Yopp, *private, Company I, 28th Virginia Infantry; killed at Battle of
Boonsboro on September 14, 1862*

Rufus Hawley, *corporal, Company E, 28th Virginia Infantry; killed at the
Battle of Second Manassas on August 30, 1862*

Newton Hawley, *private, Company E, 28th Virginia Infantry; captured at
Gettysburg*

Thomas Puckett, *private, Company F, 28th Virginia Infantry; killed at
Gaines Mill on June 27, 1862*

John Coles Terry, *corporal, Company E, 17th Virginia Cavalry*

Vincent R. Simpson, *corporal, Company E, 17th Virginia Cavalry*

Lewis F. Mays, private, Company D, 5th Virginia Cavalry
Charles Claytor Poage, 36th Battalion, Virginia Cavalry
Andrew J. Mays, Company G, 60th Virginia Infantry
S. T. Hawley, 28th Virginia Infantry
Aaron Shilling, private, Company B, 42nd Virginia Infantry
George W. Deyerle, sergeant, Company I, 28th Virginia Infantry; died of
 disease near Richmond on May 26, 1862
Robert W. King, private, Company E, 17th Virginia Cavalry

On March 2, 1866, the Virginia General Assembly passed an act to re-establish the state militia whereby each county court oversaw the elections of officers by regiments and companies. In Roanoke County, nine companies of militia were elected, including two in the southwest section. The Cave Spring Company elected Henry Persinger (captain), James Houtz (first lieutenant) and Charles Trout (second lieutenant). The company had forty-seven men. The Back Creek Company's officers were John Steel (captain) and Thomas Webster (first lieutenant). This company had eighty-six men, making it the largest militia company in the county.

Following the war came another difficult period, Reconstruction. Virginia, like all southern states, was under the authority of a military governor appointed by the federal government. Confederate veterans and those who aided the Confederacy were forbidden from holding public office—the Democrats were ousted from politics. Republicans took control during Reconstruction and quickly divided into two factions. There were the "Radical Republicans" in Virginia who, in the gubernatorial election of 1869, supported the election of the military governor and viewed any accommodation of southern concerns to be unacceptable. The other faction, "Conservative Republicans," supported the election of a nonmilitary governor and believed allowing former Confederates into political office was an act of healing the nation's wounds.

The notion of voting for a Radical Republican governor apparently created quite a controversy among the Primitive Baptists of Back Creek. The minutes of the Laurel Ridge Primitive Baptist Church reveal an interesting episode. In September 1869, the congregation had sent two of its members to the Baptist association meeting at Gills Creek Church in Stewartsville. At the meeting, spirited discussion "grew out of the fact that some of the Baptists had taken what is called the Iron Clad Oath and thereby showing a disposition to aid military rule instead of free Republican government as always contended for by Old School Baptists.

The association declared that any members who had taken said oath should be dealt with as transgressors."

At a meeting of the Laurel Ridge congregation in November, it was determined that two members, Madison Hayes and John Hartman, had voted for the Radical Republican ticket in the election. A vote was taken to determine if Hayes and Hartman should be put out of the church, and the congregation divided evenly over the question. Some suggested that other Primitive Baptists from nearby churches be invited to help the congregation better discern a course of action, but Hayes asserted that the matter was solely the business of Laurel Ridge. Thus, it was decided no others would be involved in the matter and the congregation would revisit the issue at their next meeting.

On December 6, the church met and, after worship, took up the question of disciplining Hayes and Hartman. Hayes stood his ground, asking if the church had the right to "take up matters contrary to the Constitution of the United States when they were protected by the same." The minutes record that the church's moderator responded that the Constitution allowed the church to determine its own "internal laws." With that, Hayes offered a letter of withdrawal from the church, noting that he loved the church but believed some of the brethren were "sapping the liberty" of members and he "had no pardons to ask."

The congregation did not take up the matter of John Hartman until June 9, 1870. Hartman shared that, while taking the oath and voting for the Radical ticket, he was acting in good conscience, "but as he was sorry he had wounded the brethren he was sorry he had done it and that if he had known it would turn out as it had he would have had nothing to do with it." The minutes show that Hartman then requested the church's forgiveness, and it was unanimously given. As for Madison Hayes, it would be four years before he would seek re-admission to the church and receive it.

On another political note, Elijah Poage and Dewitt Booth of Back Creek served as delegates from Roanoke County to the Conservative Republican state convention in 1867. In regard to Poage, he was so adamant about his pro-Union loyalties that in 1872 he petitioned the Southern Claims Commission, an entity designed to assist pro-Union southerners for reimbursement of losses during the war. His claim was denied.

WHEN APPLES WERE KING, 1870–1960

Soon after the Civil War, Jordan Woodrum planted an apple orchard at the base of Bent Mountain. One source estimated that by 1870, Woodrum had set out about eight hundred apple trees, consisting mostly of the Albemarle Pippin and York Imperial varieties. On top of Bent Mountain, near the Floyd County line, J. Coles Terry had also begun an orchard of considerable size.

Prior to and during the Civil War, tobacco had been the main field crop in southwest Roanoke County, but the war and other conditions doomed the industry such that prices fell sharply and the slave or tenant labor needed to sustain a large tobacco operation had come to an end. For Woodrum and Coles, they saw the future in orchards. Given that apple trees took several years after planting to yield, many viewed orchards with skepticism, especially with the severe economic hardships facing many families following the war. Nevertheless, Woodrum's and Coles' orchard enterprises would eventually change the economic and physical landscape of the southwest part of the county for decades to come.

To complement the burgeoning orchard industry of Back Creek, a number of supporting businesses developed. An example was in September 1887, when local newspapers reported that a Mr. Kimball, one of the largest purchasers of the Back Creek Pippin apples, started a barrel factory at Poages Mill with the aim to produce five thousand barrels for shipping apples.

Another significant development for the economy of the Back Creek section came in 1890 with the construction of the Roanoke & Southern

Railway. The railway was born from the desire to connect Roanoke with Winston-Salem, North Carolina. During the surveying process for the venture, the rail bed was located through the property of T.M. Starkey. The *Salem Times-Register* reported on June 20, 1890, the following: "The engineers…have surveyed a route on the west side of T.M. Starkey's and down the creek by John Persinger's, crossing the river east of the West End furnace, and crossing the road of the Norfolk & Western near Shaver's Crossing, and they find that this road has a lesser grade than any previous survey." The article speculated, erroneously, that the Baltimore & Ohio Railroad might connect with the Roanoke & Southern line somewhere near Salem. The locating of a rail line and depot in the southwest section of the county provided a tremendous boon to the export of the section's agricultural products, especially apples. By late 1890, the rail line through Starkey's had been completed, though it would be two more years before the entire rail line connecting Roanoke and Winston-Salem would be finished. On the original board of directors of the Roanoke & Southern were Andrew Lewis of Bent Mountain and T.M. Starkey. The remainder of the board was mostly leading businessmen from Roanoke and Salem. In 1893, a branch line was completed. "The branch railroad from the iron mines near Cave Spring to the main line of the Roanoke & Southern at Starkey's has been finished and ore shipments will soon be made," noted the *Roanoke Times* on August 18, 1893. The Roanoke & Southern would be acquired by the Norfolk & Western Railway and eventually become its Winston-Salem division.

Roads of all kinds were critically important. In 1891, a new dirt road in the Bent Mountain area was surveyed. The road ran from Huff's Store on Bent Mountain "by way of Bottom Creek and Puncheon's Camp" to the Montgomery County line. Crossing into the next county, the road intersected with another dirt road that went to Big Spring depot. The benefit of the road was explained by an article in the *Roanoke Times* on September 1, 1891. "There is some magnificent timber on Bent Mountain and it now has to be hauled to Roanoke or Salem on bad roads in bad weather; whereas if the proposed new road is built it will enable the Bent Mountaineers to haul their timber and produce to Big Spring or Elliston, as it is now called, and ship it there on the Norfolk and Western railroad to Roanoke, Salem, or other such places as they desire." The article also reported that once travelers reached Elliston by the new road, they could then take a macadamized road from Elliston to Salem. Major W.W. Ballard, Roanoke County commonwealth's attorney, was the leading political advocate for the new road.

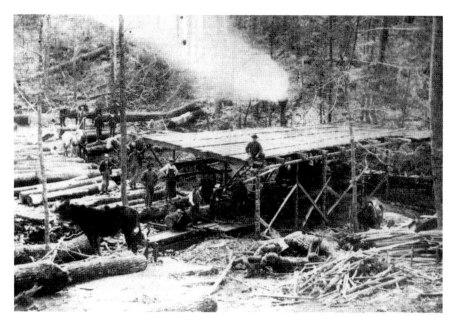

King Brothers sawmill, circa 1910. The sawmill, located in the Bottom Creek section, was powered by a steam engine. Logs were hauled in by horses. *Courtesy of Gladys King.*

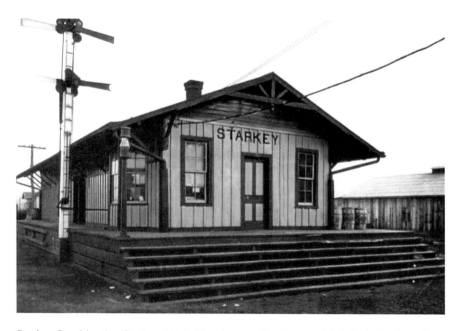

Starkey Combination Station, 1915. The depot at Starkey provided Back Creek and Bent Mountain orchardists access to larger, more lucrative markets. *Courtesy of Norfolk Southern Corporation.*

In an article for the *Salem Times-Register* of August 14, 1896, a journalist reported on the development of the Back Creek orchards. The newspaper sought to champion the development of apple orchards in the county as a means of keeping farms viable and profitable. Apparently, farmers at the time were still reluctant to enter the orchard business.

This writer well remembers that when Mr. Jordan Woodrum commenced to plant that large orchard on the foot of Bent Mountain that some people questioned his sanity. Yet who questions the sanity of his son, when he sells the crop of apples for $4,000 cash, as he did in 1893 and again in 1895? One gentleman from the same section informed me that he sold the apples from seventeen trees for $350 cash. That would be at the rate of $700 per acre.

Twenty years ago the Back Creek section was considered the poorest section of the county, but now it is the richest, apple being king, the fifty acres of mountain land in Woodrum's orchard far exceeding in productive value the best 1,000-acre farm in the county.

It was the writer's good fortune to be in the Back Creek section and witness the activity in the apple trade last fall. The road was lined with teams hauling empty barrels one way and barreled apples the other to the depot, thus employing the teams of the neighborhood to haul the apple crop. Boys and girls are given employment in picking, while it will take the men several months to pack and barrel the product. This gives employment to a large number of people, circulates the money among all classes and promotes prosperity in general.

What is done on Back Creek with red apples and pippins can be done in almost every section of Southwest Virginia. The South is a growing customer for all the red apples we can grow, and more we grow the better becomes our chance to get good prices because it will bring buyers to compete with each other, and the grower will receive the top of the market and not be left at the mercy of a single buyer.

The writer, John A. Francis, went on to document the economic return of an orchard in comparison to grain crops in his advocacy for converting farmland to apple orchards. In closing, Francis wrote, "Apple for money-making in this section is narrowed down to three varieties, Ben Davis, Johnson's Fine Winter and Wine Sap." In time, it would be the Albemarle Pippin that would become the most favored by the orchardists of Back Creek.

The development of orchards, better roads and the railway depot at Starkey lifted the economy of Back Creek significantly. By 1897, growth and settlement continued to advance at a rapid pace. In the *Virginia State Directory* for that year, the following persons and their businesses or trades were listed as follows:

Bent Mountain/Air Point: E.L. Argabright, blacksmith, undertaker; Giles Tyree, blacksmith; C.C. Hensley, carpenter; P.B. Ellicott, dentist; John Huff, gold mine; and D.W. Rierson, saddler, harness maker. There were also some sawmills in operation by the Craighead brothers, J. Coles Terry, and J.W. Woodrum. Also listed for this community were merchant firms—Mills & Perdue, J.C. Terry & Company and Bowman & Company.

Haran: B.C. Hartman, wagon builder; H.C. West, wagon builder; J.R. Austin, distiller; A.J. Kittinger, merchant; and C.E. Graham and J.A. Walters, sawmills.

Poages Mill: B.C Hartman, blacksmith; John Smallwood, carpenter; L.D. Bell, merchant; Elijah Poage, flour mill, sawmill and undertaker.

Cave Spring: Leslie Blunt, blacksmith; John Zirkle, blacksmith; J.L. Haley, carpenter; H.D. McPhearson, distiller and saloon; J.M. Airheart, merchant; J.W. Berry, merchant; J.B. Garst, flour mill; S.H. Jamison, sawmill; A.J. Phelps, sawmill; G.D. White, physician; Charles Hoffman, saddle maker; and B.L. Lockett, saloon.

Starkey (Farland): D.D. Short, carpenter; Fisher Brothers, carriage and wagon builders; T.C. Lockett, merchant; Thomas Kingry, flour mill; Phelps & Muse, sawmill; and W.R. Short, wool dealer.

In the same 1897 directory were also listed the principal farmers for southwest county, and they were as follows:

Bent Mountain/Air Point: G.W. Shelor, Jordan Woodrum, John Coles, E.D. Terry, G.W. Powell, E.J. Webster, Benjamin Henry, A.J. Mays, J.S. Moulse, J.C. Terry, W.J. Baldwin, N.C. Powell and G.P. Metz.

Haran: L.H. Kirkwood, Daniel Kittinger, Daniel N. Simpson, T.J. Webster, W.H. Ferguson, W.G. Ferguson, L.H. Arthur, J.W. Turner, J.W. McCray, J.P. Webster and Jordan Woodrum

Poages Mill: B.P. Martin, James Henry, S.W. Henry, William Grisso, James Grisso, Madison Hays, Kyle G. Wertz, J.M. Kittinger, S. Grice, T.G. Hays, G.M. Bell, L. Metts, William Metts, James Ferguson, D.A. Poage,

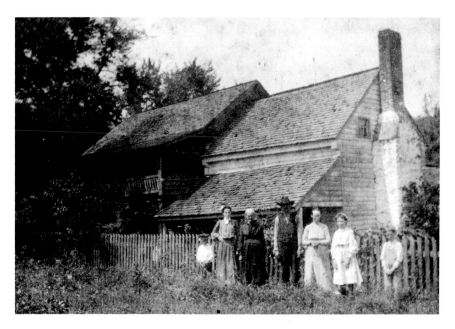

Daniel Simpson family, circa 1905. Simpson's home and farm were along Martins Creek. The home was originally a log cabin built by Abraham Martin in 1858. *Author's collection.*

Henry family and home, circa 1875. *Left to right:* James and Sarah Henry and their three daughters pose in front of their home in the Poages Mill area. *Courtesy of Walter Henry.*

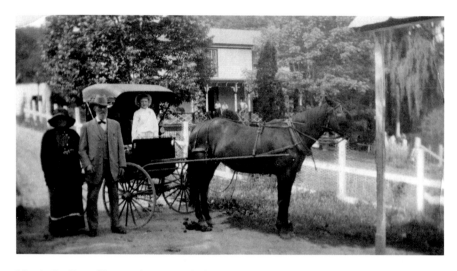

Martin family and home, circa 1900. *Left to right*: Sarah and Ballard Martin; grandson Damon is in buggy. The home was near Shingle Ridge Road. *Courtesy of David Harris*.

C. Meador, Elijah Poage, J. Sloan, H. Light, Jacob Shaver, George Poage, J.T. Henry, Thomas Bell, John Smallwood and John Hundly.

Cave Spring: J.W. Greenwood, E.M. Harris, John Campbell, J.F. Deaton, E.L. Turner, B.B. Boon, L.F. Brickey, Preston Hartman, William McCampbell, A. Washington, Joseph Richardson, T.M. Starkey, J.W. Eller, Jacob B. Garst, J.L. Zirkle, Jerry Trout, David Brumbaugh, J.M. Watts, S.O. Beckner, Benjamin Muse, Benjamin Campbell, J.C. Deyerle, C.W. Bowles, C.F. Lavinder, G.M. Bell, John Neff, S.H.C. Greenwood, John Harris and Frank Richardson.

Starkey (Farland): F.M. Starkey, Thomas Trout, D.W. Poage, B.W. Peters, B.T. Wright and B.M. Blackwell.

The increase in population and agriculture brought positive attention to the section. John Francis penned a travelogue about the various sections near Salem in the February 1897 editions of the *Times-Register*. He described the Back Creek and Bent Mountain areas in his horseback travels.

> On [Bent] *Mountain we find good crops of grain, fat cattle, hogs and cabbage in abundance; the cabbage of this section being as fine as was ever eaten, while the Irish potatoes are of the largest size and finest quality.*
>
> *Numerous young orchards have been planted along the road. Here we find Mr. Jordan Woodrum, who has turned his old orchard over*

to his son John and though venerable with age, is still planting apple trees—and knows where to buy them....[I]t was Mr. Woodrum who started the "Salem Register" away back in the fifties....In this neighborhood we find the Prices, Coles, Kings, Huffs, and other hopes to become acquainted in the near future. Our business takes us to Mr. J. Coles Terry's probably the largest land proprietor on the mountain. He, too, has turned his attention to the raising of red apples, having last year purchased a thousand trees. He, too, knew where to buy the trees. Here you find horses, fat cattle and big hogs, and hospitality for man and beast, and as you can eat a juicy steak you will see hanging on the walls a portrait of a young naval officer, in the uniform of the United States, who on inquiry I learned was Commodore Whittle, the father of Mrs. Terry, who became a distinguished officer of the Confederate States Navy.

Anyone familiar with this section thirty years ago would be astonished at the improvement of the place and people. The old-time double log houses have been torn down, and in their places have been erected substantial, neat six to eight-room cottages, tastefully designed and painted, while the old-time tobacco house has rotted down, or is used for other purposes, no one being willing to sunburn his back and strain his eyes to worm tobacco for the sake of the few dollars to be earned by its cultivation, when it's so easy to raise golden apples. The improvement in the people has been as great as the material. I remember when a few of the Back Creekers would come to Salem on public days for the purpose of "taking the town" and a few generally did giving old man Jimmy Huff and Albert trouble. But no better behaved people come to Salem than from that section. The change in people and place has largely been wrought by apples, free schools and the Bible; and Back Creek, from being considered the poorest section of the county, is now the richest—her apple crop being more than wheat crop of the county. And what is done on Back Creek can be done all over the county, as is evidenced by the nicest apples ever raised in every section of it. No danger of over-production, as the more apples we raise the more competition we will have among buyers. Here on upper Back Creek we find the Fergusons, Tinnells, Kittingers, and other good people, a still-house and Jim Turner.

In the Poage's Mill neighborhood, we find Mr. L.D. Bell, a clever man, who gave me a quart of chestnuts. He is a chip off the old block, and fast approaching the diameter of his father. At Poage's Mill we find Squire Elijah Poage, a little battered by his contact with the world and the frosts of

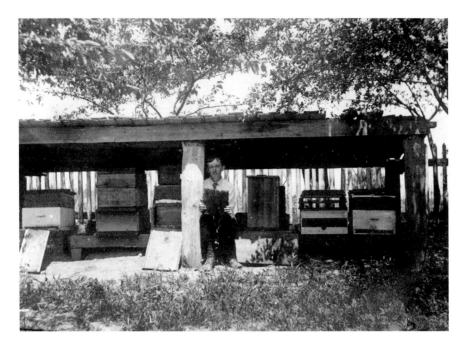

Preston Hartman, circa 1900. A young Preston Hartman poses with his beehives. Hartman farmed in the Cave Spring section for many years. *Courtesy of Bob Stauffer.*

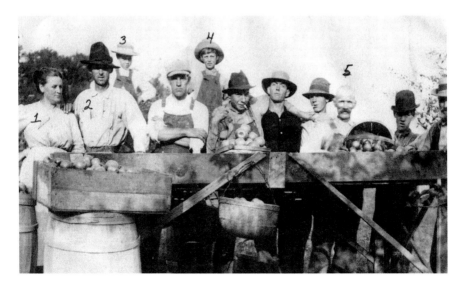

Wade family in their orchard, 1906. Those identified by numbers are Isadora Wade (1), William Wade (2), Oren Wade (3), Henry Wade (4) and Barney Owens (5). *Courtesy of Don Debusk.*

many winters, but he is still in the ring, and owns a little town of his own, besides the mill; has nice fat hogs and honey for breakfast. Notwithstanding, as goes Squire Poage, so goes Poage's Mill, no son of his will ever sit on his father's throne.

Crossing the intervening ridges, we come to Mr. G.M. Bell's, probably the biggest man in that section. He too went into the forest with a mattock with which he has made the forest to bloom as the rose—everything about him having an air of prosperity. Such work must be healthful, as witness his avoirdupois of 300 pounds.

The column continued in the February 12 edition.

Cave Spring is a nice village (none of your boom towns) with four nice churches: Baptist, Methodist, Presbyterian and Dunkard; two stores that carry a general assortment of goods...a doctor, a deputy treasurer and such good citizens as the Greenwoods, Chapmans, Turners, Hartmans, Zirkles, and others. Here, likewise, a post office in the suburbs. The town is watered by a spring from the cave. No hotel is here, but plenty of homes of entertainment. Lack of hotels gives me an excuse to dead-head my way to friend Greenwood's, the local lawyer of that place. Although the supper was cooked by "Greenwood" it was well done by the time I got through.

The bell in the Methodist Church has something of a history. Being considered too small by the large ideas of the present Methodist Church in Salem it was taken down and a large failure put in its place. It was presented to the Cave Spring congregation by the late F.J. Chapman. It was the first church bell ever in the town of Salem, and the first to call a congregation together for worship; and as our big bell is cracked it would be a very graceful act in the Cave Spring people to give it back to us.

The young people of Cave Spring are frolicsome in their natures; they throw rice and old shoes at a bridal party, and treat local political speakers to a shower of hen fruit.

We next come to T.M. Starkey's another man who has a little town of his own, and serves his district as Supervisor through all administrations, and no matter what kind of currency is in vogue always has plenty. He is also the possessor of an old-time pen of fattening hogs, a very rare thing now in the country, the people seeming willing to spend their money for western pork. His buildings are in good repair and his well-tilled farm seems to say, "by industry we thrive." I have never stopped here, but am

44

expecting an invitation next spring, as I make my rounds, if I ever get within a mile of his house to stop.

Here we strike the Roanoke and Southern Railroad, that was to have been built and finished to Salem within thirty days after it was built to Roanoke; said report to be worth thousands of dollars to the Salem Development Company, but not to the purchasers of lots. Here at Starkey's Depot last year we found John Bear with a large force of hands making barrels for the apple crop of Back Creek and this vicinity.

At the lower end of Starkey's bottom where the hills come in on the creek, you ride over a little mound and you see cinders scattered around, and close observation shows you the remains of an old furnace stack and forge, known in ancient times as "Harvey's Furnace." Mr. Harvey was the great grandfather of Mrs. Starkey, who owns the ancestral home. The greatest flood ever known in Back Creek, in 1812, swept away the furnace and all its belongings; and it was never rebuilt; so you can see iron was made in Roanoke probably one hundred years ago.

Jordan Woodrum's Pippin orchard, consisting of sixty-two acres, was sold in May 1901 to J.B. Fishburn and R.H. Woodrum of Roanoke for $5,000. Woodrum, who was credited with developing the first large-scale apple orchard operation in the Back Creek section, died in Salem two months prior, on March 24, at the age of seventy-nine.

The Bent Mountain Apple and Cold Storage Company was incorporated in July 1902. Those organizing the enterprise were John W. Woods, J.B. Fishburne, R.P. Woodrum, Ernest B. Fishburne and James P. Woods. According to newspaper reports at the time, the company was organized to erect a large cold storage plant in the Back Creek community and to plant and develop orchards in the section. The company held $100,000 in capital stock and had the ability to acquire up to twenty thousand acres of land.

Within a few months of being incorporated, the Bent Mountain Apple and Cold Storage Company had purchased the 80-acre farm of J.W. Chambers on Bent Mountain for $5,000, and the company had acquired the 125-acre Pippin orchard of Jordan Woodrum at the foot of Bent Mountain. On the Woodrum tract the company began building a cold storage plant in 1902 to house farm produce, mostly apples, until it could be shipped or until market prices were acceptable. John Woodrum still held some 3,000 acres in orchard.

A front-page article on the development and value of the apple industry in Back Creek appeared in the October 25, 1902 edition of the *Richmond*

Times-Dispatch. Such notoriety from a leading state newspaper was evidence of the region's reputation for superior apple production. In 1902, J. Coles Terry had some six thousand acres planted in orchards of Albemarle Pippins, being one of the first to plant the Albemarle Pippin on Bent Mountain. He had five hundred trees bearing fruit and sold $4,000 worth of the apple that year, most being exported to Europe. The Albemarle Pippin was a slow-growing but highly profitable tree, taking fifteen years to mature before giving fruit. Trees typically were planted forty feet apart. Other apples being grown on Bent Mountain included the Johnson's Fine Winter, York Imperial and Winesap.

By the summer of 1903, Colonel George Murrell of Bedford and the superintendent of Virginia's exhibits at the St. Louis Exposition had toured the Back Creek orchards, selecting Pippins to be a part of Virginia's showcase at the expo that year. In July 1903, the Bent Mountain Apple and Cold Storage plant was completed and operational at Haran, with Roy Moore of Salem appointed manager.

The expansion of commercial orchards in the Back Creek and Bent Mountain regions demanded a more improved road system. The orchardists, large and small, traveled two days to deliver their produce from Bent Mountain to Roanoke. I recall William Kefauver of Bent Mountain telling me that as a child he would ride with his father in a horse-drawn wagon to take apples and produce to the Roanoke market. They would spend the night along the road near Poages Mill or Cave Spring and get to Roanoke the next day. Getting to the depot at Starkey, if from Bent Mountain, would also take a day and a half. To address the problem, the Bent Mountain Apple and Cold Storage Company petitioned for a new road in 1903. Consequently, in August 1903, Roanoke County advertised for bids to construct a road to follow the north bank of Back Creek between Poages Mill and Starkey. The road would run west from Starkey depot, crossing lands owned by Andy Brickey and H. Lavinder, to intersect with the Bent Mountain Turnpike at Poage's Mill "near the Poage's residence." The road, much like the Bent Mountain Turnpike, was to be thirty feet wide and include any bridges, culverts and other necessary elements. The bids and contracts were overseen by Roanoke County road commissioners Luther Bell of Poages Mill and Joseph Woods of Catawba.

In the early 1900s, the orchard industry in southwest Roanoke County brought a surge in land prices. One such example was reported in the *Salem Times-Register* on May 8, 1903.

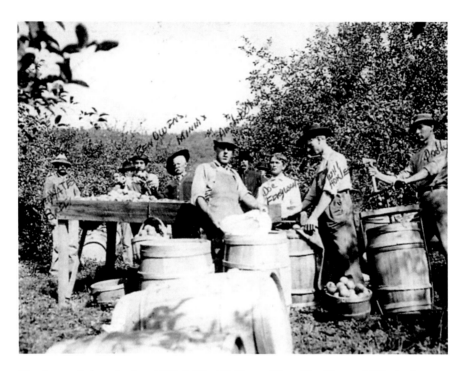

Heading apple barrels, circa 1905. *Left to right*: George Yates, Ben Owens, ? Minnix, A. Bohon, Doc Ferguson, Will Hokles and Wiley Lavinder at Ferguson's orchard. *Author's collection.*

Mr. L.D. Bell, a prominent and prosperous merchant of Poages Mill, has purchased from Messrs. L.C. Hansbrough and J.S. Baer for $5,500 that splendid farm and apple orchard near Haran, formerly owned by F. Rorer, Jr., containing 164 acres. The property was bought only a short while ago by Messrs. Hansbrough and Baer for $4,500 and the handsome profit they have realized on it is another indication of the increasing value of land and orchard properties in that splendid section of our county.

The growth in orchards was cause for much notoriety, not to mention income, for the Back Creek section. In 1902, for example, the Bent Mountain Orchard Company sold several hundred barrels of Pippins from the Woodrum orchard to Austin, Kimball & Company of New York for $5 a barrel. J. Coles Terry sold his entire crop of Pippins on Bent Mountain to the same company. These sales prompted the *Richmond Dispatch* to declare that year, "Roanoke County is getting to be known as one of the best apple sections in Virginia, and thousands of dollars are being invested in apple

orchards every year." The following year, the Woodrum orchard reportedly netted $16,000.

The apple industry of Back Creek, and especially of Bent Mountain, continued to gain prominence, as apples from the area were earning awards at various expos around the nation. The display of Bent Mountain apples at an agricultural exposition in Buffalo, New York, in 1901 prompted Gilbert S. Whittle of the *Roanoke Evening News* to visit the apple orchard operation of J. Coles Terry on Bent Mountain in 1908. He penned a highly descriptive article about Bent Mountain and its apple industry in the October 19 edition.

Apples grown on Bent Mountain upon an estate of 5,000 acres belonging to John Coles Terry, they are now sought after by buyers everywhere, and are introducing to the great public an interesting and important hitherto only locally known.

Situated in Roanoke County, it is eighteen miles from Roanoke City, a train running from that point to Starkey, a station on the Roanoke and Southern road, reducing the distance to ten miles. The remainder of the journey must be accomplished on horseback or in vehicles, the graded road at times a mere shelf on the mountainside, winding upward like a corkscrew....The beanstalk climb accomplished we find ourselves in a new world...an aerial island so to speak, girt about with dewy clouds, and green as oasis, even when the land below is parched and arid.

Should the month be June, a delicious odor greets him from the blossoming crab-apple, indigenous to the soil, which outlines the roadway, and the wild grape with which the woods are festooned. The Tiger lily too and the fragrant arbutus mingle their perfume, while the kalia latifolio (called by country people "ivy"), the great waxy white and pink rhododendron, the scarlet lobelia, the pink azalea and the rarer yellow variety, shading from the delicate straw color to the deep burnt orange, make the forests gay with bloom.

The native trees, the white pine, white walnut, oak and chestnut, grow to immense size, an oak which stood recently near the public road being six feet in diameter and proportionately tall, and were a market sufficiently convenient to make the enterprise profitable, might be converted into a high grade of lumber, a stave and barrel factory operated by Mr. Terry's son, J. Coles Terry, Jr., having already been established on the place. They support numbers of hogs running at large, and colonies of wood denizens, harboring both the red and gray fox.

It is a well-watered region.....Now and again [streams] are detained for some special service as the turning of a busy saw and grist mill on Mr.

Terry's place. While through them glide the brook trout, a shining silver fish flecked with scarlet.

The soil of Bent Mountain is a rich sandy loam of almost inexhaustible fertility....All root crops do well. Irish potatoes yield almost as much as 800 bushels to the acre and are of unusual size and quality. Mammoth cucumbers are raised...cabbages weighing twenty pounds are seen, and rye grows to the height of seven feet. Succulent growths as the wild pea vine afford grazing for sheep and goats, while blue grass suggests successful dairying.

Soon after the Confederate war, when there was a special demand for it, the growing of tobacco was the principal enterprise on Bent Mountain, a fine bright wrapper fragrant as a Havana cigar and commanding a high price in the market, being produced. With the gradual disintegration of labor, however, the industry was practically abandoned.

Some years before that time, the late Col. Joseph M. Terry, the father of Coles Terry, set out an orchard of Albemarle Pippins....With great foresight Col. Terry saw in this apple the future crop of this section, and inspired by his enthusiasm his son set out twenty-five acres in pippins, interspersed with the Winesap, the York imperial, and other standard varieties....Young orchards grew and flourished, apples being shipped from them to Liverpool [England] and fetching $12 a barrel.

Since that time, Mr. Terry has annually increased his acreage in pippin until he now has thousands of flourishing young trees in various stages of advancement. From his original orchard of twenty-five acres he realized in a recent year between $6,000 and $7,000, his returns in "bad years" never less than $3,000; while it is estimated his young trees, when fully matured, will average an annual income of $50,000.

The greater part of the crop is shipped to foreign markets....Filled with busy workers here and there beneath the heavy-laden trees, the orchards present a beautiful and animated scene....The buyers, from North or West as the case may be, bring with them their own expert packers, the juxtaposition of these laborers from widely separated sections—differing essentially as well as in voice, speech, dress and style—present a queer and interesting study. Pickers are paid by the basketful, the friendly rivalry giving zest and impetus to the work. Each apple is taken from the tree by hand and placed in a basket as carefully as if it were an egg. All are then sorted into piles, according to their size, those reaching stipulated stands being barreled. The remainder, denominated "culls," are sold in neighboring markets, or to distillers or evaporators.

With the increase in population a better class of houses is being built, and painted frame dwellings are gradually replacing the rude log cabin formerly the rule with the average inhabitant. A tiny hamlet is indeed springing up, with a union church, a post office, a store and a blacksmith shop as a nucleus.

The writer continued his flowery prose by suggesting a bright future for Bent Mountain and predicting that with certain amenities the community could even flourish more. He suggested that the citizens of Bent Mountain consider establishing a summer resort with a mineral spring, an industrial school for boys to learn agriculture and girls to study domestic science and a well-equipped hospital with resident physician and nurses.

In 1910, a journalist writing for the *Fruit Grower*, published in St. Joseph, Missouri, visited the orchard of John Woodrum at the base of Bent Mountain. His article was reprinted in the *Salem Times-Register and Sentinel* on April 14.

"This article is to tell of a great orchard in Virginia....It is located in what is known locally as the 'Back Creek Country' about eighteen miles from Roanoke." Due to road conditions, the reporter and his companions arrived at the Woodrum home mid-afternoon. Having not eaten lunch, Woodrum's wife provided a hearty meal that was described in detail: "a table loaded

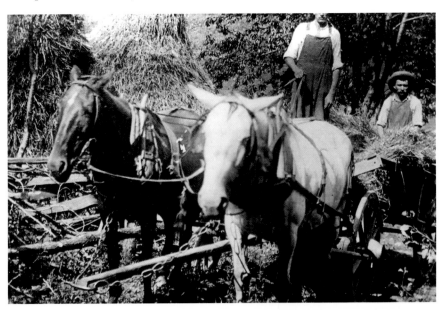

Hay wagon, circa 1910. George M. Burris (*right*) sits on a hay wagon, presumably at the family's farm at Bent Mountain. *Courtesy of Salem History Museum.*

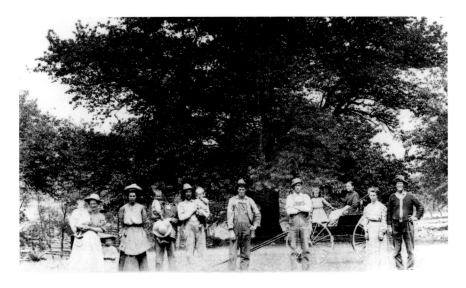

American chestnut, circa 1910. Olvin Martin (*far right*) and family pose at a Chestnut tree. Once plentiful, chestnuts had died out in Appalachia by the 1940s. *Courtesy of Joyce Turman.*

down with tomato soup, Virginia ham, scrambled eggs, fresh peas, good bread and butter, rich milk, honey, apple sauce and pear preserves."

Great detail was provided about the Woodrum orchard and its history. The story noted that the apple harvest from 1909, coming from eight hundred trees, yielded $15,000 cash or a value of $600 per acre. The majority of Woodrum's trees were Albemarle Pippin and York Imperial.

At a land exposition in Pittsburgh, Pennsylvania, in 1911, Virginia agricultural leaders showcased many state products, among them Pippin apples from the Woodrum orchard. So impressive were Woodrum's apples, the expo leaders had placed them at President Howard Taft's table when he came to deliver a dinner speech for the exposition.

In *A History of Roanoke County*, published in 1912, George Jack profiled many of the leading orchardists at that time in the southwest part of Roanoke County. George W. Powell had planted 1,000 apple trees consisting of Pippin, Ben Davis, Johnson's Winter and Rome Beauty on Bent Mountain on his 100-acre farm. John Coles' 1,200-acre orchard on Bent Mountain was estimated to be worth $250,000. Libbey C. Shockey had purchased the orchard of J.L. Perdue and was operating a 64-acre orchard of over 800 trees on Bent Mountain. In the same area was Wilson Baldwin, who had an orchard of 1,100 trees on the Roanoke and Franklin County line. Dr. Edward Tinsley, a physician, had even ventured into the apple business. He

had an orchard of more than 1,000 trees cultivating Winesap, York Imperial and Rome Beauty apples. Benjamin Bowman held title to 171 acres of land planted in more than 600 apple trees, notably Pippin, Johnson's Winter, Ben Davis and Winesap. John Huff had a 250-acre orchard on the Roanoke and Franklin County line with 1,500 apple trees. In the Bottom Creek section, Samuel Willett had an orchard of 900 Pippin trees. Joseph Perdue had an orchard of 800 trees on Bent Mountain. Andrew Howell had a small orchard of Johnson's Winter at Bent Mountain.

At the base of Bent Mountain and extending east toward Cave Spring were many orchardists noted by Jack for their extensive apple business. James Grisso had 1,800 Pippin trees; Thomas Bell had 3,000 trees of the Pippin and Winesap varieties; Kyles Griffin Aliff had over 1,000 trees; John Willett had 1,700 Pippin trees; and James Turner had extensive orchards. Thomas Bell had two orchards near Cave Spring of Pippin and Winesap varieties.

During this same period, there were a number of mercantile businesses within the region. The firm of Bowman & Willett was operating at Poages Mill, and its store was an extension of the mercantile business the partners had in Roanoke on South Jefferson Street. The principal partners were J.B. Willett and H.E. Bowman. Their Roanoke store opened in 1906; the store at Poages Mill opened in 1909. Joseph Perdue opened a mercantile on Bent Mountain in 1891 that he operated until 1911, when he retired and sold the store to L.C. Shockey. Shockey, prior to the purchase of Perdue's store, had been a merchant in Copper Hill for eight years. C.M. Conner & Company was a mercantile located at Air Point that was operating in 1912. This was a partnership between Clemens Conner and Preston Simpson. Conner had previously operated a mercantile in the Copper Hill section of Floyd County and at Poages Mill. He and Simpson formed their mercantile company in 1907 at Air Point. Luther Bell had a store in the Cave Spring area for several years in the early 1900s before becoming a full-time orchardist. John Huff opened a mercantile on Bent Mountain in 1870 that he operated until 1895. McH. Booth had numerous business interests in the Bent Mountain section, operating a saw- and gristmill and a mercantile in the early 1900s.

John Keaton purchased a mercantile owned and operated by H.W. Gearheart "in the extreme southern end of Roanoke County," according to Jack, and renamed the firm John S. Keaton & Son. Reuben Moore, a native of Colorado, began a mercantile at Air Point in the late 1890s and then relocated the business to Bent Mountain. Benjamin Grisso acquired the mercantile of N.C. Powell at Poages Mill in 1910. Grisso also had a large orchard, mainly Albemarle Pippins, along the north branch of Back Creek.

Elijah Poage began operating a large mill along Back Creek in the late 1840s. Poage began working with a foot-turning lathe as a young man, producing chairs with turned posts. Later, he greatly expanded the mill enterprise for the manufacture of cornmeal and flour, adding a sawmill that became the first to use a circular saw in his section of the county. Poage was an established and well-known cabinetmaker. With his production of coffins, he also became the undertaker for southwest Roanoke County. Poage continued to operate his mill until his death in 1900, and then the mill was purchased in 1901 by Charles Price, who converted it to a roller mill. Charles Young, whose home is Elijah Poage's former warehouse and shop, showed me the approximate location of Poage's Mill (Google map 37.1971, -80.0568), where iron stakes are still imbedded in large boulders.

Roscoe Wertz owned the large Wertz orchard that had been established by his father, Kyle Griffin Wertz, and left to him when his father died in 1893. The Wertz tract consisted of some 1,800 trees of many varieties near Poages Mill and was considered to be one of the oldest orchards in the Poages Mill community, having been established by Levi Hayes around 1879.

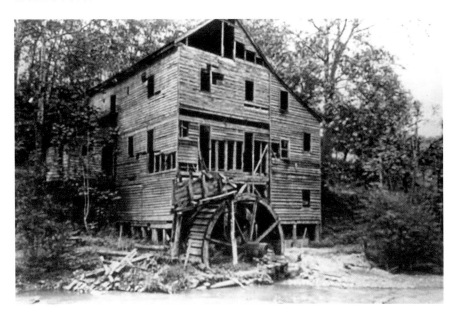

Poage's Mill, 1929. Built along Back Creek in the 1840s by Elijah Poage, the mill was operated for decades by Poage until his death in 1900. *Author's collection.*

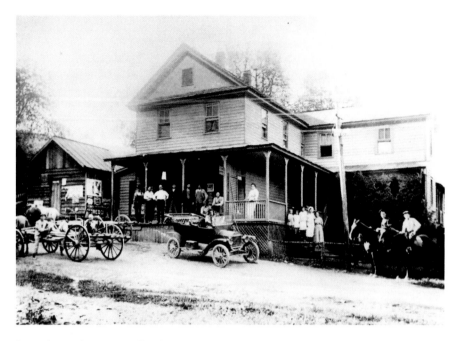

Poage Store, circa 1910. Elijah Poage's store and warehouse still operated after his death. It is today a residence at 6547 Old Mill Road. *Courtesy of Debra Christley.*

Charles Smallwood began his career as a carpenter and reportedly built many residences in the Cave Spring and Poages Mill sections. When his wife inherited the orchard of her father, James Ferguson, Smallwood quickly adapted to being an orchardist. He later purchased the orchard owned by James Turner. His orchards had an estimated two thousand trees.

Almost all of the mercantile businesses during this period were operated by orchardists or their relatives, demonstrating the varied business interests many of the men had during this period and the wealth the apple industry provided them.

In October 1914, controlling interest in the Bent Mountain Apple and Cold Storage Company was sold by Ernest Fishburne, who had managed the company for the previous six years, to J.B. Willett and D.B. Persinger. Persinger became president and treasurer, and Willett was selected as vice-president and manager.

The *Salem Times-Register and Sentinel* reported in September 1915 that several buyers came to Roanoke County to acquire apples for export. L.E. Calvert represented buyers in England and took a significant interest in the orchards of Back Creek, closing contracts for the entire crops that year of the

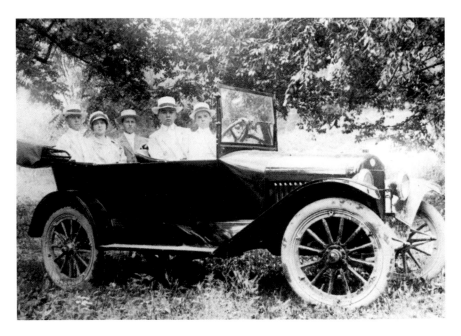

Car ride, 1919. Enjoying a spin in their new Metz car on Bent Mountain are (*left to right*) Neva, Vera, Elbe, Raymond and Alton Reed. *Courtesy of Roanoke County Library.*

Woodrum orchard, the Bent Mountain Apple and Cold Storage Company, and the orchard of M.B. McClung. L.D. Bell of Back Creek served as buyer for Looms & Company of New York and made significant purchases of Pippins among Back Creek orchardists, as well.

The Woodrum orchard was sold in 1916 to O.L. Stearnes for $30,000. At the time of the sale, the orchard was described as containing 160 acres with 2,800 mature trees bearing the famed Albemarle Pippin. John L. Woodrum, the proprietor, moved to Corbett, Maryland, where he died in 1922.

At the Virginia State Fair in 1917, held in Richmond, orchardist J.B. Willett took first prize in two apple categories, Mammoth Black Twig and Winesap.

A business directory published in 1917 listed the mercantile and other businesses operating in southwest Roanoke County as follows:

Bent Mountain and Air Point: A.B. Argabright, blacksmith and wheelwright; Bent Mountain Cooperage Company (barrel factory); J.B. Coles, general store; L.C. Shockey, general store; W.C. Woods, general store; McH. Booth, sawmill; and Edward Tinsley, physician.

Cave Spring: P.B. Jennings, grocer; J.P. Richardson, general store; and W.D. Robinson, general store.

Haran: J.B. Willett, general store.

Poages Mill: Henry Brothers, cannery; Frank Harris, contractor; C.L. Graham & Son, general store; D.H. Poff, grocer; W.T. Rierson, grocer; H.C. Poage, lumber mill; O.L. Grisso, general store.

Starkey: E.S. Terry, general store; Shenandoah Packing Company.

Hundreds of men were listed from these sections as farmers or orchardists and are too numerous to list here.

The entrance of America into World War I brought a halt to shipping apples to Europe, impacting the area's orchard market. Further, many young men were drafted from southwest Roanoke County for military service, diminishing the labor force. Three men from the Bent Mountain and Back Creek sections died during the conflict: Private Claude Lancaster of Bent Mountain, who was killed in action on October 15, 1918, at Argonne; Private Clarence E. Metz of Poages Mill, who was killed in action on November 6, 1918; and Private Martin Tinnell of Poages Mill, who died of disease on October 12, 1918.

In addition to apples, cabbage was another well-known product of the Bent Mountain section. Cool evening temperatures even in summer provided optimal growing conditions. The bulletins of the Virginia Department of Agriculture from 1916 and into the mid-1920s shared much information about Bent Mountain cabbage. The harvest was late August through early December, with some farmers storing cabbage in pits, and the markets included Roanoke, Rocky Mount, Martinsville and Danville. It was of "excellent quality and sells at a premium." Some heads of cabbage weighed as much as fifteen pounds, but cabbage fields were labor-intensive, so only limited acreage was used. A map produced by the Virginia Department of Agriculture in 1924 showed that almost all cabbage fields were located at or near the Roanoke-Floyd County line. Cabbage was grown at Bent Mountain for several decades before becoming a victim of increased deer populations and low market prices.

With the postwar development of the Back Creek and Bent Mountain sections, the state highway department constructed what is now Route 221, completing it in 1932. The previous road, Route 205 (Bent Mountain Turnpike), had generally followed along Back Creek and was prone to washing out in floods and had steep curves as it meandered along what had earlier been wagon roads and trails. The new two-lane Route 221 was

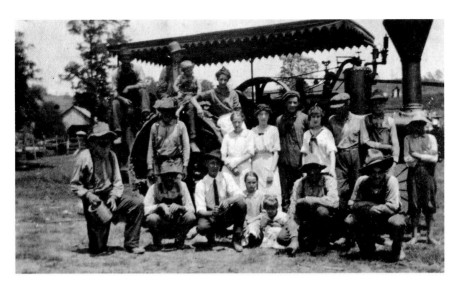

Poage family, circa 1920s. Poage family members and others pose in front of an engine used on the family's farm. The farm, along Route 221, still operates. *Courtesy of Molly Koon.*

Charlie Poage, circa 1920s. Charlie Poage, son of William Poage, is with his workhorses. The Poage farmhouse is in the background. *Courtesy of Molly Koon.*

located away from Back Creek where possible, had concrete bridges and was less curvy. Remnants of the old Route 205 can still be seen today.

In 1982, the late Wiley Lavinder shared with Joyce Turman his memories of the construction. He said state convicts did much of the work under the supervision of a Mr. Higginbotham. The convict camp was located along what is today Apple Grove Lane, near its intersection with Whistler. Lavinder and others have shared that the convicts formed a baseball team that played every Saturday at the camp.

Roanoke County records indicate that when the highway was being constructed at Bent Mountain, rock-crushing equipment was located near present-day Poff's Garage and that a large outcropping, known as "Lover's Rock," was dynamited and the remnants ground into gravel for the roadbed.

Farmers were not the only ones to use the new highway. Older residents recall that certain spots along Route 221 were given nicknames. There was "Gypsy Hill"—the small knoll along 221 just south of Back Creek Elementary School where gypsies often camped. "Beggars' Bottom" was directly across the highway from the entrance to today's Forest Edge subdivision, commonly used by gypsies and others who begged passersby traveling between Floyd and Roanoke. Where 221 crests Bent Mountain,

Wheeler and Bessie Beckner, circa 1920s. The Beckners and John Steele (*left*) logged timber for railroad ties. They lived in the Cotton Hill area. *Courtesy of Grandle Meador.*

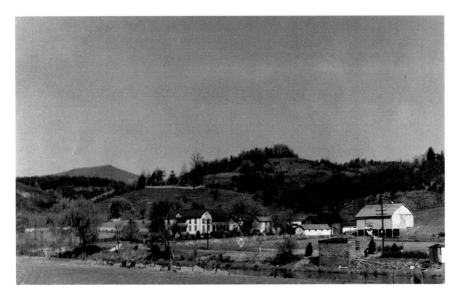

Poage Farm, 1939. Route 221, constructed in 1932, bisected William Poage's farm and provided a location for his filling station and store. *Courtesy of Molly Koon.*

there are two springs adjacent to the highway, and residents say this was the site where farmers from Floyd in earlier times would spend the night to water and rest their horses before descending the mountain.

Another significant development came in 1937 with the arrival of electricity. A notation in Holt family records reads, "The electric lights were turned on February 3, 1937, on Bent Mountain."

THE LARGEST ORCHARD OPERATION remained the Back Creek Orchard Company. Over time, the operation encompassed not only Jordan Woodrum's original orchard on the side and at the foot of Bent Mountain but additional land across the highway in the vicinity of Big Bend and Hog Rock, plus orchards at Air Point and in the area of present-day Apple Grove Lane and Whistler Drive. An estimated one hundred men harvested the orchard during its peak years.

Genevieve Henderson wrote the following about the orchard company:

> *Apples were shipped in barrels. Apple pickers would come from Floyd and Franklin Counties; and the third floor of the packing shed at the foot of Bent Mountain was set up with beds where they could sleep*

59

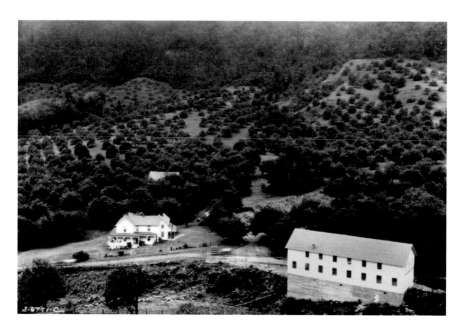

Aerial view of Back Creek Orchard Company, undated. The orchard company's building was three floors, providing cold storage, a dormitory and a supply room. *Courtesy of Roanoke County Library.*

and meals were provided in a nearby "cook house." Each apple picker had a heavy white bag which he placed over his shoulder and across his chest. The apples would be dropped into the bag until it was full, with a full bag holding about a bushel of apples. Each picker was also given numbered cards; and each time he emptied a bushel of apples, he gave the card to the person collecting the apples. This helped keep a good record of not only how many bushels had been picked that day but also how much money was owed the picker. In later years, pickers were paid ten cents per bushel, but in earlier years it may have been ten cents per day. Many of these apples were sent out of state, some as far away as England. It has been stated that the Queen of England "fancied these apples."

It is believed that the three-story packing shed referenced above was built in the early 1900s. Apples were brought in on the ground-level second floor and prepared for sale or shipping. The first floor was cold storage, and the third floor functioned as a kind of dormitory for the pickers. Also on the second floor, equipment was maintained, supplies stored and horses shod. This building still remains and is used for general storage. The Back Creek

Orchard Company also had a packing shed on what is now Apple Grove Lane near the intersection with Whistler.

Maintaining an orchard operation, regardless of size, was not a small undertaking. The orchard harvest was weather-dependent, and the trees required regular pruning and spraying. There was the continual removal of dead or dying trees and the planting of new ones. The orchards had to be mowed, and in early years, this meant with a handheld scythe. The spraying was probably the costliest and most labor-intensive maintenance activity. Tanks would be filled with a mixture of chemicals and transferred to horse-drawn wagons. Henderson recalled the spraying activity: "Men pulled spray hoses from the tanks and sprayed each apple tree many times during the growing season, starting with an oil spray at the end of winter and then sprays (usually arsenic and lead or sulfur and lime before better chemicals became available) were used from the time the trees bloomed until the apples were almost ready for picking." Henderson said that in later years

Orchard spray engine, undated. Shown here is the spray engine used by Raleigh "Buck" Owens for use in his orchards. Spraying was a necessity. *Courtesy of Joyce Turman.*

Ben Lewis, circa 1940s. Ben Lewis was one of the few African American residents in the Back Creek section in the mid-twentieth century. *Courtesy of Kat Jacobs.*

at the Back Creek Orchard, pipes were buried throughout and the spray material from a large tank in the spray shed flowed from the shed through those pipes. Workers then hooked their hoses to the pipes, replacing the horse-drawn wagons with small tanks.

Alonza "Kit" Kittinger recalled working in his family's orchards as a boy in the 1940s. "It seemed to me that spraying the trees was almost a continuous process. The different sprays were designated by the County Agent for Agriculture. One spray I recall had a mixture of three pounds of arsenic with one hundred gallons of water. When this was mixed it looked almost like a strawberry milkshake. It killed some kind of bug or blight harmful to apples." Kittinger noted that in his family's orchard he scaled thirty-foot ladders with a half-bushel basket hung on one of the rungs. "We took a lot of apples to the city market on Market Square. I usually went to the office to get the permit, for 50 cents, for the space to park our truck. We sold the apples by the gallon, peck, or bushel. Prices were as low as two or two and a half dollars per bushel. The Winesaps, Stamens and Golden Delicious were my favorites. Cull apples were taken to a cider mill in Roanoke where either cider or vinegar was made." He also relates that some apples, either in barrels or bushels, were taken for cold storage that was located diagonally across from the old fish pond in Elmwood Park beside the N&W Railway track.

During World War II, there were two German prisoner-of-war camps in the Roanoke Valley. One was located near Salem and the other in Mason Cove (now Ward Haven Camp, owned by the Roanoke Valley Baptist Association). German prisoners were assigned to Back Creek to help harvest apples. Kittinger remembers, "I recall trucks loaded with them went by Back Creek School up to the big orchard near the foot of Bent Mountain. My sister Jessica reminded me that these prisoners also picked apples on our farm. Mother was always concerned about their presence but no problems ever occurred."

Henderson recalls German soldiers working the Back Creek Orchard Company's trees and the soldiers sleeping on the third floor of the company's packing shed. Gordon Saul writes:

> *The prisoners were considered to be hardy, willing workers who were compensated by the government for their work at the minimum wage. Me and two ten-year-old buddies, Earl Harrison and Rodney Huffman, worked for several days during the 1944 wheat harvest on the Watts Farm as water boys, carrying water to the thirsty workers. Being naturally curious*

boys we wanted to know how the fighting was going in Germany and if these prisoners had shot any Americans. The Germans would always laugh good-heartedly and say, "Oh no! We only shot Ruskies."

Many men from southwest Roanoke County served in the military during World War II, and some did not return. Those from the section who died in service during the global conflict included Lawrence Furrow, George W. Grisso, George B. Harris, George B. Harris Jr., John R. Jamison Jr., Alonzo E. Janney, Henry R. Jinks and Darrell Johnson.

In the late 1940s and throughout the 1950s, many of the large orchards of Back Creek were divided and sold. In the late 1940s (possibly in 1948), the large Back Creek Orchard Company's holdings were sold. Jack Kefauver, a commercial real estate agent, handled the sale. According to Henderson, the orchards at Air Point and along Apple Grove Lane and Whistler Road were sold in separate tracts; houses have replaced the trees. George and Wilma (Underwood) Likens purchased a small tract where his parents had lived. Kefauver acquired the property along Route 221 in the vicinity of Big Bend, and he and Edgar Baldwin from Bent Mountain purchased tracts on the north side of the highway and up the mountain in the area of Hog Rock. Clinton and Ruth (Simpson) Craighead from Bent Mountain acquired the main Back Creek Orchard tract below Route 221 in 1948 and moved their family there. Thus, by 1950, the largest orchard operation, the Back Creek Orchard Company,

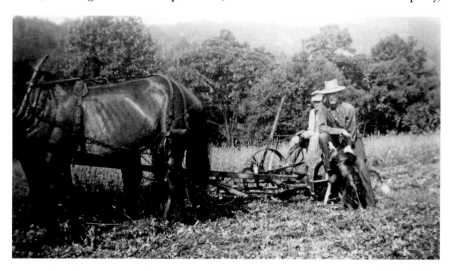

Mowing fields, circa 1945. Omer Simpson and his son Francis use horsepower to mow a field on Simpson's farm on Martins Creek Road. *Author's collection.*

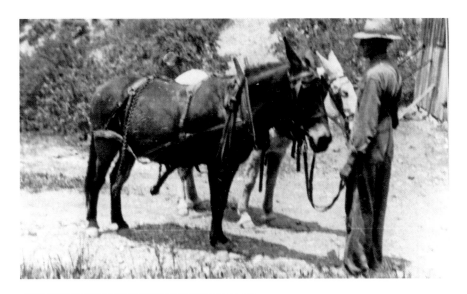

Above: Mule power, circa 1940s. Sam Hailey and his work mules were indicative of the ongoing use of horses and mules even with the availability of tractors. *Courtesy of Joyce Turman.*

Left: Charlie Altis, circa 1940s. Altis' home and orchard were located along Route 221, where the entrance to Old Mill Plantation subdivision is today. *Courtesy of Mauvileen Altis.*

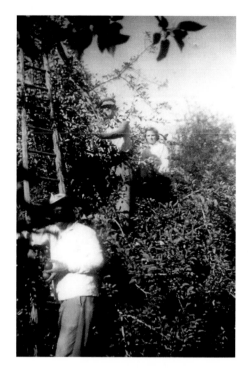

Left: Picking apples, 1958. *Left to right*: Marvin, Jesse and Betty Conner are picking apples in the Thompson Orchard on Bent Mountain. *Courtesy of Cindy Windel.*

Below: Reed Orchard, 1990. The house and orchard were purchased by Homer Reed in 1948 from the Woodrums; intersection of Poor Mountain Road and Tinsley Lane. *Courtesy of Glenn Reed.*

had ceased to exist, though smaller orchards continued to be maintained on the tracts that had been sold.

At Bent Mountain, Homer Reed purchased the former Woodrum orchards in 1948, and the Reed family continued that commercial orchard operation until 1995. Other orchardists who continued to operate at Bent Mountain in the 1950s, '60s and '70s were as follows: Junior Wimmer, Jack Conner, Ed and Lorraine Witt, Charles Lindbergh Waldron, Emmeritte Conner, Howard "Bud" King, Jack Poff, Albert Harvey Poff, Harvey Howell, Marvin Thompson, Melvin Reed, B.W. Angle, Dalton Sink, Shike King, Boyd Bartlette, John Cooper, Joe Powell, Byrd Fralin, Elbe Reed, Vester Grant, Paul Hollyfield, Bill Hall, Paul Willett, Boyd Williams, Morgan King, Jack Kefauver, Doug Lancaster, Raymond Wimmer, Lank Alderman, Ed Conner, Noah Thompson, George Fralin, C.F. Holt, Clifton Stewart, Grady Fine and Curtis DeWeese. (Today, the only large orchards remaining at Bent Mountain are the Witt Orchard along Poor Mountain Road and King Brothers Orchard along King Brothers Road.) While orchards thrived at Bent Mountain during this period, in the Poages Mill and Cave Spring sections, the large orchard tracts gradually became residential subdivisions or were sold off in smaller tracts.

THE ORCHARDISTS OF SOUTHWEST Roanoke County were responsible for much of the development of the section, and not just in agriculture. Their enterprise gave rise to small businesses, improved roads and an elevated social and economic life. Two outgrowths of the orchard industry were the telephone companies and a proposed but never realized railway whose histories now follow.

An interesting article appeared in the May 16, 1904 edition of the *Roanoke Evening News*, outlining a proposal by the Virginia and North Carolina Electric Railway Company to construct an electric railroad from Roanoke to Mount Airy, North Carolina, by way of Back Creek and through Floyd County. The line would cover about ninety miles at an estimated cost of $1 million. The officers of the railway company were S.R. Brame (Floyd, president), R.H. Angell (Roanoke, vice-president) and J.C. Davenport (Roanoke, treasurer). Others on the board of directors included J.B. Fishburne and John Woodrum, as well as men from Floyd and Patrick Counties. The officers had acquired the services of the Payne & Jackson firm in Williamson, West Virginia, to survey a proposed route

from Roanoke running through Norwich, Cave Spring, Bent Mountain, Air Point, Copper Hill, Pine Run, Big Run, Beaver Dam Creek, Floyd Courthouse, Toncray Copper Mines and Conner's Grove over Buffalo Ridge to Reed Island Creek to the summit of the Blue Ridge and then to Mount Airy.

The men involved in the proposed enterprise were of such reputation that the newspaper articles speculated much success and confidence that the electric railway would become a reality. A proposed electric railway from Roanoke to Mount Airy was in concert with many other proposed and existing electric railways occurring at this time.

So confident were regional leaders that the railway would happen, a front-page headline in the *Roanoke Evening News* the previous month declared, "The Electric Line Is Now an Assured Fact." The article gave significant details of the railway's path through the Back Creek section as being

> *past the Greenwood home at Cave Spring, through the gap one mile west of Cave Spring, take either the Starkey Road or the stream around the gap... over to the location of the new road along Back Creek, follow this road to Poage's Mill, thence to Haran post office, after crossing Ferguson's branch, thence to the Pike gap. Pass the cold storage plant. After passing the Ferguson farm, follow the road to approximately the bend in the mountain, then going below the road to the May gap, and above the Woodrum orchards, over to the Baldwin gap in old Bent Road. Thence by Moore's store to Perdue's store, through the low gap past W.E. Tice's, thence up the stream past Elder I.K. Wimmer's and passing to the left of Copper Hill.*

The remaining road was described going through Floyd and Patrick Counties. All of this detail had been enthusiastically shared at a meeting at Floyd Courthouse to raise capital investment.

Despite the strong interest in an electric railway through Back Creek and points southwest, the Virginia and North Carolina Electric Railway did not materialize. Nonetheless, some leaders of the effort were not dissuaded from a railway from Roanoke to Floyd. Thus, in 1908, some Roanoke businessmen explored the opportunity to create a steam railroad to run from Roanoke to Floyd Courthouse. One must understand that during this time, agriculture and ore, not coal, were the primary freight of railroads in southwestern Virginia. In August of that year, the Roanoke and Bent Mountain Railway Company was chartered.

An article appeared in a February 1910 edition of the *Floyd Press* that provided a summary of the company's progress:

> *A meeting of those interested in the proposition to build a railroad from Roanoke to Floyd courthouse was held yesterday morning in the office of Mr. M.M. Cadwell in the Watt, Rettew and Clay Building. The undertaking was discussed in all phases. It was the opinion that the status of the proposition offers much encouragement and that the outlook promises that the road will be built. The name selected is "The Roanoke and Bent Mountain Railway Company." A reorganization of the official board was decided upon and the following officers were elected: President, A.L. Sibert; Secretary, C.M. Armes; Board of Directors, A.L. Sibert, C.M. Armes, E.A. Thurman, R.H. Angell, James B. Botts, W.C. Lawson, J. Coles Terry, L.G. Stewart, M.M. Caldwell, S.B. Pace and C.G. Ogden. No formal reports were submitted, however, statements made to show that the enterprise is in good shape and that definite action may be expected in the immediate future. The gentlemen who are behind the scheme feel that conditions are most encouraging and that it will not be very long before Roanoke and Floyd Courthouse will be connected by a railroad. Plans were discussed and a campaign of aggressive activity was mapped out. Business-like and systematic methods will be adopted in the promotion of this enterprise.*

The article stated that the fifty miles of track required to connect Roanoke and Floyd would cost about $800,000 and that three-fourths of the route had already been surveyed with the line section up Bent Mountain being the most difficult but not impossible.

The article, reprinted in the *Roanoke Times*, concluded, "After the line reaches the top of Bent Mountain it passes into one of the most fertile and prosperous sections of Virginia. It lies on a great plateau or table land, 2400 feet above sea level. Its forests are practically untouched and its mineral resources are most attractive. Soapstone of the very best quality is found in inexhaustible quantities and iron and copper abound in vast deposits. It is estimated that the building will bring in touch with Roanoke thirty thousand people who do not trade here now."

In July 1910, representatives of the proposed railroad went to Mount Airy, North Carolina, to gather interest from the citizens there as to the rail line being extended from Floyd to their community, probably trying to build upon earlier interest in the electric railway proposal. The plans for

the Roanoke and Bent Mountain Railway Company were making headlines across Virginia, with the *Richmond Times-Dispatch* declaring, "Plans Enlarged for New Railroad" in its July 8 edition. Proponents had secured the support of Congressman Carter Glass of Lynchburg, who was advocating for a federal geographic survey for the rail line, especially in Floyd County, where no rail service existed.

For all the flurry of activity surrounding the proposed railway up Bent Mountain, nothing developed beyond the company being chartered and some preliminary surveys. At this same time, the Roanoke & Southern Railway was being built from Roanoke to Winston-Salem, North Carolina, by many of the same interests. Perhaps that effort drew attention away from the Bent Mountain rail line, or the cost to construct such a line was too prohibitive. The specific reasons for abandoning the proposed railway remain unknown. However, one can only imagine what a railway running through southwest Roanoke County would have done to alter the life, economy and development of the section.

The Fruit Growers' Telephone Company was granted a charter by the State Corporation Commission on November 16, 1910. John T. Henry was president, J.B. Willett was vice-president and R.C. Wertz served as secretary-treasurer. Capital stock was limited to $5,000. Two weeks later, the Roanoke County Board of Supervisors granted the company the right to erect lines along county roads and for the officers to receive a small salary. This decision came as a result of a petition presented to the county by the company, wherein the officers outlined their plans to erect a telephone line in the Back Creek area to the top of Bent Mountain. The central exchange was at the store of Luther Bell at Poages Mill (presently 6831 Landmark Circle) and had nearly two hundred initial customers. Bell also served as manager of the exchange. In addition to the officers, other early board directors included Ernest Fishburne, C.J. Smallwood and Thomas M. Bell. The total cost for the construction of lines, poles, switchboard and telephones was $2,000. In its first year of operation, the corporation had twenty-five subscribers, almost all orchardists within a two-mile radius of Bell's store.

The Bent Mountain Telephone Company was granted a state charter on September 14, 1911. Officers were J.F. Reed (president), Wilson Baldwin (vice-president) and Dr. E.O. Tinsley. The purpose of the company was to raise $5,000 in capital through the sale of stock to erect 2,500 miles of telephone wire. The headquarters for the telephone company was in a two-

story house on the David Woods property along the current Route 221. Willard Woods, David's grandson, was one of the first linemen, and the central switchboard was located on the second floor of the home. The lines, attached to green glass insulators atop chestnut poles, ran alongside roads and fences.

In October 1911, the directors of the Bent Mountain and Fruit Growers' Telephone Companies met at Poages Mill and agreed to share costs to link with the Virginia-Tennessee Telephone lines that were in Roanoke City. The two miles of line required to reach Roanoke were completed a few weeks later, thereby connecting the entirety of the Back Creek section with Roanoke's telephone service at no charge. Subscribers could also access long-distance service through the Roanoke switchboard. The lines of the Fruit Growers connected with the lines of the Virginia-Tennessee near the Roanoke City Almshouse (close to where Virginia Western Community College is located today).

On July 2, 1919, the Bent Mountain Telephone Company became the Bent Mountain Mutual Telephone Company as chartered on that date by the State Corporation Commission. At the annual meeting of the stockholders of the company held at Riley Poff's store on May 28, 1936, new bylaws and regulations were adopted. In addition to outlining

Erecting telephone poles, circa 1911. Poles are being erected for the Fruit Growers' Telephone Company in the Back Creek section. *Author's collection.*

Fruit Growers' Telephone Exchange, 1910. The switchboard was initially located in Bell's store, now a residence on Landmark Circle. *Author's collection.*

officers' duties and meeting schedules, the document also contained some interesting elements that illuminate how early phone companies functioned. As examples, only stockholders could receive telephone service; each stockholder paid five dollars per year for each "telephone instrument connected" with the company's lines; no extra phone could be added to any line without approval of three-fourths of the stockholders; delinquent dues past thirty days resulted in phone service being discontinued; music was forbidden; no person could use a telephone for more than five minutes per call; and business messages took precedence over social conversations. Given that switchboard operators could listen in on calls, the regulations actually encouraged such eavesdropping. "The switchboard operators, upon pain of dismissal, shall promptly report...any abusive, profane, obscene or indecent language." The switchboard operator also had the authority to "promptly break the connection of any user of the phone when it is apparent that such user is under the influence of intoxicating liquors." At this time, the switchboard operation was at Poff's store.

During the late 1930s and early '40s, Uwalker "Babe" Wimmer Williams, her daughters Echo Shamlin Wimmer Martin and Lucy Williams Vest and her great-granddaughters Anne Marie Vest and Edith Vest were the

switchboard operators. Later, a daughter-in-law, Effie Vest Williams, worked the switchboard. It was truly a Williams family operation, as the switchboard operations had been moved to the Boyd "Boy" Williams' home (presently 9104 Floyd Highway North).

In 1944, the Bent Mountain Mutual Telephone Company erected a new building to house its switchboard operation at what is today 9642 Floyd Highway, Copper Hill. Each stockholder ("phone-holder") was assessed ten dollars to cover the cost for the new building. The improved switchboard operation was overseen by the Chesapeake and Potomac Telephone Company. During this time, C.F. Holt was company treasurer, and J.E. Wimmer was president. By early June, twenty-three "phone holders" had not paid their assessment, and letters were sent notifying them their phone service would be disconnected if payment was not received by July 1. Some wrote back to the treasurer apologizing for the oversight, while others asked for a payment plan due to financial hardship.

In 1944, Wilbert King became the switchboard operator, and he and his wife, Nannie DeWeese King, lived in the home built by the phone company. King had been paralyzed in a logging accident in Maryland, so the switchboard operation was suitable to his physical limitations. King's hours were 5:00 a.m. to 9:00 p.m. daily, with an alarm during the night for emergency calls. He occasionally had help from his wife, five sons and one daughter. The switchboard had a hand crank to supply power in the event of an electrical outage. The Bent Mountain exchange included Bent Mountain, Air Point and Copper Hill; all other calls were long distance.

The Bent Mountain Mutual Telephone Company was purchased by the Chesapeake and Potomac Telephone Company on February 4, 1958. C&P provided upgrades for the telephone exchange, including twenty-four-hour service, assigning telephone numbers (eliminating the long and short ring system) and a new directory. C&P continued to employ King as a switchboard operator until 1962, when the direct dial system was implemented, thereby eliminating the need for a local switchboard. In the 1960s, C&P had a relay station (small brick building) near the Pantry Restaurant.

A CHANGING LANDSCAPE, 1960–PRESENT

Beginning in the mid-1960s and continuing through present times, southwest Roanoke County experienced tremendous residential and commercial development. With the exception of the Bent Mountain area, suburbs replaced the large orchard tracts and family farms of previous generations.

In 1970, Route 419 opened to traffic and with it the county's most significant commercial and retail corridor. Notably in the Cave Spring area was today's Cave Spring Corners strip mall, one of the first multi-retail developments in the area. When initially built in 1969, it was Grant Plaza, anchored by a W.T. Grant store. Other early businesses at Grant Plaza were Chef's International Gourmet, Ernie's, Grants Beauty Salon, Grants Restaurant, Kroger, Security National Bank, SuperX Drugs, Virginia ABC Store and Village Square Dress Shop. Grants closed when the national chain went bankrupt, and the space was occupied by Hills from the late 1970s through the early 1990s, and then by Ames. Eventually, the portion occupied by Ames at the south end of the strip mall was purchased and razed by Kroger, which built a new grocery at that end in 2005, having moved from the north end of Cave Spring Corners.

Tanglewood Mall opened in 1973 with approximately one hundred national and regional retailers.

Brambleton Avenue between Route 419 and Roselawn Road experienced significant change, from becoming four lanes to having mini–strip malls and small office buildings. Brambleton Avenue coupled

with businesses along Old Cave Spring Road transformed Cave Spring into a thriving commercial center. From 1960 to the mid-1980s, many businesses operated in this section, among them the following: Ike Sutphin's Cave Spring Antique Repair Shop, Cave Spring Auto Parts, Stover Dry Cleaners, Final Touch Beauty Salon, Light's Custom Gun Works, Carter Carpet and Tile, Mount Vernon Meats, Cave Spring Hardware, Kesler Drilling Company, Cave Spring Radio and TV Repair, Excelsweld Company, R.A. Lester & Son Garage, Steer House restaurant, Spencer's Cave Spring Esso, Gideon Restaurant, Skyline Cleaners, E.B.M.'s Western World, Brown's Hall of Cards, Feather Tile Company, Cave Spring Medical Clinic, Patricia's Pet Shop, Rogue's Furniture Gallery, Wind Chimes Book and Gift Shop, Martha White Foods, Fishers of Men Bookstore and Dick's Auto Body Repair. Oakey's Funeral Service South Chapel opened in 1983, and Harris Teeter opened at Colonial and Brambleton Avenues in 1997 before being bought by and converted to a Kroger in 1999.

The Blue Ridge Parkway was a source of employment for many men in Bent Mountain and Floyd County during its construction north through Floyd County. The parkway's fifteen-mile section between Route 220 and Adney's Gap near Bent Mountain was completed and opened to traffic on

Grant Plaza, 1970. Grant Plaza opened in 1969 and is now Cave Spring Corners. It was the first large commercial development in Cave Spring. *Annual Report of Roanoke County, 1970.*

Aerial view of Route 419, 1970. This image shows Route 419 under construction (*top*) at Chaparral Drive. The Penn Forest Boulevard/Chaparral intersection is at bottom. *Courtesy of Carole Hawkins*.

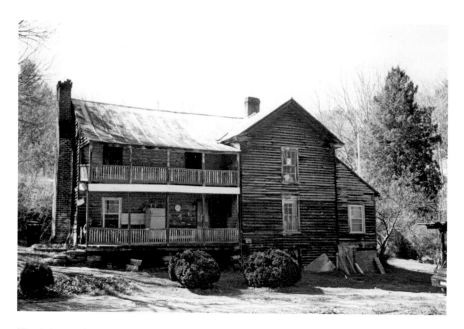

Harris homeplace, 2002. The nineteenth-century Harris homeplace was razed in 2012 for the widening of Route 221. The Harris Family Bridge commemorates its existence. *Courtesy of David Harris.*

October 1, 1960. The contractors were Albert Brothers of Salem and R.M. Cantrell & Son of Annandale, Virginia. The section's bridges, mountain cuts and nine overlooks cost $3 million and took two years to complete.

The most recent widening of Route 221 to four lanes between Route 897 (Crystal Creek Drive) and Route 688 (Cotton Hill Road) was completed in late 2013. The $20 million Virginia Department of Transportation project eliminated curves and included two bridges (one being the Harris Family Bridge). The contractor was W.C. English of Lynchburg. The state highway department acquired twenty-seven acres of property for needed right-of-way for the project, including a tract that contained the Harris homeplace, which was razed.

Roanoke County opened parks during this period, including Penn Forest Park, Starkey Park, Happy Hollow Gardens and the Bent Mountain Community Center Park. Penn Forest Park, adjacent to Penn Forest Elementary School, became the Darrell Shell Memorial Park in July 1990 in honor of the county's former director of parks and recreation. Starkey Park opened in the fall of 1989. The Taylor Tract Park and Trail System opened in 2008 in coordination with the South County Library project to which it is

adjacent. The thirty-four-acre Happy Hollow Gardens off Mount Chestnut Road is on land that was donated to the county by sisters Mary Jane Burgess and Cherie Burgess Shindell for "the enjoyment of its citizens as a place of peace and beauty" according to county records. It had been the home of their uncle and aunt H.B. and Ellen Wharton. Happy Hollow was formally dedicated and opened to the public on May 11, 1989.

RELIGIOUS LIFE

Early settlers in southwest Roanoke County were predominantly Scots-Irish, English and German, and they brought with them their Presbyterian, Baptist, Brethren (Dunkard) and Lutheran traditions.

The earliest churches were union churches being used by a variety of Christian denominations, usually on different Sundays. There was the Laurel Ridge Church dating to the early 1820s, Kittinger Chapel in the 1860s and a union church at Cave Spring. The histories of these church buildings are woven into some of the congregational histories that follow. The earliest religious meetings happened in homes and at the shop of Elijah Poage. There were outdoor revivals, and clergy often traveled from Salem or Big Lick to perform weddings, baptisms and preaching services. Denominational lines were often blurred, as families attended whatever services might be occurring regardless of the preacher's denominational affiliation. There were shared Sunday schools, and church gatherings became significant social occasions. Some church events were attended by literally hundreds, at times more than one thousand, from the Back Creek section, and a few of those gatherings are noted in what follows. Only as the population grew and economic prosperity came to the area after the Civil War did denominational bodies begin to separate and erect their individual churches.

One large revival occurred in 1920 near the Roanoke and Floyd County line at the Copper Hill Church of the Brethren involving several denominations. The revival preacher was Walter "Dad" Kahle, whose

sermons were so popular the revival lasted three full weeks! Reportedly, some seventy-five persons were baptized as a result.

To better appreciate the rich religious heritage of the early days of Back Creek, biographies of some of the early preachers who served the section are necessary. Their names are often found in the marriage certificates of Back Creek families, and they conducted the funerals of many, even if not members of their particular church.

The Reverend Urias Powers came to the Roanoke Valley to serve the Salem Presbyterian Church. Graduating from Dartmouth College in 1818, Powers was licensed to preach by the Union Association of Vermont and New Hampshire in October 1822. His first assignment was as a missionary in South Carolina. Plagued by ill health, Powers returned to New Hampshire for two years but then resumed his missionary activities, forming a Presbyterian congregation at Cheraw, South Carolina. After serving other Presbyterian missions in South Carolina, Powers came to Salem, Virginia, in May 1837. After preaching in Salem, he was formally installed as the church's minister in 1839. He remained as pastor of the Salem Presbyterian Church for thirteen years.

Following his Salem pastorate, Powers began to preach at Big Lick (Roanoke) Presbyterian Church, where he remained until ill health forced his retirement. During the Civil War, Powers filled in for Big Lick's pastor, who was serving as a chaplain in the army. During Powers' years at both Salem and Big Lick, he established a preaching point in Cave Spring. This was likely the same congregation that built the small brick church referenced in the histories of Cave Spring Presbyterian Church and Cave Spring Baptist Church that follow. Given the large number of Scots-Irish settlers and descendants in the Back Creek region, Powers performed numerous marriages, baptisms and funerals. Powers died in Big Lick on February 12, 1870, at the age of seventy-eight.

The Reverend William Longwood Hatcher was an early Baptist minister in the Back Creek section. He was born in Bedford County at his parents' home on the North Fork of Otter River on January 31, 1806. In July 1831, Hatcher attended revival services at the Quakers' Meeting House, was converted and baptized. On November 6, 1832, Hatcher married Nancy Hurt of Bedford County, and the couple settled in the Fort Lewis section of what was then Botetourt County. Seven years later, Hatcher entered the ministry and served a congregation in Montgomery County, being formally ordained in 1843. Having little formal education, Hatcher pursued his church work while also farming. When the pastor of Salem Church (now

Fort Lewis Baptist) became too ill to serve, Hatcher stepped in and led the congregation for twenty-nine years. During his work at Fort Lewis, Hatcher came to the Back Creek section to help nurture Baptist work. Being a "missionary" Baptist, he served the Laurel Ridge Church for thirty years from 1843 to 1873 (see Haran Church's history). Hatcher took no remuneration for his work, though he did receive a saddle and an overcoat from the Baptists in Back Creek. Hatcher rode horseback regularly from his farm in Fort Lewis to Back Creek, conducting services at Laurel Ridge and Kittinger's Chapel. After a long illness, Hatcher died at age seventy-seven on November 18, 1882.

Friction would occasionally develop among religious groups, usually around mutual use of union chapels and sometimes over doctrinal matters. Nothing stirred the religious passions of Back Creek more, however, than the presence of Mormon missionaries in 1888. The anti-Mormon *Salem Times-Register* spilled much ink in covering, if not heightening, the controversy. In its November 25, 1887 edition, the editors suggested that Back Creek residents give the missionaries "a coat of tar and feathers and start them journeying elsewhere."

On June 17, 1888, a large audience estimated between 1,000 and 1,200 persons turned out to hear Reverend D.C. Moomaw preach a sermon, "Mormonism: Past, Present and Future," at Kittinger Chapel in an effort to dissuade Mormon conversions. Other speakers included A.S. Beckner and a Dr. Fox, all from Roanoke College in Salem. The entire front page of the *Salem Times-Register* for July 13, 1888, was dedicated to printing in full the speech Moomaw delivered.

Sadly, the passions turned violent. The Salem newspaper reported in August 1889, "We learn that a couple of Mormon elders were stopping at the house of a Mr. Burnett, near Cave Spring, several nights ago, and that some of the citizens of that section called on them with the intention of treating them to a coating of tar and feathers, but the elders begged so mercifully that the infuriated crowd desisted from their purpose and the Mormons left early the next morning."

The next month, the "White Caps" became involved. An organization akin to the Ku Klux Klan, White Caps were organizations of white farmers who, mostly in the South, targeted immigrants, blacks, unwed mothers and others who they felt undermined the community's values. They used threats, arson, whipping and other brutalities to elicit conformity. The Roanoke chapter, claiming three hundred members, published a notice in the September 20, 1889 edition of the *Salem Times-*

Register threatening harm to the missionaries if they did not leave the county. The late Roy W. Ferguson, a member of the Mormon Church, wrote, "Mobs with stockings over their faces searched homes looking for missionaries. They threatened to burn homes and businesses of those interested in the church. One member stuffed two missionaries into a large barrel, placed the barrel on his wagon, and drove his horses and wagon out of the area in order to save the missionaries." These and other threats led to Mormon missionaries leaving the Back Creek area for a few years.

By 1895, Mormon missionaries had returned to Back Creek. While there continued to be some persecution, the Church of Jesus Christ of Latter-day Saints became an established and integral part of the community. In mid-July 1896, for example, the Mormons held a weekend conference at Mount View Church, and the Salem newspaper reported some 200 in attendance. At that meeting, Thomas Maury of Salem went and took a photograph of some thirty-five Mormon elders who had come from around the state. The *Salem Times-Register* stated, "Everything passed off in a very orderly manner."

Eventually, news of Mormon activity in Back Creek subsided. The congregation grew, with a few from Back Creek going to Utah, and a permanent church was established (see the church's history in this chapter). While the persecution that occurred in Back Creek of the early Mormons is not pleasant, it must be remembered that what happened in Back Creek was reflective of what many Mormon missionaries had to endure across the nation for the cause of their faith.

The Back Creek section has a diverse religious heritage. What follows are histories of some of the congregations. While there are many newer churches in southwest Roanoke County, this work focuses only on those whose histories date back fifty years or more.

Bent Mountain Baptist Church

Bent Mountain Baptist Church was known as the Mount Hope Church when it was organized in 1875. By 1878, it was being called the Bent Mountain Hope African Church. Among those who organized the church were Joseph Gregory Sr., Gabriel Martin, Abraham Pryor and Lee Page. Other early members included Benjamin Terry, Mahalia Muse, Flynn Tinsley, Lucinda Martin, Fannie Tinsley, Susan Gregory, Sophia Page, Julia Terry and Louisa Thompson.

On April 28, 1878, land on which the church stood was surveyed by James Day; on November 11, 1879, the land was sold and deeded by Peyton and Sarah Randolph to Harvey Coles, James Brown and Anderson Harvey, the church's trustees. The acre of land was purchased for five dollars and was part of an eighteen-acre tract that had been conveyed to Randolph by the governor of Virginia on July 20, 1874. Randolph was a former slave who lived on Bent Mountain. The survey registered by Day referred to the church as the "Old Mount Hope African Church" and as the "Old Mount Hope Colored Church." The land was situated on the headwaters of Bottom Creek.

The first building of the Mount Hope Church was a log cabin located on a ridge above Grace Briggs' home (1115 Leaning Oak Road) on Virginia Route 690. It burned, and a second building, the Bent Mountain Hope African Church, was erected. This building was eventually razed, or it may have burned, with the date being uncertain. By 1894, the church was being referred to as the Colored Baptist Church, located near Puncheon Camp, near the church's original tract. The new location had been purchased for ten dollars by B.S. and Lucy Price, with Byrd Webb as church trustee.

On April 4, 1911, a quarter of an acre was deeded to the trustees of Bent Mountain Baptist Church by Tazewell Finley for eight dollars. Church trustees were Coles Terry, Joseph Terry and Joseph Gregory. A new structure was built. At present, all that remains is the cement and rock foundation. It was torn down when the present church was built, parts of the old church being used in the new structure, which was completed in 1940 and is in use today. In the 2000s, an addition expanded the church.

BETHEL AFRICAN METHODIST EPISCOPAL CHURCH

Bethel African Methodist Episcopal Church had its inception in 1867, when Benjamin Deyerle and his wife, Jilianne, deeded two acres of land to trustees Henry Clark, Bowyer Beane, Philip Watkins and Edmond Beale for the purpose of erecting a place of worship for the African Methodist Episcopal Church. The deed was recorded in Roanoke County on December 28, 1867. The trustees supervised the construction of a log structure for worship and educational training. Reverend I.K. Plato and Mr. Bowyer Beane, a Cherokee Indian, served as leaders of worship services and teaching.

The first black church in Roanoke County after the Civil War, Bethel was known as the Cave Spring AME Church. The first minister assigned by the Virginia Conference was Reverend John W. Diggs, a native of Frederick County, Maryland. Cave Spring was a member of the Danville District. The Roanoke District was organized in April 1897. Cave Spring, Ballyhack and Piedmont (Mount Lebanon) made up the Cave Spring Circuit. At the November 3, 1885 Quarterly Conference, Elder Robert Davis presided and Brother John Bailey served as secretary. The following officers attended: G. Jimmerson, George Wade, Moses St. Clair, William Barnett, Andrew Washington, Edward Clarkson, Walker Divers, James Wright, D.L. Ferguson, Otis Raymond, Frank Mac George, Ben Casey and Bob Wright.

In 1886, funds were collected for church repair. The present structure was built in 1907 and the cornerstone laid. In 1909, there were thirty-three members on record. The church was rebuilt in 1912. A choir was organized in 1935 that sang music by reading shaped notes. A renovation of the church was completed on November 21, 1955. In 1961, the present choir stand, pulpit area, kitchen and dining area were built, and stained-glass windows were installed by William M. Beane. In April 1977, several families united with the church after the closing of Bethel AME Church, Salem.

In 1978, plans were formulated for the educational annex, which was dedicated on December 2, 1980. A highway project, from which the church was spared, had resulted in structural damage, creating again a need for renovations.

Cave Spring Baptist Church

Cave Spring Baptist Church was organized in 1875 through the efforts of the Virginia Baptist Mission Board and its appointee, Reverend Matthew Wilson. Wilson was a pioneer preacher and church planter. The congregation's first meeting was at a brick Presbyterian church in the Cave Spring section (see Cave Spring Presbyterian Church).

In 1888, a little more than an acre of land was purchased on the west side of what was then the Salem Franklin Turnpike for $75 that is now the present-day site of the Cave Spring Lions Club. That same year, a small church was erected on the site—a single-room, white-painted, poplar weatherboard structure measuring thirty by forty feet—for a cost of $387. It had double doors on the front and two Gothic windows on each side. The

church was dedicated on the third Sunday of October in 1888. In 1931, five rooms were added; a basement was later dug.

In 1948, the congregation purchased land on the west side of Route 221 (present-day location). When the new church was built, the congregation moved to that location. A parsonage was constructed in 1954; it was relocated in 1963. An educational building was completed in 1967. A new sanctuary was built and dedicated in 1988.

The late Bill Bowman, a lifelong member of the church, provided me some interesting information about the congregation. According to Bowman's research, the church membership was predominantly women, but it was 1918 before women could vote in church business meetings and their presence be counted toward a quorum. The congregation was also strict in regulating the behavior of members. Bowman wrote, "In the first fifty years it is recorded that 100 members were excluded for not living up to the standards set by the church. Some of the reasons were being intoxicated, not living good lives, not being fit subjects for members of a church, disorderly conduct, wicked living, and for not getting along with their fellow man."

In 1903, when a distillery was being erected near the church on a branch of Back Creek, the church adopted a resolution condemning "strong drink" and threatened to expel any member who furnished water, wood, grain or fruit to support a distillery. So strict was the church that when one brother

Cave Spring Baptist Church, circa 1950s. This postcard shows the church's parsonage and sanctuary. The parsonage was erected in 1954 and relocated in 1963. *Author's collection.*

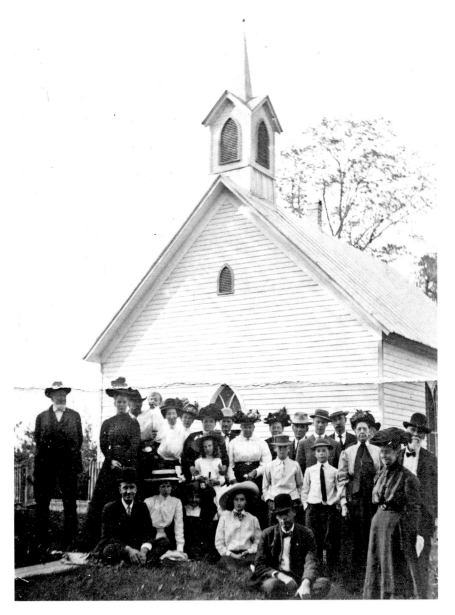

Cave Spring Baptist Church, 1903. The original church was located where the present-day Cave Spring Lions Club building exists. The church was razed in 1962. *Courtesy of Cave Spring Baptist Church.*

was seen taking a drink, but not drunk, he was asked to abstain from any further drink and receive the church's pardon. He refused to ever be drunk but not to always abstain from taking a drink. He was expelled.

Dancing was also condemned by the church in its early days. Bowman's research of church records found that in 1900, "Sister Berry" was appointed to visit some members who had been accused of "walking disorderly." The members denied they had been dancing but were playing a game called "Stealing Partners." The church then decided that any "game" played with music would be considered dancing and against church rules.

For all of its early strictness, Bowman wrote, "As we can see [the] church three-quarters of a century ago was quick to condemn the acts of its members and discipline them accordingly, but it was also equally as quick to forgive and restore fellowship to a repentant person."

CAVE SPRING BRETHREN CHURCH

In 1863, a preaching point of the Peters Creek Brethren Church was established in the Cave Spring community. According to Oak Grove Church records, "The Cave Spring point was located on the Roanoke-Floyd Pike near cave spring, in the area where the [former] Cave Spring United Methodist Church is now established." The church served the Cave Spring, Poages Mill and Oak Grove communities. Services were not held weekly at the church, with some occurring at the shop of Elijah Poage. Early ministers at the church included Christley Wertz, Johnny Eller, John Brubaker and Elias Brubaker. In the Civil War period and for some years thereafter, more regular worship occurred at Kittinger Chapel. In the early 1900s, the Cave Spring Church had dissolved, as there were established congregations at Poages Mill and Oak Grove. The Cave Spring church building and lot were sold in 1908 for $610, and the proceeds were used to help erect a building for the Oak Grove congregation.

CAVE SPRING LUTHERAN CHURCH

According to early records of the Virginia Synod, Cave Spring Lutheran Church opened in 1871 and remained in existence until 1881, after which it became a preaching point until 1891 and then was closed. The precise

location of this church is unknown, though the members may have met in the brick church built and used by the Presbyterians, as it was noted that Lutherans met there (see history of Cave Spring Presbyterian Church).

CAVE SPRING PRESBYTERIAN CHURCH

Little is known of the Cave Spring Presbyterian Church other than it being referenced occasionally in newspaper articles in the 1800s. One such reference appeared in the October 16, 1855 edition of the *Richmond Daily Dispatch* when the church, noted as "Cave Spring Presbyterian, Roanoke County," was listed among contributors to the Richmond Relief Fund. Frederick Johnson had sent thirty dollars from the church for that cause. Johnson was associated with the Salem Presbyterian Church. The church was located on the knoll above the actual Cave Spring, probably in the vicinity of what is today the Country Cookin' restaurant or the back parking lot of Oakey's South Chapel. Records from the Presbytery of the Peaks yielded no additional information, though Presbyterian churches could only exist if a seminary-trained minister was available to serve the congregation. Perhaps a lack of available clergy precipitated its eventual closure. When the congregation formally dissolved is unknown, but the brick church was razed in 1922 or 1923 (another source says 1936), and some of the bricks were used for the manse of Salem Presbyterian Church.

A 1938 article in the *Salem Times-Register* described the church as "a substantive brick church built in the old way with a gallery around three sides of the auditorium."

The brick church was also used by the Baptists of Cave Spring (see Cave Spring Baptist Church history) from 1875 to 1888. By 1888, however, friction developed between the Baptists and Presbyterians over use of the church. An article about the matter appeared in the April 20, 1888 edition of the *Salem Times-Register* that provided a useful history and description of the brick church. The article was written by the trustees of the church as they explained the context for the Baptist-Presbyterian conflict.

> *In order to do so, it will be necessary to go back about thirty-four years to the time and circumstances under which this Presbyterian church was built, at a cost of $1,100. A very large part of this (perhaps as much as eight or nine hundred dollars) was contributed by members of the Salem Presbyterian Church, a few of whom lived at and near Cave Spring. A small part was*

contributed by Methodists, Lutherans and Dunkards in the neighborhood, and about fifteen dollars by members of the Baptist church, they having a church not more than a mile from Cave Spring. The deed for the lot was made to the following trustees, viz.: John B. Harding, Sparrel F. Simmons, Samuel H.C. Greenwood, Joseph Pritchard, Madison Pitzer, John B. Logan and Frederick Johnston "upon trust (as expressed in the deed) that the said parties of the second part shall hold the property hereby conveyed, and the church built there on for the use and benefit of the Presbyterian church (old school), but so that the same when not occupied by the Presbyterians shall be free for the use of any other orthodox denomination of Christians." All of these trustees have since died or removed, except three—S.F. Simmons, S.H.C. Greenwood and F. Johnston, the second of whom (S.H.C. Greenwood) has always kept the key of the church, which has been under his oversight and care. For some years after the church was built the ministers of the Salem Presbyterian Church (especially Rev. B.F. Lacy) preached in it regularly, but there was no separate organization, and those who were brought into the church under their ministry, connected themselves either with the Salem or Big Lick Church. Since the war the church has not been used as much as formerly by the Presbyterians; nor has it been occupied, except at rare intervals by other denominations until about six years ago, when the Missionary Baptists applied for leave to make occasional appointments, which was freely granted to them; but it appears to have ended in the old story of "giving an inch and taking an ell," for they soon began to make regular appointments for the first Sabbath of every month, and have kept those appointments ever since. Not satisfied with this, they chose to consider the side galleries in the church, inconvenient and useless, and the pulpit too high, and so without consulting the trustees or anyone else they made arrangements to have these changes made, and even went so far as to employ a workman to remove the galleries and lower the pulpit. They also proposed to open a Baptist Sabbath school on the first Sabbath in April. At this point, Mr. Greenwood, thinking that this was presuming on the privileges granted them, and that it meant not merely a temporary use, but permanent occupation of the church, judged it best to call a halt, not knowing but that the next step would be to insist on making some other changes perhaps putting in a baptistry, and thus fully equipping it as a Baptist church, which it was never intended to be as it had been built by Presbyterians, for Presbyterians, and not for Baptists.

Assuming the historical information contained in this article is correct, the Presbyterians built their brick church in 1854.

Cave Spring United Methodist Church

In 1845, court records indicate that property was deeded to Andrew Greenwood and Jacob Persinger by the Wertz family for the purpose of erecting a union church to be used by the Methodists, Lutherans and Presbyterians (probably the same property on which the Cave Spring Presbyterian Church was located).

By 1853, the Methodists had been deeded property on McVitty Road to construct their own church. Trustees for the church were John Chapman, Dr. George F. White, George E. Camper, Robert Thaxton, Andrew L. Pitzer, William Harris, James Poage, William Shartzer and James Crawford. These trustees consulted Benjamin Deyerle, a wealthy builder in Roanoke County, for construction of the brick church. Deyerle molded and burned the brick for his building on his nearby farm, probably overseeing the process that was done by his slaves. George Hartman, a cabinetmaker and founder of the church, also contributed to its construction.

The original building had a front porch and steps, as a different entry was built later. At the rear of the church was a slave gallery. Early membership rolls divided the congregation into two sections—black and white. By 1900, the church was heated by two wood stoves, one on each side of the sanctuary between the windows. An African American woman, Bettie Jenkins, lived nearby and built the fire for Sundays. She also rang the church bell. According to the church history, "Bettie performed her duties faithfully. She always sat on the last bench and would take communion after everyone else was served." At one time, the church also had a pump organ.

Methodist records indicate that the Cave Spring Church was in the "Roanoke District, Baltimore Conference" in its early years. The church was also on the "Salem circuit." That circuit in 1871 included Cave Spring, Botetourt Spring, Vinton, Big Lick and Mount Pleasant. From 1943 to 1951, Cave Spring was coupled with Lawrence Memorial Church on Bent Mountain.

In 1946, the congregation built an education wing with six classrooms and a basement for a cost of $2,500. During construction, a huge fireplace was discovered behind the pulpit!

The Women's Missionary Society at the church held its first meeting on May 14, 1882, and was only the second such society in the valley. The society changed names through the years, including Parsonage Society, Foreign Missionary Society, Women's Auxiliary, Society of Christian Service and United Methodist Women.

In 1951, Cave Spring United Methodist Church became a "station," meaning it was no longer on a circuit or paired with another congregation. In the 1950s, the church experienced tremendous growth and began holding some Sunday school classes at Cave Spring High School (later the middle school). At a meeting on March 4, 1956, the congregation voted to relocate the church and subsequently purchased a five-acre tract off Colonial Avenue for $6,375 from Jessee Grubb (present-day location). Ground was broken for the new church on May 16, 1959, and in November of that year, the congregation held its final worship service in the building at 3320 Old McVitty Road. Today, that building is one of the oldest in the Cave Spring area. The church was leased and later sold to the Unitarians and is today a Honey Tree Early Learning Center.

On November 29, 1959, the date stone was placed at the new church at 4505 Hazel Drive, with the first service being on December 6, 1959. The church building was expanded in 1961. In 1968, three denominations—the Methodist Church, the Church of United Brethren in Christ and the Evangelical Church—merged to become what is today the United Methodist Church. The church was expanded again in 1977. A new sanctuary was completed in 1998.

CENTRAL (STARKEY) BAPTIST CHURCH

Central Baptist Church, located on Starkey Road, began on May 5, 1905, and was originally across from the old Starkey School in a wood A-frame chapel with Reverend M.W. Royal as the pastor. The congregation moved to their current location when they erected the present-day brick structure (now education wing) in 1942. The church was originally known as Starkey Baptist Church and was on a four-church circuit with Mount Pleasant, Laurel Ridge (Haran) and Cave Spring Baptist Churches. By 1917, the church had changed its name to Central. The name change was prompted by a very practical reason. Calvary Baptist Church in downtown Roanoke donated to the church its silver Communion set that was engraved with the initials "CBC." Wanting to use the Communion trays, the church simply changed its name to match the initials! The original frame chapel was purchased by Joe and Mabel Doran and converted into a store.

Dr. David Henderson, a former pastor, wrote that the church had a very colorful past, as was shared with him by a charter member, a Miss Kidd, who was still living in 1984 at the time Henderson recorded her memory. "Back

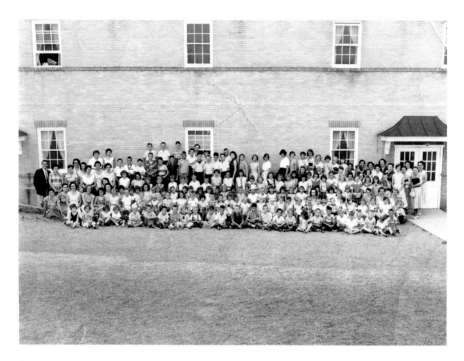

Central Baptist Church, 1956. Posing in front of the auditorium and education wing for Vacation Bible School is Reverend Arnold Williams *(far left in suit)* with pupils and faculty. *Courtesy of David Harris.*

when the church was formed and up through the middle of the 20th Century, Starkey was a rough and tumble place. Other than the train about all there was to do was drink and go to church. There were three churches in this tiny community, but the Baptist seemed to have the biggest attendance and the most action. Sunday morning services were calm, but by Sunday evening several of the young men of the church and community had paid a visit to 'the hills' which hid the local stills."

In 1957, the present-day sanctuary was built for $60,000, being constructed by the church members. They literally went into nearby woods and cut the timber needed for the interior. At the groundbreaking ceremony that year, Dr. Harry Gamble of Calvary Baptist Church spoke, and the oldest active member of the church, Stokley Terry, turned dirt with the ceremonial shovel.

The Church of Jesus Christ of Latter-day Saints

In the fall of 1887, Joe Lavinder, a resident of the Haran section, returned from a Franklin County trip and reported that he had heard the preaching of Mormon missionaries. William Griffin Ferguson wanted to hear these missionaries, so he gave Lavinder one of his best roan mares to bring the missionaries to Back Creek. The first meeting was held at the William Griffin Ferguson farm, located at the current intersection of Martins Creek Road and Route 221. That first meeting was attended by a crowd of curious men who wanted to check out the Mormons. Many returned the following night, along with their wives.

The first convert in the Back Creek community was Zulah Ann Gladden, who was baptized on January 23, 1888. William Griffin Ferguson was baptized on May 1, 1888, and Margaret Rachel Owens Ferguson on August 26, 1888. The names Bohon, Grice, Owens, Harris, Ferguson, Gladden, Neighbors, Willett and Cleaver would follow. By 1900, the surnames of Hale, Goodwin, Henderson, Wade, Poage and Unrue were in church records. Church meetings in the area were first held in members' homes or in the schoolhouse on Twelve O'Clock Knob Road. An 1888 notice in the *Salem Times-Register* indicated that a Mormon Sunday School was started at the Mountain View School house in the spring of that year. As membership increased, William Harrison Ferguson cleared a section of land near his home so outdoor meetings could be held in the summer.

An early description of a Mormon baptism was published in the August 31, 1888 edition of the *Salem Times-Register*.

> *Before going further we must tell you all about a Mormon baptizing which occurred in this section* [Back Creek] *last Sunday evening. About half-past three o'clock in the evening several men met on the branch near the John Ferguson school-house, and began the building of a dam by cutting and carrying logs, brush, leaves, and trees. The proceedings reminded one very much of a log-rolling, with much activity on the roller. About 4 PM, the candidates, Mrs. M.H. Ferguson and her sister, Miss Owen, were baptized by the Elders, who proceeded very much after the fashion of the Baptists. After this ceremony the crowd repaired to Mr. John Ferguson's, where the blessings of the Holy Ghost were invoked upon the converts by the leader laying both his hands on the head of Mrs. Ferguson, while the other two laid one hand each on the leading Mormon and the other also on the head of Mrs. Ferguson. Miss Owen was treated in like manner.*

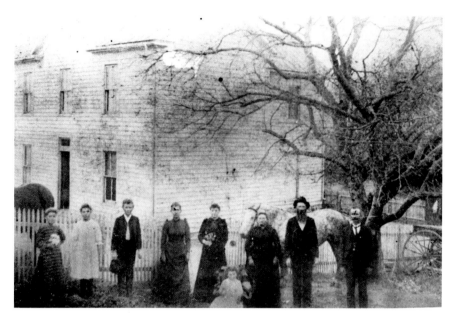

Ferguson family, circa 1895. William H Ferguson (*second from right*) and his wife, Margaret (*third from right*), were early Mormon leaders in Back Creek. *Courtesy of Genevieve Henderson.*

The land for the first chapel in Back Creek was donated by Harrison Ferguson, and trees were cut and sawed on-site. That first chapel was located near the Benjamin Bohon homeplace on what is present-day Levi Road off Canyon Road. The boards for the chapel were planed at the Bohon barn. Fifteen people attended the first meeting in the new white-framed, high-ceilinged chapel in 1897. A month later, attendance had risen to fifty. Fifty-nine people were recorded attending the first formal Sunday school. The chapel was built on large rocks under the center and at each corner of the building, such that the structure swayed and creaked during strong winds. Light was provided by kerosene lamps and heat by a potbellied stove.

Forty-five years later, a more accessible site on Twelve O'Clock Knob Road, a short distance off Route 221, was acquired. On Monday, July 20, 1942, the chapel building was dismantled board by board, and the lumber was used to build a chapel on the new site, which had a basement furnace and was more accessible in wintry weather. The chapel was framed, under roof and ready for service the following Sunday. Baptisms had to be scheduled when missionaries were in the area, so in July 1948, twenty-two persons were baptized into the Back Creek congregation.

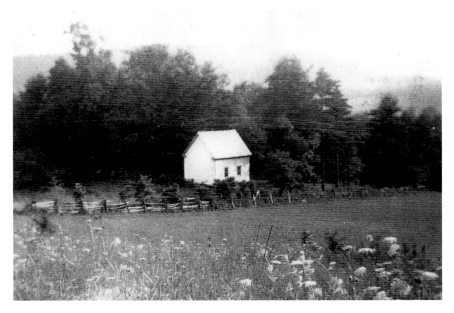

First Mormon chapel, circa 1900. The Church of Jesus Christ of Latter-day Saints erected its first chapel at Back Creek in 1897. *Courtesy of Don Debusk.*

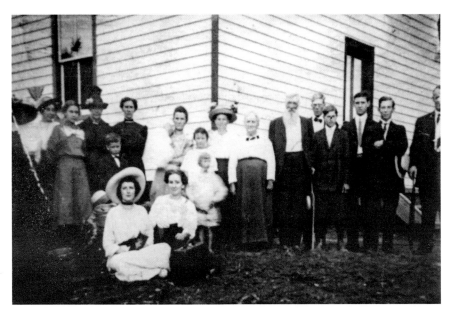

Early Back Creek Mormons, circa 1910. Mormon missionaries baptized their first converts in 1888, following meetings on the farm of William Ferguson. *Courtesy of Genevieve Henderson.*

While the Latter-day Saints congregation was being developed in the Back Creek section, there was also a Mormon chapel in Roanoke. In 1948, it was decided to merge the Back Creek and Roanoke congregations. Memberships were 120 and 115, respectively. In June 1950, the new chapel was erected on Grandin Road (present-day Unitarian Universalist Church building), and this chapel would serve as the meeting place for twenty-five years.

With growth in membership, the congregation was split into two wards, based on the residential location of the members. A new building was dedicated on February 27, 1977, in Salem and the congregation relocated.

In the early 1980s, the decision was made to again locate a chapel in the Back Creek area due to membership growth. A site was found on Cotton Hill Road, and the new chapel was constructed, serving two wards—the Back Creek Ward and the Cave Spring Ward. Almost a century had passed since the first meetings of Mormons had been held on Back Creek. Today, many descendants of those first members have returned to Back Creek to worship in the chapel there.

COPPER HILL CHURCH OF THE BRETHREN

The Copper Hill Church was formed from the Peters Creek Church of the Brethren in the 1860s, becoming an independent congregation in 1874 with twelve charter members. Early meetings were held in homes and an old log building about one and a half miles south of the present-day location on Route 221. The original church was erected at the current site in 1892 and was for a time called "John's Chapel" after John Shaver, an early deacon instrumental in founding the congregation.

The original church was remodeled in 1930 and twice again in the 1940s. The educational wing was added in 1974. The earliest ministers ordained by and for service to the church included Isaac Shaver (1888), Noah Wimmer (1889), Daniel Shaver (1902), John Wimmer (1902), George Stump (1911), Charles Williams (1911), Eugene King (1911), Joseph Wimmer (1919) and Cleophus Stump (1919).

The congregation established four preaching points as early as 1888. These included Adney's Gap, Bottom Creek, Crossroads and Mount Union. Mount Union became an independent church in 1963 at Air Point. The Adney's Gap and Bottom Creek churches had closed by the 1960s, and the Crossroads Church is still being used by various denominations. Copper Hill also established a Ladies Aid Society in 1926.

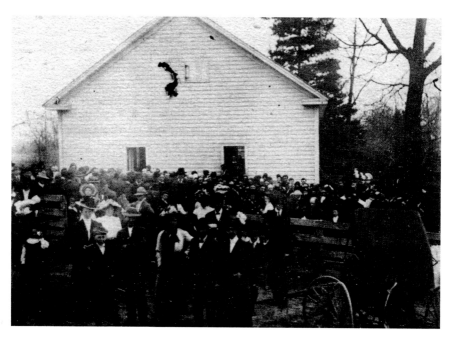

Copper Hill Church of the Brethren, circa 1900. The church shown here was erected in 1892 and was originally called "John's Chapel." *Courtesy of Copper Hill Church of the Brethren.*

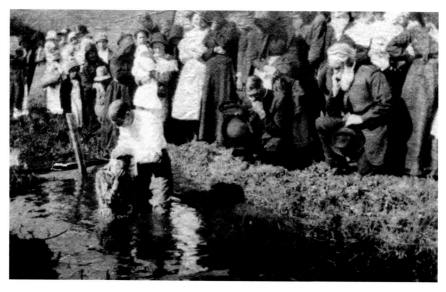

Brethren baptism, 1921. Baptisms often occurred in streams or farm ponds, as shown here of one related to the Copper Hill Brethren Church. *Courtesy of Copper Hill Church of the Brethren.*

It should be noted that there is a white-frame church building directly across the highway from the Copper Hill Church of the Brethren. Some would think this was the original church, but it is not. That building was formerly the home of a Methodist congregation.

Haran (Laurel Ridge) Baptist Church

The presence of Baptists in the Back Creek section dates to the early 1800s, with the earliest known congregation being the Laurel Ridge Baptists, whose minutes date to 1825. For the early history, please see the section about Laurel Ridge Baptist Church. The "missionary" Baptists broke away in the 1830s and formed a separate group, effectively creating two Laurel Ridge Baptist congregations meeting in the area. This history follows the missionary Baptist faction that eventually became known as Haran Baptist Church.

The Laurel Ridge Church (not be confused with the Laurel Ridge Primitive Baptists, who were meeting at this same time) was accepted into the Strawberry Baptist Association at a meeting held at the Timber Ridge Meeting House in Botetourt County on September 7, 1840. At that meeting, a group from the association was appointed to oversee the congregation for purposes of fellowship and full admission. Upon recommendation of the group that was composed of A.C. Dempsey, Lewis Fellers, M. Lunsford, Joshua Burnett, James Leftwich and William Harris, the Laurel Ridge Church was granted admission into the Strawberry Baptist Association at a meeting at Fincastle Baptist Church on May 1, 1841. From 1843 to 1873, Reverend William Logwood Hatcher served the congregation.

During this period, both the Laurel Ridge Primitive Baptists and the "missionary" Baptists continued to use the Laurel Ridge Church, a log structure (see Laurel Ridge Primitive Baptist history for more about this building). While a theological difference had split the Baptists, friendships and Christian courtesy marked the relationship, as the two groups shared the same building, worshipping at different times. Later, the missionary Baptists would meet at Kittinger Chapel.

In 1852, the Laurel Ridge Church joined with the newly formed Valley Baptist Association, consisting of churches in the Roanoke Valley. The association met at Laurel Ridge in 1856 and again in 1866. It is believed that, after the Civil War, the Laurel Ridge Church met at Kittinger Chapel, as records reflect that the church shared a Sunday school with the Lutherans

and Brethren. In the Civil War period, the clerk of the Laurel Ridge Church was A.B. Tinnell of Poages Mill. Prominent lay leaders included David Sloan and A.J. Loving. In the 1890s, Laurel Ridge was part of a charge and shared a pastor with Cave Spring, Fort Lewis and Mount Pleasant Baptist Churches. When the Valley Baptist Association met at Laurel Ridge Church (Kittinger Chapel) in 1914, the Roanoke newspapers reported some 2,500 Baptists in attendance. So great was the crowd that the association's Woman's Missionary Union had to convene in the nearby Back Creek School.

In the latter part of 1920 and 1921, the logs began rolling for the Laurel Ridge congregation to start a building of their own. The logs were sawed, and I.M. Walker, O.F. Hunt, Garland Price, Omer C. Simpson, H.L. Kirkwood and Tilden H. Martin began planning the building, just a chapel, on the property donated by the Tinnell family. The structure, built by "free labor," was dedicated as Haran Baptist Church in the fall of 1924. At that time, the preaching service was held only on the fourth Sunday of each month, although Sunday school was held every week. It should be noted that in the early 1920s, some of the church's functions were held at the Haran School prior to the church being completed. Some years later, a second preaching service was added on the second Sunday of each month.

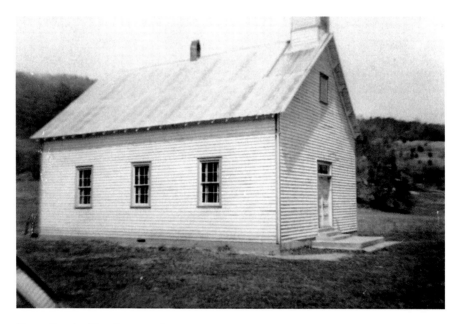

Haran Baptist Church, 1924. The first wood-frame chapel for Haran Church was dedicated in 1924, having been constructed by the members. *Author's collection.*

Lorene Simpson Preas recalls the early days of the church, as her parents, Omer and Mary (Grisso) Simpson, were charter members.

> *The church was a one-room, white clapboard building with huge curtains that were drawn to divide the room for classrooms. There was a stove in the center of the building that provided the heat. Several families of the church (the Willetts, Riersons, Martins, Websters and Kirkwoods) would take turns seeing that the church was warm in time for Sunday School....The men took turns serving as Sunday School leaders. During the summers there was plenty of picnics, ice cream suppers and pie suppers to make money for the church....In the summer, we always had wiener roasts at church for the young adults and children....We had a revival usually once a year and that was when you 'joined' the church.*

Baptisms were conducted in Back Creek, just south of the church.

In the early 1920s, the Haran (Laurel Ridge) Baptist Church was part of the "Starkey Field" and shared a pastor with Cave Spring and Central Baptist Churches.

Around 1950, a new sanctuary was erected; the old one was divided into classrooms. The new sanctuary was dedicated in June 1952. The first full-time pastor, Reverend Donald Knapp, was called in January 1961. A

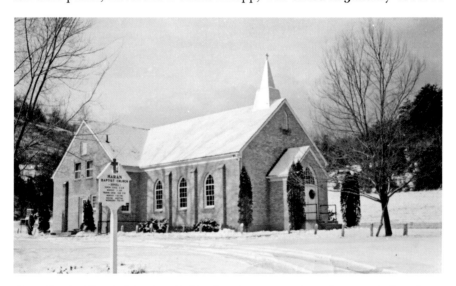

Haran Baptist Church, March 1963. The "new" sanctuary shown here was dedicated in August 1964, following an education addition and remodeling of the 1952 structure. *Author's collection.*

new wing was built for classrooms, the sanctuary was enlarged and the new building was dedicated in August 1964.

In June 1974, the church voted to secure the services of an architect to provide a scheme for remodeling. The first worship service in the remodeled sanctuary was on Youth Sunday, June 1, 1975. An addition that included a fellowship hall, new restrooms and Sunday school classrooms was completed in 1991.

KITTINGER CHAPEL

The earliest mention of Kittinger Chapel dates to 1868, though its existence may have been earlier. Initially a "union church," Kittinger Chapel eventually was used exclusively by Lutherans. The Lutheran congregation was so active that in 1895 the Eastern Conference of the Southwestern Virginia Lutheran Synod held its annual session at the church. The church's name derived from John M. Kittinger, who donated the land for the church. The land had originally belonged to Andrew Shaver, Kittinger's father-in-law.

By the 1920s and '30s, the church was connected with the Virginia Heights Lutheran Church (now Christ Lutheran) in Roanoke as a preaching point.

In the 1940s, students from Roanoke College would often supply preach on Sundays under the supervision of the religion faculty. "Kitt" Kittinger recalls that

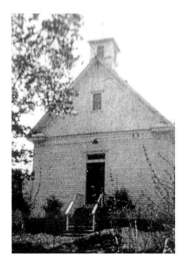

Kittinger Chapel, undated. Kittinger Chapel began as a union church and later was used exclusively by Lutherans until its closing in 1959. The chapel was on Landmark Circle. *Courtesy of the Floyd County Historical Society.*

in those days a Mr. Stover always came early to build a fire in the stove that was located in the center of the church for heat.

The church closed in 1959 and was formally removed from the Virginia Synod's roll. The church fell into disrepair and by the 1980s was being used for storage. It was razed in the late 1990s, the chapel being located on Landmark Circle (Route 707).

Laurel Ridge (Bellview) Primitive Baptist Church

The Laurel Ridge Church is the earliest known congregation in Southwest Roanoke County, as its minutes date to 1825. According to the church records, the Baptists met in the early years in homes, including the home of David Ferguson. Sometimes, a home was selected that had a nearby creek for baptisms.

In 1832, there was a split among Baptists. One faction believed in missionary societies, Sunday school and other programs, while the other faction did not. The latter became known as Primitive Baptists. In the Back Creek section, this rift created two different Baptist congregations; both referred to themselves as Laurel Ridge, creating some confusion for those trying to sort their respective histories. For the missionary Baptists, one should refer to the history of Haran Baptist Church. This narrative will focus on the Primitive Baptists.

By 1835, the congregation was meeting monthly, for preaching and church minutes indicate that in the 1850s and early 1860s, some of those meetings were at the shop of Elijah Poage. By 1866, the church was meeting in the "Laurel Ridge meeting house," also referred to as the "Back Creek meeting house." Current church members believe this was the same place and was probably the original log church that sat in the vicinity of the present-day brick church. In fact, the cornerstones of the log church remain in place today on the church property. The log church was built from trees felled on the property, and the construction was overseen by Wesley Muse and William Wertz. The structure also served as a schoolhouse. The log church was razed in 1936, and the logs were made into boards. The land on which the church sat was considered public in the sense that there was no clear owner. Working with Elijah Poage, justice of the peace, David Sloan acted to formally deed the land in 1875 to George Bell, Madison Hayes (son of Levi Hayes) and Lewis Zirkle "for the benefit of Lawrel Ridge Church," understanding that the church was a union church where several denominations met for worship. Sloan had received the land from Levi Hayes, who understood the land was to be used for church purposes. In 1876, Benjamin Deyerle deeded adjoining property to be a "public burying ground." A cemetery was already at the church site, with some burials being unmarked slave graves.

The log church was described as having an end door entrance, and over the door and around the two sides was a gallery for slaves and free blacks.

(Blacks being a part of the Laurel Ridge Church dates to 1833, when the minutes record that John Hardy, "a man of color," was received into membership.) The pulpit was a "Bay-window type" with steps on either side leading to the platform. The pews were English style with high backs. Two small windows on each side furnished light, and evening services were held using candles. For the Primitive Baptists, early preachers at the church were Elders John Hall and a Mr. Castle, and the first members were Pheobe and Libby Grice.

In 1892, the congregation moved out of the log church and into a new church on land deeded for that purpose by George Bell. When that move occurred, the congregation began using the name Bellview Primitive Baptist Church, with the name referencing the grantor of the property.

Elder John C. Hall wrote about the day in the summer of 1892 when the Primitive Baptists first worshipped in the "new house." It was an all-day affair, and more than two thousand persons attended. There was preaching in the morning, followed by a break for persons to eat, and then afternoon preaching. Elder Hall assumed almost the entirety of the preaching duties, as two other elders were prevented from traveling to the affair. During a

Bellview Primitive Baptist Church, c. 1965. The church was constructed in 1892 and used for more than eighty years. Today, it is a residence. *Courtesy of Laurel Ridge Primitive Baptist Church.*

late morning service, Elder Hall noticed the presence of Reverend J.G. Councill of the "missionary" Baptists and invited him to sit on the platform for the service. During the lunch break, Councill noted that there were many missionary Baptists at the event and asked permission to preach an afternoon service at the "old house" for that group. Elder Hall graciously gave his approval.

Even though the church had relocated across the road, the congregation continued to maintain the grove and cemetery where the former church had stood. They would also have dinner on the grounds in the grove for their annual Communion service on the third Sunday in August.

In 1975, the Bellview Church erected a larger brick structure near the site of the original log church. When they moved across the road into the new, present-day church, the congregation reverted to the Laurel Ridge name.

LAWRENCE MEMORIAL UNITED METHODIST CHURCH (BENT MOUNTAIN)

The first Methodist church on Bent Mountain was a log structure known as Meadow Branch Methodist Church, though its exact location is uncertain. The congregation started around 1850. Land was then donated by J. Coles Terry around 1894 for moving the Methodist church to a better location. A frame building was erected near Thompson's Store, and the new church was called Mount Zion Methodist Church. A small notice in the September 5, 1894 edition of the *Roanoke Times* read, "The ladies of Meadow Branch Church, Bent Mountain, expect on September 8th to give a festival near Terry's store for the purpose of securing funds for the erection of a new church." The new frame church was completed and dedicated in 1896. An article in the October 2, 1896 edition of the *Salem Times-Register* read as follows:

> *The largest crowd ever assembled on Bent Mountain in this county, met last Sunday, the occasion being the dedication of the Bent Mountain Methodist church. This enterprise was started more than a year ago. An acre of ground adjoining his old storehouse property was donated by J. Coles Terry. The people of the vicinity contributed in money and work, sufficient to erect a neat frame building, ample for the accommodation of the neighborhood. This building takes the place of a small, unsightly house, which had first been used as a store, then as a country school house, and was for many years*

the only place of worship in that immediate vicinity. A sermon suitable for the occasion was preached by the Presiding Elder, Key. B.F. Ball, who took his text from Isaiah 51:3, and by him dedicated to the worship of Almighty God. Rev. H.A. Wilson, preacher in charge and Rev. J.H. Brumbaugh, a former pastor, were present and assisted in the service.

By 1945, the Methodists had moved again, erecting a brick church near Bent Mountain Elementary School where it exists today (10140 Tinsley Lane). The brick church was named Lawrence Memorial in memory of Henry Lawrence, who founded the first Methodist church in this section. The former Mount Zion Church was sold to the Primitive Baptists, and it became Thompson Grove Primitive Baptist Church. An interesting note about the current brick church is that the first couple married in the church was Lois Reed and Boyd Overstreet. The present church sits on a lot donated by Grace Terry Moncure that she purchased from the Shockey farm. It was Mrs. Moncure who made the suggestion for the Lawrence Memorial name, though some records state the land was donated by Mr. and Mrs. W.W. Webb.

MOUNT GERIZEM EPISCOPAL MISSION

Mount Gerizem Church was an Episcopal mission church of St. Paul's Episcopal Church in Salem. According to records of the Diocese of Southwestern Virginia, the congregation was started in 1924 and remained active through 1944. The connection with the Salem church was strong, as the rector's name for the congregation was always the same as the one for St. Paul's Church.

The church was located on Twelve O'Clock Knob Road near the intersection with Wade Road and is today a private residence (4638 Twelve O'Clock Knob Road). The mission congregation had been started by the Reverend David Lewis of St. Paul's. The St. Paul's Church sold the mission chapel on August 13, 1951, noting that the parishioners had dwindled to just a few and that those attending "were more in accord with Baptist philosophies." The small group that was attending asked to purchase the chapel and possibly begin a Baptist church in it. Thus, St. Paul's sold the chapel to the William Horsley family for $1,000. There is no indication in the history of Back Creek that the chapel became used for Baptist services, however.

The late Charlie Lavinder told of his father, Wiley Lavinder, playing the fiddle on Saturday nights at the Episcopal mission chapel for neighborhood gatherings but that drinking alcohol was not allowed. Apparently, the roughly constructed flooring had wide enough openings between the planks that elder Lavinder would "accidently" drop his bow, the retrieval of which provided him with an excuse to go around outside, where the bow landed next to his hidden refreshment.

Diocese records also indicate that there was an Episcopal mission on Bent Mountain from 1912 to at least 1927. Prominent supporters of the mission were Mr. and Mrs. J. Coles Terry, who were also members at St. Paul's in Salem. The mission may have met on their property. In 1917, the mission reported having ten communicants.

Mount Olivet Baptist Church

Mount Olivet Baptist Church, Bent Mountain, was first called Mount Neriah for a period of years and was built on land donated by Eliott and Sara Smith. The Smiths are buried in unmarked graves near the back of the church. The original church was constructed of logs with beamed ceilings and log benches. There was a railing around the altar where members knelt to pray and to receive Communion. This was also used for mourners. (Mourners' benches were not for funerals but were used during revivals for those who came forward to "mourn" for their sins and be converted or repent.) The early log church was believed to have dated to 1837. The church's name changed to Mount Olivet sometime in the early 1870s. The old log church was also used as a school during this period; Henry C. Light was one of the teachers.

The log structure was torn down and the present sanctuary built on the same site. The new church was dedicated on August 21, 1904. Much of the carpentry work on the new church was done by P.M. Siner, Josie Custer and William Stephens. Siner made the pulpit that was still being used at the time of this writing. Siner's pews were replaced in the church with new ones in the 1990s. In 1934, the church added a wing for Sunday school that was built by I.L. Huff and Mose Wimmer, and a vestibule was added in 1965.

The Women's Missionary Society was organized at the church in 1909 by Mrs. Zadock Bernard with eight charter members. The first president was Mrs. E.O. Tinsley, who served in that capacity for forty-seven years and was then followed by Mrs. W.E. Kefauver. From 1904 to 1914, the

Mount Olivet Baptist Church, 1984. The church, with its 1904 sanctuary and 1934 addition, is shown here. The congregation began in 1837. *Courtesy of Dana DeWitt.*

church was without a pastor, so home missionaries would often conduct services when available, especially at summer revivals. Members of the Billy Sunday Club of Roanoke would also preach on occasion during this period. For many years, preaching would occur on the third Sundays, with Mount Olivet being part of a circuit of Baptist churches in Floyd County.

The late Sue Tinsley Angle, a lifelong member of Mount Olivet who passed away in 2015 at the age of ninety-nine, recalled in 1975 some early days at the church. "During revival services in the Twenties, the congregation was so large that the children had to sit on the floor at the back of the pulpit. The old timey revival hymns rang out loud and clear to the accompaniment of the old pump organ." On a personal note, I served this congregation during my seminary days and can recall many of the descendants of the church's founders still being active there. Upon graduation from seminary and leaving the congregation for full-time ministry, an oil painting of the church was given to me by Allen and Ruby Stone and Rodney and Dana DeWitt.

Mount Union Church of the Brethren

The Mount Union Church of the Brethren came into existence in the 1880s as a preaching point of the Copper Hill Church. The congregation was originally referred to as "Air Point Church" and erected its first building in 1894 on the present site. The church was a "union" church, with services being conducted there by Missionary Baptists, Primitive Baptists, Methodists, German Baptist Brethren, Episcopalians and Brethren denominations. This contributed to its name—"union" because of its history as a multidenominational meetinghouse, and "mount" because it was located at the crest of Bent Mountain.

A history of the church described the original 1894 building. "The building was a one-room structure, using rocks as cornerstones. There was a 'crawl space' under the structure which made it convenient to put the wood for the stove until it was needed. The stove was in the middle of the floor so everyone would be warm as they worshipped and besides the kerosene lamps for light, there were two windows on each side."

In 1957, the original church structure was remodeled with a vestibule added to the front, pulpit area and basement. The "new" sanctuary was dedicated on September 20, 1959. In 1963, Mount Union became independent of Copper Hill Church with seventy-three charter members. In 1974, an educational wing was added to the church.

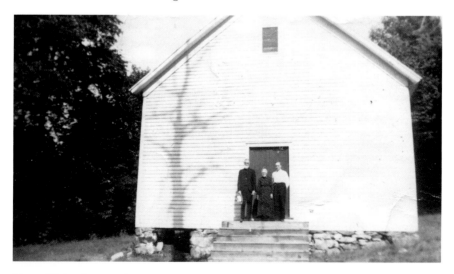

Mount Union Church of the Brethren, 1941. This image shows the 1896 sanctuary. Reverend Oscar Fife (*right*) is on the steps with his parents. *Courtesy of Martha Brizendine.*

POAGES MILL CHURCH OF THE BRETHREN

The church is named after a nearby mill located on Back Creek that is no longer standing. It was a church plant of Peter's Creek Church of the Brethren. Peters Creek Church was established prior to 1840. There were four preaching points nurtured by that congregation: Poages Mill, Peters Creek, Cave Spring and Bend Chapel.

The history of the Poages Mill Church dates back to when Brethren in the area met for services in a shop building belonging to Elijah Poage during the Civil War. These services were not held regularly. The Cave Spring Brethren Church was erected in 1863 to serve the communities of Oak Grove, Cave Spring and Poages Mill. Ministers who preached at Poage's shop and the Cave Spring church house included Christley Wertz, Johnny Eller, John Brubaker and Elias Brubaker.

The first regular services were held at Kittinger's Chapel once a month. This was a place of worship for several denominations: Brethren, Lutheran, Primitive Baptist and the Missionary Baptist. The first Brethren trustee at Kittinger's Chapel was Samuel Henry. Fletcher Deaton dedicated the chapel for Brethren worship, and Brethren preachers there included John Eller, John Naff, Moses Brubaker, D.M. Eller, Nathan Garst, Fletcher Deaton, John Garst, P.S. Miller, D.C. Naff, C.E. Eller, Henry Garst and Jerry Garst. The Brethren soon realized a need for their own place of worship.

On January 13, 1900, 1⅛ acres of land were purchased from Elijah and Mary Poage for fifty dollars. Then, a small frame structure, just a few hundred feet from where the present church now stands, was completed in 1902. C.E. Eller delivered the first sermon there, and John Grisso's funeral was the first such service conducted from the church, on March 15, 1902. In 1923, Oak Grove Church and Poages Mill Church decided to become a single congregation due to their respective growth and to separate from the Peters Creek Church. The separation was granted on March 17, 1923. Several months later, on October 13, Oak Grove and Poages Mill dissolved their union and became standalone churches due to their strong growth. C.S. Ikenberry, C.D. Hylton and J.S. Cumpacker led the services during this period. Local leaders of Poages Mill Church included John Wertz, Samuel Henry and John Henry Grisso. In that same year, an addition was built on the south side of Poages Mill Church. The first love feast held in Poages Mill Church was in September 1924. J.T. Henry served as foreman for that service. A "Christian Workers" group was founded in 1924, with Harvey Grisso serving as the group's first president. The Ladies

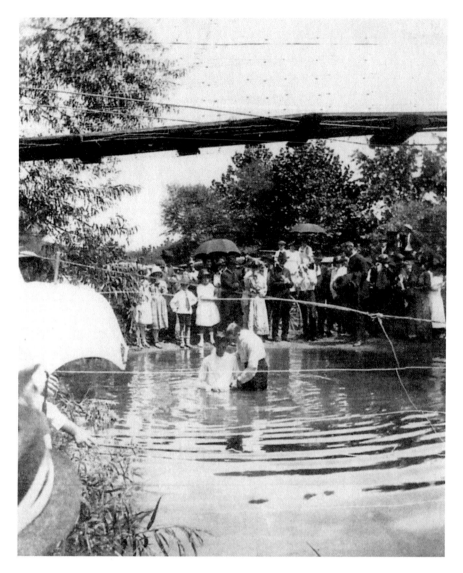

Brethren baptism, 1925. James C. Fralin is being baptized in Back Creek near the Poage farm by Chris Eller, Brethren minister at Poages Mill Church. *Courtesy of Marie Saul.*

Aid Society was organized in 1939. A well house was built in 1930, and a piano was bought for the church in 1932.

As the church grew, the congregation felt the need for a new sanctuary, so in 1947, work was begun on the present sanctuary and Sunday school rooms. The logs, which came from members' land, were cut by hand, hauled

to the lumber mill and finishing plant and then used for the inside structure as well as for the ceiling and flooring. The Ladies Aid Society made quilts and apple butter, sold cards and served dinners to raise money to purchase chairs for the choir, chairs and tables for Sunday school classes and pews for the sanctuary. The youth had pie suppers and sold stationery to help purchase the rose window, which is mounted in the center of the front of the sanctuary.

In May 1948, this new brick structure was dedicated. The original building was sold at auction for $1,000 and then removed. A parsonage was also built in 1957. An addition to the existing structure, including a fellowship hall, Sunday school rooms and offices, was built in 1968.

Rock African Methodist Episcopal Church

The Rock AME Church is first mentioned in court records on December 8, 1904. Its exact location is unknown, but it was near the Roanoke County line, possibly in the Bottom Creek section. The church's exact name is also uncertain, as it was often spelled or pronounced phonetically in records as "Rock Ami" or "Rock Emmy" Church. Those associated with the church as trustees were Giles Hickman, Fillmore Frogg, William Webb and Peter Kent, with Webb serving for many years as the congregation's pastor. In fact, Webb may have been the church's only pastor. Many of its members were Floyd and Montgomery County residents. In the late 1920s, its membership was dissolved and joined to Bent Mountain Baptist Church, with Webb serving as the interim pastor of Bent Mountain Church. In some histories, this church is also called Rock Ami Baptist Church.

St. John's Evangelical Lutheran Church

On May 15, 1956, a group met with Dr. William McCauley to start a Lutheran mission in the Cave Spring area. Present were nine adults and five children. A month later, on June 10, the group held its first worship service in the former Cave Spring Baptist Church, owned and used by the Cave Spring Lions Club. The congregation formally adopted their present name on September 26, 1958. In that same year, a parsonage was purchased. The church was officially constituted on November 23, 1958, with fifty-one charter members and seventy-three baptized members. In

1962, the congregation moved to its present-day location on land they had purchased in 1956. For decades, the church was affiliated with the Evangelical Lutheran Church of America (ECLA), but several years ago, the congregation severed those ties to join a different, more conservative Lutheran denomination.

Thompson Grove Primitive Baptist Church

Located adjacent to Route 221 at the intersection with Ivy Ridge Road (Route 708) on Bent Mountain, Thompson Grove Church was started in August 1945 when elders of the Primitive Baptist Church met to discuss the purchase of the former Mount Zion Methodist Church. (The Methodists had relocated to their new brick church near Bent Mountain Elementary School and renamed their church Lawrence Memorial.) Elders J.P. Helms and B.V. Helms were called to the home of Noah and Ada Thompson to discuss buying the church house that was situated across from their home. After examining the property and on the advice of the elders, trustees were appointed, and the property was purchased by the Thompsons at a cost of $1,000 from Lawrence Memorial Methodist Church. The deed was executed on November 13, 1945. The deed was to R.E. Metz and M.C. Sumner, trustees for "the old school Primitive Baptist Church," with the property to be known as Thompson Grove Church in honor of the Thompsons. With contributions from Brethren and friends of the church, the property was paid for in less than two years. The first meeting was held on the first Sunday in December 1945 by Elders J.P. Helms and B.V. Helms, and the elders continued to hold meetings together every first Sunday until Elder B.V. Helms was called to serve Little Creek Church near Rocky Mount, Virginia. The church continued under the leadership of Elder Helms and visiting elders.

The presbytery of Primitive Baptist was convened on a Saturday afternoon on May 3, 1952, and elders were chosen, including Randolph Perdue, B.V. Helms, S.L. Moran and J.P. Helms. According to the minutes of the church, "After questioning the brethren, the clerk was asked to read the Church Covenant and the rules of decorum together with a brief history of the church and after all the presbytery being satisfied Thompson Grove Church was established as a sovereign church in gospel order." The church was subsequently received into the Pigg River (Primitive Baptist) District Association.

In the first years of the church's existence, about three-fourths of an acre of land was donated to the church by Noah and Ada Thompson, the land being on the front side of the church. There was also a small portion of land donated to the church by Ola Metz, being at the back of the church. Improvements to the church have included a metal roof, cement steps, new foundation and lights.

The Primitive Baptists continued to meet regularly at Thompson Grove Church once per month, usually on the first Sunday, until 2015. At this writing, the congregation is no longer meeting, having one surviving member, though the church property remains in the hands of the trustees.

THERE WERE OTHER CHURCHES in the Back Creek and Bent Mountain sections whose formal histories have been lost. The Christo Church (9447 Patterson Drive) in Bent Mountain opened around 1920 on property provided by the Deweese family and was used by various religious groups over several decades, with the last being Wesleyans. The church closed around 2000 and is used now to store hay. A Brethren church was started in the Bottom Creek section on land belonging to the Craighead family; the vacant building still remains. It was originally a preaching point for the Copper Hill Church of the Brethren in the late 1880s, with a chapel being built and dedicated in 1917. The church ceased meeting in the 1960s.

In Starkey, the current Covenant Anglican Church building was home to a Pentecostal congregation in the 1940s. There was also a small African-American church, called Back Creek Church, that met in the original Starkey schoolhouse at the intersection of Merriman Road and Penwood Drive, for many years.

A Dunkard church was established at Cave Spring in 1857 when a piece of land lying south of the present-day Lions Club building was purchased and a small wood-frame church was erected. It was later used as a residence. Trustees for the Dunkard Church in 1857 were Christian Wertz, Benjamin Brubaker and John Wertz. The structure was razed sometime in the 1950s.

Long Tabernacle was established by Wilfred Long in the 1940s and was in the vicinity of the Strawberry Mountain subdivision.

SOCIAL AND RECREATIONAL LIFE

G enerations ago, social life was anchored in family, school and church. There were dances, apple butter making, quilting bees, Sunday dinners and pie suppers. Funerals were also a basis for families and neighbors to gather. Graves had to be dug, usually somewhere on the family farm, and bodies were kept in homes for visitations. I recall my older relatives sharing about "sitting up with the body" overnight in the home. Often, the funeral would be conducted from the residence in the afternoon, followed by a procession to the family burial ground, and then supper would be served.

Hog killings, harvest and hay cutting were occasions when neighbors would help neighbors. In a 1936 interview with the Federal Writers' Project, Mary Poage recalled the social elements of the apple harvest. "Women would have an 'apple cutting' while the men shucked corn, with a large quantity of apples set aside for drying. The women would arrive in long aprons and with a paring knife. They would work the entire day with some preparing a big supper for all involved."

In the files at the Roanoke County School Board is a brief history of the Bent Mountain community written in the early 1940s. The unidentified writer, who apparently grew up at Bent Mountain, wrote about the social activities that occurred during her childhood and adolescence in the early 1900s.

There were apple butter boilings where the young people would make a party out of it by stirring together. The custom was that if the couple hit the bail with the paddle the young fellow could kiss his partner and often he would force the paddle to hit the bail in order to get an extra kiss. The writer's grandmother often told of old time quilting bees when all the ladies were invited to bring their needles and thimbles and spend the entire day quilting with lunch prepared by the hostess. When the quilt was finished and removed from the frame the hostess would throw it over one of the young girls present which meant she would be the next one to get married.

The men had their corn husking and the writer has been told that sometimes a jug would be placed somewhere deep in the pile and the workers were told that they would have to husk the corn that far before they would get a drink. It was probably thought that those who liked the jug would work harder in order to reach it. The one getting a red ear would get an extra drink.

Music was important to the culture of the region. There were often string band concerts at local schools, especially Bent Mountain and Back Creek Elementary Schools. Some older residents of Bent Mountain recall when

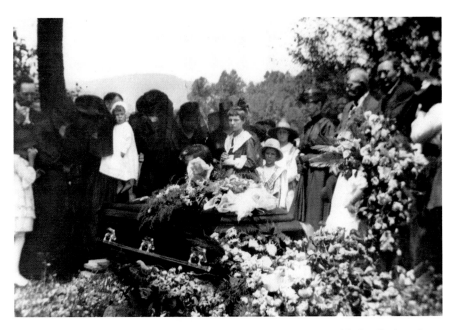

Mountain burial, circa 1909. Funerals were significant social events, with the digging of graves, in-home visitation and services and neighborhood-wide dinners. *Author's collection.*

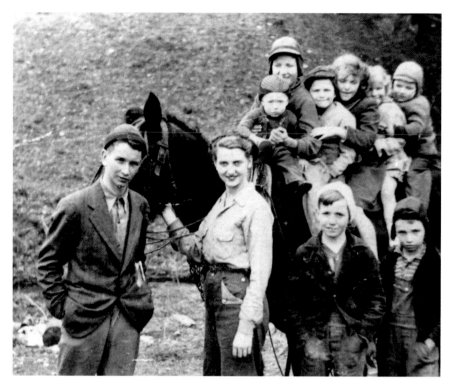

Horse ride, circa 1940s. Nadine Henderson takes her nieces and nephews for a horseback ride. Family was often the center of earlier social life. *Courtesy of Genevieve Henderson.*

bluegrass legends Lester Flatt and Earl Scruggs, in their younger years, played in a grove of trees along Route 221 just south of today's Bent Mountain Bistro. Local musicians, known as the Hardy Mountain Boys, wrote and recorded "Bent Mountain Breakdown" several decades ago.

There were clubs, sports and other gatherings that provided a more structured social life, and a few of those histories follow.

Back Creek Civic League

The current Back Creek Civic League was organized in 1987, with Charlie Lavinder as its first president. The league has worked to provide items for the Back Creek fire station, helped provide input to the Virginia Department of Transportation regarding road and traffic matters, acquired items for the Back Creek Elementary School library and playground, instituted

neighborhood watch programs and hosted regular meetings of citizens with local and state government officials and others.

There was also an active Back Creek Civic League functioning in the early 1960s. One of its primary activities was successfully opposing the construction of a slaughterhouse operation in the section.

BACK CREEK COMMUNITY CLUB

The Back Creek Community Club was organized in 1973, starting first with an affiliation with the Homemakers Extension Clubs in the Roanoke Valley that later became Extension Homemakers. In the early 2000s, the club decided to discontinue that affiliation in order to have its focus and programs be more determined by its membership. Over the years, the club has assisted the Back Creek Fire Station No. 11 with fundraising activities, primarily through bake sales, and the club has been involved with activities of the Back Creek Civic League and at Back Creek Elementary School. Much of the focus of the club is developing friendships, community service and educational and social programs.

BACK CREEK SOCIAL SERVICE CLUB

The social service club was organized in 1923 and was originally known as the Back Creek Red Cross Club, probably a reorganization of the Red Cross's Mothers' Clubs popular in the World War I era. As a Red Cross–affiliated organization, the primary work of the club was to support Red Cross activities and other charities.

The Back Creek Social Service Club met regularly in the 1940s and '50s. The women's organization raised funds for charitable purposes to meet needs in the Back Creek section and larger Roanoke Valley, including Mercy House and the Catawba Sanatorium. Its activities were regularly reported in the social columns, and the club typically met at Back Creek Elementary School or in homes. In 1943, the club's officers were Mrs. W.H. Coon (president), Mrs. G.T. Willett (vice-president), Mrs. R.A. Henry (treasurer), Mrs. Harvey Poage (secretary) and Mrs. R.C. Wertz (chaplain).

There was also an active social service club at Starkey. While little is known about that particular club, one can assume it functioned in the same manner and for similar purposes as the Back Creek club.

Baseball

America's pastime came to Back Creek as early as 1907, when the area fielded a team to play other communities. In 1908, the Poages Mill baseball team held an intra-team game that drew quite a crowd. "The first Poages Mill team defeated the second Poages Mill team Saturday afternoon in one of the most exciting games played on the local diamond," reported the *Roanoke Evening News* on July 2, 1908. Pitching for the first team were Rufus Henry, A. Martin and W. Henry, and for the second team were Grisso and Wertz. The umpire for the game was D.L. Henry. The Poages Mill team won its first twelve games that season! The Poages Mill squad played teams from Roanoke, Salem, Vinton, Franklin County, Belmont and Starkey.

Later, teams in the Back Creek section would play in the Twilight League and the Virginia Amateur League. Baseball leagues comprised teams from rural communities and company teams from Roanoke city. Gordon Saul recalled that the teams of the Virginia Amateur League played through the 1950s and maybe into the early '60s. "I believe the commissioner was a legendary former local player, 'Smokey Joe' Woods. Some of the competition was teams from Vinton, Starkey, Glenvar, Williamson Road and Norwich."

According to Walter Henry and Ralph Henry, who both played baseball, as did their fathers, for Back Creek teams, there were a number of baseball fields in the section. One was on the south side of Back Creek near present-day Haran Baptist Church. In the 1920s and '30s, some of the men who played on the home team there were Lamar Martin, Ben Marlow, Jim Day, Alfonso Martin, Howard Henry and Ralph Bell. Probably the earliest field was located along Back Creek near the present-day Route 221 and Old Mill Road intersection in what was called "Sloan's Bottom." The Back Creek team that played there had Rufus Henry (known for his knuckleball), Lamar Martin and Howard Henry. A third field was where the present-day ball diamond exists at Back Creek Elementary School. A fourth field used in the 1930s and early '40s was at the intersection of Whistler and Apple Grove Lane. A fifth field was located behind what is today Cave Spring Middle School. Numerous teams existed in the Back Creek section, such that untangling individual team histories would be almost impossible.

Some of those who played for the Back Creek teams in the late 1940s, 1950s and early 1960s were David "Snook" Willett, Jack Willett, Hoover Bohon, Curtis Mowles, Robert Mowles, Bill Henry, Ralph Henry, Ned Martin, Bobby Martin, Joe Martin, Danny Likens, Dewey Likens Jr., Ron Henry, Andy Martin, Lawrence Martin, Jack Cochran, D.D. Henderson,

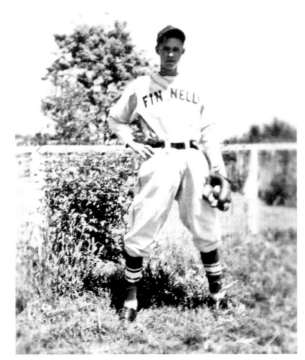

Left: Ralph Henry, August 1948. Henry played for the Back Creek baseball team. The uniform reads "Finnell's," as the team was sponsored by Finnell's Store. *Courtesy of Ralph Henry.*

Below: Poages Mill baseball team, 1908. R.C. Wertz (1), O.L. Grisso (2), John Wertz (3), Bill Grisso (4), Ott Wertz (5), Walt Henry (6), E.B. Martin (7), John Bowles (8) and R.C. Henry (9). *Courtesy of Walter Henry.*

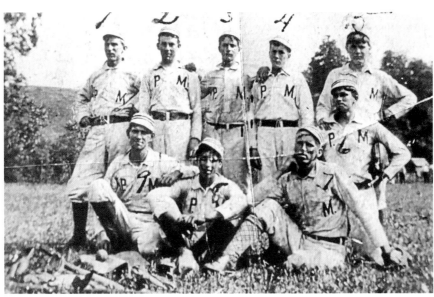

Jack Harrison, George Hill, Rudy Kirkwood, Jimmy Kirkwood, Ermin Sumner, Dick Agee, Scoot Jones, Don Ragland, Hugh Poage, Charles Day, Frank Bielke, Buck Jones, Harry Mills, John Pinkard, George Hill, Pick Hammond, Elton Stanley, O.C. Simpson Jr., Morris Creggar, Paul Rotenberry, Jack Burris, Kenneth Burris and Bobby Altis. Van Wood was the team's first manager in 1948. Ralph Bell often umpired.

Jake and Mary Likens usually sold drinks and snacks at the games (soda was ten cents).

In 1999, Jack Burris donated his Back Creek uniform (blue on white pinstripes with red letters) to the Salem History Museum. Burris provided information pertaining to the post–World War II Back Creek teams. The Virginia Amateur League was started in 1948. Teams in the league included Salem, Glenvar, Back Creek, Starkey, Vinton, Veterans' Hospital, Buchanan, Glasgow, New Castle and Bedford. Over the years, other teams joined the league, including Newport, Pembroke, Floyd and Christiansburg. Each team played all opponents twice. Various businesses sponsored the team, buying the uniforms and equipment, including Peter's Grocery, M.P. Reed's Store, Jake's Market and Finnell's Store.

Bent Mountain Hunt Club

The Bent Mountain Hunt Club started in 1940, and some of the early members were Will Wimmer, C.F. Holt, Walter Overfelt, Dewey Holt, Doug Lancaster, Jake Hurst and Lank Alderman. The club built a log clubhouse on Callaway Road that later burned and was replaced by a cinderblock building. The club also owned a hunting cabin in Sussex County, Virginia, due to the lack of deer in the Bent Mountain area in the early decades of the club's existence. Sammy Holt recalls joining the club in 1958; at that time, there were twenty-two members and dues were $20 per year. A copy of the club rules dated 1978 outlined expectations of behavior and duties. No alcohol and no guests were allowed; "all members that miss a deer including cooks and head man must pay the penalty of washing dishes"; last man to put a deer down can claim it; every man in the club will be equal; stands could not be claimed when hunting with a group; and a blessing was said at every meal. The club dissolved in 2008 with fourteen members (dues were $400 per year), and the hunting cabin in Sussex County was sold.

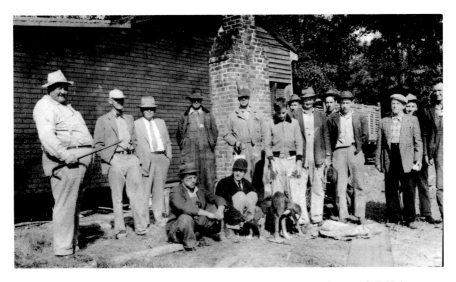

Bent Mountain Hunt Club, circa 1940s. *Left to right, standing*: Will Wimmer, C.F. Holt, Walter Overfelt, Dewey Holt, Doug Lancaster, ?, Woodrow Reed, Jake Hurst, ? and Lank Alderman. Others are unidentified. *Courtesy of Glenna Wimmer*.

CAVE SPRING LIONS CLUB

The Cave Spring Lions Club was founded in July 1941 with twenty-two charter members. The service organization was responsible for introducing scouting to the section in 1942 through its Boys and Girls Committee. Luther Bell, a club leader, spearheaded this effort. In 1962, the club built the brick clubhouse on the hill near Cave Spring that is the present site, having razed the former Cave Spring Baptist Church structure that was there originally. Construction of the $17,500 clubhouse was overseen by F.W. Martin and begun in May. The clubhouse was formally dedicated on August 22, 1962, in a dinner meeting that featured former International Lions past president Dr. E.G. Gill of Roanoke as speaker.

In the 1940s, the club would occasionally meet at Bent Mountain High School.

On July 28, 2016, the club celebrated its seventy-fifth anniversary with a dinner at the Holiday Inn Tanglewood, with guest speaker past Lions International director Richard Chaffin.

Cave Spring Masonic Lodge

Cave Spring Lodge No. 230, AF&AM, requested a charter on January 10, 1964, when Robert Edward Slaydon wrote a letter to Right Worshipful James A. Newton, district deputy grand master of Masonic District No. 22, requesting a charter for the Cave Spring Lodge. The lodge had been working under the supervision of the grand master of Masons in Virginia since June 26, 1963.

On February 12, 1964, the Cave Spring Lodge was issued a charter by the Grand Lodge of Virginia. The lodge was composed of fifty-two charter members, holding its first meeting as a chartered lodge on February 23, 1964. At that time, the officers of the lodge were R.E. Slaydon (worshipful master), A.C. Wright (senior warden) and H.G. Stover Jr. (junior warden). Later, the lodge erected its building at the present-day location, the corner of Ranchcrest and Merriman Roads.

Dances at Back Creek School

Following World War II and through the 1950s, community dances became a popular event in the gymnasium at Back Creek Elementary School. Country bands would provide the music, usually for square dancing, for a small admission fee. Sometimes, the dances would involve cakewalks and pie suppers. There were some regular couples who seemingly never missed—Otho and Ruth Bell, Ed and Vola Sloan, Lamar and Mae Martin, the Coons—and there was Dick Agee, who danced on one leg

Dance at Back Creek Elementary School, circa 1950s. Ott and Lucy Poage (*foreground*) were regulars at the popular community dances at BCES. *Courtesy of Lynne Mowles.*

while swinging the other in midair! The dances would typically end with Otho and Ruth Bell requesting their favorite slow dance, "The Tennessee Waltz." Genevieve Henderson writes, "Those were the good days, and many Back Creek romances got their start on the dance floor."

Joyce Turman recalls that Otho Bell would number off the couples and call the figures for the square dancing, and the circle would encompass the entire perimeter of the gym floor.

GOLF COURSES AND CLUBS

Hunting Hills Country Club and its eighteen-hole golf course opened in 1970 near Starkey. The club and surrounding subdivision were developed by Gordon Willis Sr., president of Old Heritage Corporation.

Hollyfields Golf Club at Bent Mountain was developed on 175 acres by Paul Hollyfield, whose dream was to create an eighteen-hole, first-class, European-style course. He retained the services of the Robert Trent Jones Company to design the course. Hollyfield opened his course in 1986 with nine holes completed, but he died the following year from cancer at age seventy-four. His daughter Sally Hollyfield took over the club, opening it to the public. Located along Route 221 and Mill Creek Lane, the club was unique in Virginia in that it banned motorized carts. "We want golf to be played the way it was meant to be played," Ms. Hollyfield once told a local newspaper. (I played several times at the course and recall it was a great summer course due to the cooler temperatures than those in Roanoke.) The full eighteen-hole course was never realized, and the club closed in 2002 when the land and course were sold at auction for $1 million on June 1 of that year. Four buyers purchased various parcels; two were developers from North Carolina—John Atkinson and Robert McHenry. Two months later, Atkinson and McHenry announced their intention to build a fifty-lot, upscale residential community on the former course to be called Stoneridge at Bent Mountain.

KNIGHTS OF THE MYSTIC CHAIN

One of the earliest known social organizations in Back Creek was a fraternal society known as the Ancient Order Knights of the Mystic Chain. Its main hall was located on College Avenue in Salem, and area lodges were called

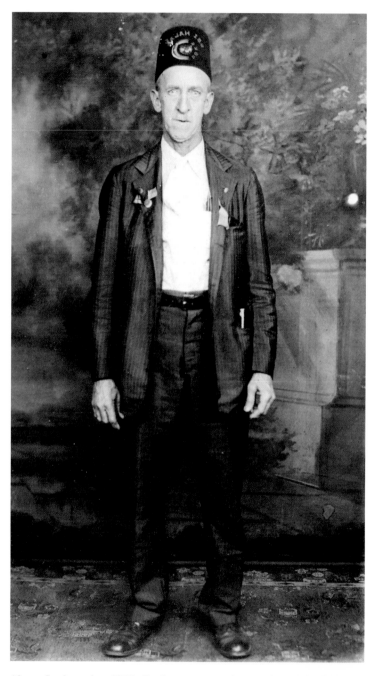

Alonzo Lockett, circa 1920s. Lockett was an active member of the Knights of the Mystic Chain. The Cave Spring Castle often met at his store in Starkey. *Courtesy of David Harris.*

"castles." Based on newspaper notices of this order's meetings, there was "Cave Spring Castle No. 8" and "Haran Castle No. 9." Where these castles regularly met, aside from the hall in Salem, is difficult to determine, but they were in existence as early as 1901. A small notice in the Back Creek community column of the Salem newspaper stated that the "Haran Castle" held an oyster dinner at the home of Luther Bell in 1903, and the Cave Spring Castle would meet occasionally at Lockett's Store at Starkey. A 1910 Virginia business directory stated that the Haran Castle met every Thursday evening "at Poages Mill in the Mystic Chain hall" and that R.C. Wertz was secretary. The same publication indicated that the Cave Spring Castle met on Saturday nights in "Co-Operative Hall Locketts Store" and that the secretary was J.M. Gates.

Nationally, the Ancient Order Knights of the Mystic Chain was founded in 1871 by Freemasons. Many castles (chapters) had female auxiliaries, though none seemed to exist in Back Creek.

Mothers Clubs

During World War I, the American Red Cross began what were called Mothers Clubs, which sought to raise funds for Red Cross relief projects and, after America's entrance into the war, provide items for soldiers serving overseas. These clubs met regularly to knit, sew and craft items that could be worn or used by the soldiers or to be sold at neighborhood charity events, such as lawn fetes, pie suppers and school gatherings.

There were Mothers Clubs in southwest Roanoke County, and their activities were often covered by the local newspapers.

For example, on March 9, 1918, the Cave Spring Mothers Club met at the home of Mrs. Will Harris. She had erected a quilt on a frame, and the ladies gathered to complete it. The hostess provided lunch, which concluded with strawberry cake. Following dinner, the club met for business and raised enough funds to pay their small debts. They prided themselves that fourteen pairs of socks had been knitted by club members for the Red Cross. The club decided to hold pie suppers at the schoolhouses on the fourth Saturday nights to raise funds. Members in attendance included Mrs. John Grisso, Mrs. George Harris, Mrs. Williams, Mrs. Zirkle, Miss Mary Grisso, Mrs. Turner, Mrs. Carl Beckner, Mrs. Lavinder, Mrs. Lacey Greenwood, Mrs. George Wiseman and Mrs. Henry Wiseman.

In February 1921, the Cave Spring Mothers' Club met at the home of Mrs. C.W. Bowles. Mrs. S.H. Turner conducted the business session, which included sending five dollars to the Near East Relief Fund to help starving children. The following month, the club met at the home of Mrs. Mattie Turner.

Other women whose names regularly appeared in notices about the Cave Spring club, either as attendees or hostesses, included Mrs. John Greenwood, Naomi Greenwood, Agnes Turner, Mrs. Henry Turner, Mrs. F. Hall, Mrs. J.L. Zirkle, Mrs. George Harris, Mrs. D.H. Minott, Mrs. Joel Grisso, Miss Laura Wells and Mrs. R.K. Temple. The club had about fifteen active members and dissolved after the end of World War I, though an effort was made to revive the club in 1923 by Mrs. John H. Grisso.

There was also a Starkey Mothers' Club. In December 1920, it organized a taffy-pulling for the schoolchildren there.

Poages Mill Circle (Woman's Club)

In 1923, the Roanoke County Woman's Club was organized. Among the initial organizers was Mrs. R.K. Temple of Cave Spring. The club was soon divided into regional circles that met in homes to foster relationships between women, conduct home demonstration work, organize public health and childcare clinics and promote the fine arts. The Poages Mill Circle was quite active in all of these endeavors. According to the 1932–33 yearbook of Roanoke County Woman's Club, the Poages Mill Circle's membership included Mrs. E.G. Grisso, Mrs. W.M. Rierson, Mrs. G.T. Willett, Mrs. Wendel Coles, Mrs. W.E. Easter, Mrs. J.W. Poage, Mrs. E.O. Tinsley, Mrs. Mattie Kirkwood, Mrs. B.S. Coon, Mrs. S.H. Willett, Mrs. R.C. Wertz, Mrs. George Hurt, Mrs. A.S. Poage, Mrs. L.D. Bell, Mrs. A.C. Eddy, Mrs. H.B. Wharton, Mrs. J.B. Willett, Mrs. E.H. Snyder, Mrs. E.B. Hunt and Mrs. Harvey Poage (chairman). According to newspaper clippings, the Poages Mill Circle was active through the 1950s.

Starkey Speedway

Sometimes known as the Roanoke Raceway beginning in 1962, the Starkey Speedway was a quarter-mile paved oval short track with a half-mile outer dirt track that opened in 1950. In 1952, the track became a part

of the Dixie Circuit that included stock-car venues throughout Virginia, including Lynchburg and Danville. The first NASCAR Cup Series race there was in 1958. There were four NASCAR Cup races at Starkey, and the dates and winners are as follows: May 15, 1958, Jim Reed; June 24, 1961, Junior Johnson; August 15, 1962, Richard Petty; and August 23, 1964, Junior Johnson. The largest purse was the last NASCAR race, which earned Junior Johnson $4,740. The track record was set by Richard Petty in his 1962 victory—51.165 miles per hour with a Pontiac. Other early prominent NASCAR drivers who competed at Starkey included Wendell Scott, Glen Wood, Jack Smith, Jim Reed, Curtis Turner, Rex White and Ned Jarrett. The 1964 race was Glen Wood's last event. On May 25, 1956, Curtis Turner won a NASCAR-sanctioned convertible series race there. The NASCAR events featured eighteen to twenty-two cars per race. Although only four NASCAR Cup events occurred at the speedway, there were numerous amateur stock-car races and other events, including the Cristiani Brothers Circus in 1958. Eventually, the track closed in the 1970s after races had moved to larger venues and neighbors began complaining about noise. Further, the county board of supervisors imposed insurance

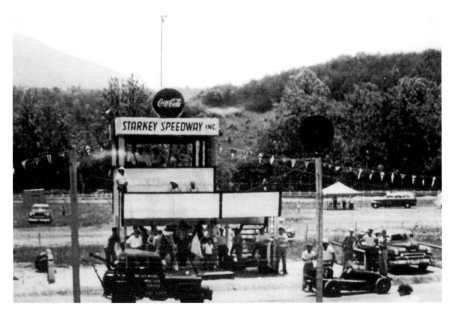

Starkey Speedway, circa 1950s. The speedway opened in 1950 and held auto races through the early 1970s before closing. *Author's collection.*

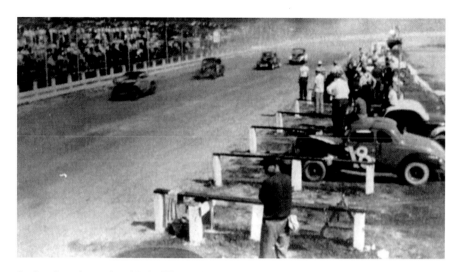

Starkey Speedway, circa 1950s. The track was used for four NASCAR Cup races between 1958 and 1964. The races included prominent drivers such as Richard Petty. *Author's collection.*

and other requirements on the track owners in 1971, creating financial challenges. The former raceway site is at 37.198193 latitude and -80.0022596 longitude.

There was a drag strip at Starkey, separate from the raceway, that operated in the 1960s and '70s adjacent to Buck Mountain Road near the present-day entrance to the Faircrest subdivision.

SWIMMING POOLS

While many families dammed up Back Creek at various spots and created their swimming holes, there were five swimming pools in the area. Kefauver's pool was located in the Bottom Creek section of Bent Mountain. It had a pool house for changing clothes and music over loudspeakers. It operated in the 1930s and '40s. Owner Jack Kefauver also built small cabins around the pool area in the woods, some of which are still standing. While the pool—created by a concrete dam on Bottom Creek—provided patrons the opportunity to sunbathe and socialize, the pool water was ice cold. In the 1940s, Kefauver's operation was advertised as "Bent Mountain Lake and Cottages" with "picnic grounds, swimming, dancing, and cottage rentals." Later, the pool, clubhouse and vacation cabins became known as Laurel Ranch.

Finnell's Swimming Pool, August 1960. Built in 1947 by B.G. Finnell Jr., the creek-fed pool operated for more than fifty years. *Courtesy of Laura Hall.*

In the 1940s and '50s, there was a concrete swimming pool located along Back Creek in what is today a field across from the site of the former Ye Olde English Inn. Molly Koon recalls that the pool was somewhat rough by modern standards, with no real amenities. The pool's owners also operated at that time Al and Ruth's on the opposite side of Route 221. The pool was filled in by the mid-1950s.

At the foot of Bent Mountain, along Route 221 in the Haran section, was Finnell's pool behind Finnell's Store. The author can recall swimming in the creek-fed pool as a boy in the 1960s and '70s. The pool was built by B.G. Finnell Jr. in 1947 and was sold in 1962 to Ronald Ramsey, who renamed it Brookcliff Swim Club. The pool closed around 2002.

Laurel Ranch, circa 1940s. An unidentified group enjoys a day at Jack Kefauver's Laurel Ranch swimming pool, which included a clubhouse (*background*). *Courtesy of Ed Frost.*

The Spring Run Swim Club opened in 1958 as a members-only club. It is located at 6328 Ran Lynn Drive and remains in operation today.

In the Starkey community in the early 1950s was a private pool located on the north side of Merriman Road on the hill across from the South County Library, where some contemporary-style homes exist today. David Harris said the pool was near a log cabin and the owner was approached about opening the pool to neighborhood children. He agreed, and local Boy Scouts from Central Baptist Church repaired and cleaned up the old pool. Ice-cold water was pumped from a spring where the library is located today. Harris said the pool eventually had some bathhouses. It closed by the late 1950s.

HEALTH AND PUBLIC SAFETY

Prior to the Civil War, Dr. John H. Rice had a medical practice located in the Cave Spring section. He had come to the county in 1858 from Pittsylvania County, Virginia. How long Rice was in the Back Creek area is unknown. Another Civil War–era physician in southwest Roanoke County was Dr. Charles A. Hardin (sometimes spelled Harding). According to Dr. W.L. Moorman of Salem, Hardin had a home in the present-day vicinity of Colonial Avenue's intersection with Route 419 in the 1860s. Hardin moved to Ohio after the Civil War to be near his son, also a physician, where he died in 1878.

Dr. Joseph A. Gale was practicing medicine at Cave Spring by the late 1860s. Gale had been visiting a cousin in Catawba and learned of the need for a physician at Cave Spring and shortly thereafter established his practice in the village in a rented room that served as his office and sleeping quarters. Gale's practice served those primarily in the Poages Mill, Cave Spring and Starkey sections of the county. Gale was a native of Norfolk, Virginia. His early medical training came as a medical steward in the Confederate army, where he was in charge of the dispensary of Chimborazo Hospital in Richmond. During and following the war, Gale began his formal medical training at the University of Virginia and continued to Bellevue Hospital Medical College in New York City. He was president of the Medical Society of Virginia in 1903–4 and later served as chief surgeon for the Norfolk & Western Railway in Roanoke. In Cave Spring, Gale's house is at present-day 4909 Cave Spring Lane. Charlotte

M. Temple wrote in a 1942 history of the Cave Spring community: "Here lived the country doctor Dr. Joseph Addington Gale.... [T]he brick residence built by Dr. Gale is still the most imposing one in the village." In 1869, Gale married Patty Harvey of Starkey, daughter of the owner of Speedwell. Sadly, she died eleven months after their wedding. He married again in 1875 to Eliza Simmons. After his second marriage, he built the stately brick home in Cave Spring. He left his Cave Spring medical practice in 1881, relocating to Roanoke. Gale would cap his medical career by being one of the two founding members of the Lewis-Gale Hospital in Roanoke, an institution that still bears his name today. Gale died on July 5, 1916, in the hospital that bore his name and was interred at Evergreen Cemetery in Roanoke.

According to Temple's history of Cave Spring, a medical student, Dr. George D. White, boarded at Gale's residence. White took over Gale's practice when the latter moved his office to Roanoke. White practiced medicine in Cave Spring from the early 1880s until his death in the 1930s. White purchased Gale's home in Cave Spring, which he also used as his office. Dr. White also served as the physician for the Castle Rock Mining Company near Sugar Loaf Mountain.

Another of the earliest physicians to serve the Back Creek area was Dr. Charles Graham Cannaday. He practiced medicine in the Poages Mill section for a few years in the 1880s. He was the son of a country doctor in Floyd County, Dr. H.A. Cannaday. Born in High Point, North Carolina, in 1860, Cannaday spent most of his childhood in Floyd County. He graduated from the College of Physicians and Surgeons in Baltimore, Maryland, and at the Hospital Medical College of St. Louis, Missouri. He then came to the Poages Mill area to establish a medical practice around 1886.

One interesting incident regarding Cannaday was the *Salem Times-Register* reporting erroneously his death in 1887. The newspaper reported in its October 21 edition that Cannaday, "well-known as a popular physician at Poages Mill," had collapsed and died at his parents' home in Floyd County—but the doctor was very much alive. Consequently, the newspaper reported a few weeks later, in its November 11 edition, that "the doctor is not dead and is again at his post of duty."

Cannaday did not stay long in the Back Creek section. In 1888, he moved his practice to Roanoke. Prior to his move, Cannaday placed a notice in local papers: "Accounts must be paid by November 25, 1887, staying at the residence of N.J. Christman on Back Creek." A year later, in May 1889, Cannaday relocated to Big Spring in Montgomery County.

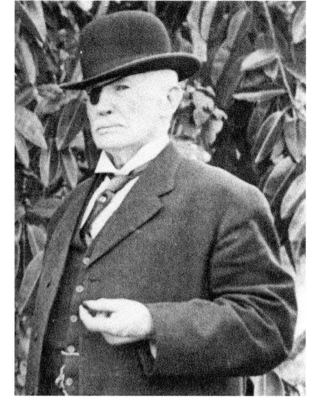

Right: Dr. Joseph Gale, circa 1910. Gale practiced in Cave Spring from the 1860s until 1881. He later cofounded Lewis-Gale Hospital. *Courtesy of Lewis-Gale Hospital.*

Below: Home of Drs. Gale and White, circa 1890. Dr. Gale sold his home to Dr. George White, who also used it as his office (presently 4909 Cave Spring Lane). *Courtesy of Lewis-Gale Hospital.*

133

Cannaday had a distinguished career as a local physician. He went to Vienna, Austria, where he studied for two years at an institute that specialized in female diseases and ailments. He then returned to Roanoke, where he established the Rebekah Sanitarium (hospital) in 1893. He served as president of the Roanoke Academy of Medicine in 1907. Cannaday collapsed and died of heart disease in 1908 at the age of forty-eight, cutting short the life and practice of one of the most progressive physicians in Roanoke at that time.

Dr. Edward O. Tinsley served the Bent Mountain and Air Point communities beginning in 1897. He built a large residence there in 1900. I recall visits with Tinsley's daughter, Sue Tinsley Angle, in the late 1980s, at the home. The large white farmhouse had a wraparound porch, and at the corner of the porch yet detached from the house itself was a small enclosed room with a window. This was Tinsley's medical office according to his daughter. She laughed about some of the visitors who came seeking medical attention, some having sustained minor injuries due to drunken fights. Angle said her father was quite sympathetic to those who had little means to pay, so he often received vegetables, canned goods, chickens and other items in lieu of monetary payment. (Sue Angle died in 2015.) Tinsley, a native of the Hales Ford section of Franklin County, was the eldest son of Joseph and Miranda Tinsley. Born in 1868, Tinsley studied medicine and surgery at the College of Physicians and Surgeons in Baltimore, graduating in 1897. He began his medical practice on Bent Mountain in September of that year.

Tinsley rode horseback to see patients in his early practice, which extended some dozen miles in circumference around his residence. Tinsley was also an orchardist and had varied business interests, necessitating him owning one of the first automobiles on the mountain. In 1907, the first automobile to appear on Bent Mountain was driven by Robert Angell of Roanoke, who drove to lunch with Tinsley. Awed by the machine, Tinsley bought one shortly thereafter.

Genevieve Henderson shares a humorous story passed through her family about Tinsley. "My aunt always laughed about the time Dr. Tinsley had been called to their home to deliver a new baby and it was going to take longer than they thought at first. Dr. Tinsley decided to take a nap while he waited. Aunt Ocie was just a few years old, and she awoke to find Dr. Tinsley sleeping in her bed."

Lois Reed Overstreet recalls that her parents told her Tinsley delivered her when she was born in the family home at Bent Mountain in 1926. Tinsley charged her parents twenty-five dollars for his services that day.

Dr. Edward Tinsley, circa 1900. Tinsley made rounds on horseback during the early years of his Bent Mountain medical practice, which spanned five decades. *Courtesy of Roanoke County Public Library.*

Tinsley died on May 7, 1936, and was interred two days later at Evergreen Cemetery in Roanoke. His home and attached office were razed several years ago.

Following Dr. Tinsley's death, other doctors came to Bent Mountain but stayed only a short time. The first of the successors was a Dr. Hurt, who arrived on April 3, 1937. He rented a home and office from Colonel C.F. Holt, who ran a general store. Dr. Hurt moved to Staunton, Virginia, on March 1, 1938, and he later moved to Vinton, where he had an office on Pollard Street. Hurt was followed by a Dr. Cane, who came to Bent Mountain three days later on March 4, 1938. Cane completed the calendar year and was succeeded by a Dr. Speed, who arrived on January 1, 1940. After several months, Speed moved and was followed by Dr. A.K. Turner. The arrivals and departures of these physicians were noted in Holt family records.

In the 1920s and '30s, two midwives served the black community in the Bent Mountain area, Nancy Paige and Nellie Grogan. Mrs. Marie Brown, granddaughter of Nancy Paige and great-niece of Nellie Grogan, shared much information with me about these ladies. Paige had thirteen children of her own and, according to Brown, chewed tobacco, sewed and cooked. Self-

Home of Dr. Tinsley, circa 1940. Sunny Side was located on present-day Tinsley Lane. The white enclosure at the right porch corner was Tinsley's medical office. *Courtesy of Dana DeWitt.*

taught as a midwife, Paige helped birth numerous children, including those in white families who could not afford a doctor. Following Paige's death in the mid-1930s, Grogan assumed the duties of being a midwife. Brown recalled that when a woman would begin her labor, word would be sent "someone go tell Aunt Nellie!" Grogan's services as a midwife continued until most black families began using the services of Burrell Memorial Hospital in Roanoke.

Beginning in 1940 and through 1956, Dr. Algernon Keeling Turner served the Bent Mountain and Back Creek sections. He established the Turner Clinic at the old Back Creek School (presently 6874 Landmark Circle) once the building had been vacated for educational purposes with the opening of the Back Creek Elementary School. Turner was a general practitioner. When he delivered babies, mothers were often welcome to convalesce at his clinic for a few days before returning home. Turner's wife, Sylvia, was his nurse along with a Mrs. Tayloe. In his early years of practice, Turner had a location to receive patients on Bent Mountain. It is uncertain if he continued to have an office on Bent Mountain after he opened the Turner Clinic.

Turner's practice on Bent Mountain formally began on September 1, 1940. He was associated with Gingrich's Hospital in Fredericksburg, Pennsylvania. On May 14, 1940, he wrote a letter to C. Fletcher Holt, a merchant at Bent

Mountain. "I have decided to locate at Bent Mountain but it will be at least June 15th before I can get there. In fact, it may be a few days later as I want to get my equipment together. I have already made arrangements for my stock of medicine." The letter went on to say that he desired to board with the Holts until his wife could join him later that summer and that there was not a need for Holt to set out a garden for him, as he would be arriving too late in the summer. A few days later, Holt responded by letter to Turner. "We are glad to know you are coming to Bent Mountain to be our doctor." Holt stated he would rent a home to Turner and his wife for twenty dollars per month and that the doctor could take meals with Holt and his wife until Turner's wife could join him.

Ralph Henry recalled that as a boy Turner was called to his home to remove Henry's tonsils. "He laid me out on the kitchen table and just took 'em out!" Turner retired from practice in 1956; his practice and clinic were assumed by Dr. John Jeremiah, a native of Wales. Turner died not long after his retirement, passing away on January 23, 1957, at the age of fifty. He was interred the following day in Evergreen Cemetery in Roanoke.

Like his predecessor, Jeremiah delivered babies, performed minor surgeries and treated ailments and illnesses. Jeremiah kept a few convalescent beds at the clinic. He resided in the Poages Mill section for many years and was later affiliated with Lewis-Gale Hospital. Many of his patients followed him to his new office.

Before the old Turner Clinic closed (it was last called Back Creek Clinic), there was the practice of Dr. Charles Swecker. He had two offices, one at the Back Creek Clinic and the other on Brambleton Avenue near the Brandon Avenue intersection. Swecker passed away in 1998.

Dr. Sam Smith began his general practice in the Back Creek area in the late 1960s. Drafted during the Vietnam War following his Harvard Medical School education, Smith was sent to the army induction center in Roanoke on Jefferson Street. This assignment interrupted his pediatric residency. Smith came to love southwest Virginia and chose to remain in the region following the Vietnam conflict. He established his practice on Bent Mountain Road in a former apple shed on the homesite of the late Ada Webster. According to his colleague, Dr. Kevin Kelleher, Smith liked to play the guitar and would do so with his feet on his desk while patients took time in the restroom to provide specimens. In the early 1980s, Lewis-Gale Clinic contracted with and built Smith a new office (7119 Bent Mountain Road) across from the present-day Back Creek Elementary School on land acquired from the Rierson family, whose farmhouse and barn were located

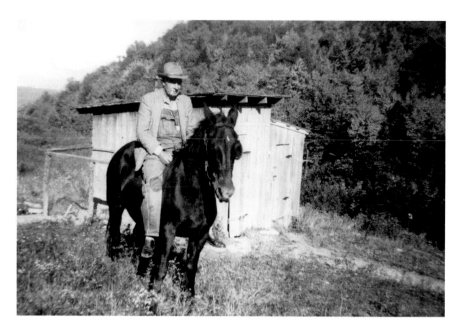

John Philip Austin, 1958. Austin lived across from Mount Union Church and was the first person to have heart bypass at Roanoke Memorial Hospital. *Courtesy of Sheri Poff.*

behind the medical clinic. Smith was later joined there by Kelleher in 1984. Kelleher described Smith: "Sam would see patients with rolled up sleeves and suspenders, but always wore a tie. I did almost all the surgery for the office since he said 'cutting and sewing made him sweat.' Sam would often wear cowboy boots and had an antique rifle in his office. He was attended by his nurse Betty Helvey for over 30 years. She lives in the Haran area of Back Creek and was [as] beloved as Dr. Smith."

Smith retired due to health concerns in 2000, and Kelleher briefly left Back Creek to comply with contract obligations, only to return and build a clinic across from the Cave Spring Middle School. Kelleher practiced at the Back Creek location from July 1984 until 2000 and then opened his Cave Spring Family Practice on October 12, 2001, where he remains to this day. The land for the clinic had been originally slated for a convenience store, much to the angst of nearby residents, as it was across from the middle school. "The land owner was glad to have me anchor a professional office there after the bad publicity," writes Kelleher.

Following Smith and Kelleher at the Back Creek Clinic were three physicians and a nurse practitioner. However, none stayed long, and the clinic finally closed in 2006. Dr. Ella Youngblood was one of the last

physicians to practice in the clinic across from Back Creek Elementary School, and she later joined Kelleher at the new Cave Spring Family Practice as his first associate. The building at the Back Creek Clinic was sold to a property management company in Dallas, Texas, and remained empty for a few years. The building was then occupied by Dalton Heating and Air Conditioning and is at present. Youngblood later joined her practice to that of Dr. "Chuck" Ball on Colonial Avenue at Ogden Road.

Two other physicians who have served the Back Creek section include Dr. Luther Lowe and Dr. Homer Bartley. Lowe's office was located on Brambleton Avenue near the Coffee Pot restaurant. He was a sole practitioner who, with his wife, operated the clinic from 1936 until the 1980s and wore the "Casey shirt"—short sleeves with a high collar. It was said he treated firefighters for free, and he was known for his sharp mind at many Grand Rounds. He founded the Third Street Coffee House, where he often played the piano and had the notable habit of drinking a glass of wine at five o'clock, often with his last patient of the day. Next to the office was a small apartment that he occasionally opened to families down on their luck. Bartley's office was near the Cave Spring Middle School.

THE GROWING POPULATION OF the Back Creek section required improved fire and rescue service. Prior to the establishment of rescue squads and fire stations in the section, residents were served by the volunteer fire station on Williamson Road, with a response time that could take up to thirty minutes.

Roanoke County Board of Supervisors member for the Cave Spring district Luther Bell proposed the establishment of a volunteer fire station for the section in 1941. The following year, local business owners J.W. Griggs and W.H. Witt were appointed to serve as chief and assistant chief, respectively, of the Cave Spring Volunteer Fire Department No. 3. Griggs owned a service station at the southwest corner of View Avenue and Brambleton Avenue, and the station was located adjacent to Griggs's business. A two-story, cinderblock building was erected with two bays and meeting space in 1942. The department started with fifteen volunteers, a donated 1939 Dodge dump truck that had been converted to a pumper and a coverage area that encompassed two thousand residences.

By 1949, Griggs had sold his service station and became the first full-time volunteer fire chief for the station. According to county records, 90 percent of the volunteers lived within a one-mile radius of the station. The first man to arrive at the station responding to the alarm earned the driver's seat in

the fire truck. Griggs remained as chief until his retirement in 1968. He was followed by Isaac "Ike" Sutphin, who had helped start the Cave Spring Rescue Squad in 1958. Over the next several years, new equipment and vehicles were added to the station.

By 1970, the number of residences in the service area had doubled, necessitating a newer, larger facility for the fire station. That year, Roanoke County erected a new, $90,000 station at the present-day location of the Cave Spring Fire Department on Old Cave Spring Road. The station, with a fully equipped kitchen and bunk room, accommodated twenty-seven volunteers. The first paid staff arrived in 1971. Over the next two decades, the station received upgrades and additional bays. The station was built on land donated for that purpose by Sutphin, who had a business adjacent to the property where he built, repaired and restored furniture.

Sutphin retired as chief in 1976 and was succeeded by Don Gillespie, who remained as chief until he retired in 1990. He was followed by David Kilbane and John King. Kilbane retired in 2009, and Robert Perdue became chief and is in that position at present.

The Cave Spring Rescue Squad was formally constituted on April 24, 1958, when thirteen members were sworn in as charter members. They ran their first call on May 3. The establishment of the squad was the result of efforts led by Robert Monahan and Roanoke County civil defense coordinator Treadway Coleman. Calls for service were routed to Monahan's residence.

The crew used a 1951 Cadillac ambulance from the U.S. Army and formed a "Junior Crew" in 1964. The crew's first rescue squad building was at 3916 Brambleton Avenue. By 1974, the "lil cadi" ambulance was retired and the squad obtained two custom Dodge vans to serve as ambulances. The squad obtained the "jaws of life" hydraulic rescue tool in 1973 and became one of the first crews in the county to provide advanced life-support emergency care. In 1990, the squad began requiring overnight shifts, decreasing the average response time from six to two minutes.

With the rapid growth of southwest Roanoke County in the 1950s, residents of Bent Mountain organized to create a volunteer fire department. There had been several house fires in the community, and the response times from the Cave Spring station up the mountain were too long.

Clinton Poff, owner of Poff's Garage, assumed the role of the department's first chief. He retrofitted a 1950 three-quarter-ton GMC pickup to have dual rear wheels and a three-hundred-gallon water tank with a Hale portable pump to serve as the department's fire truck. Community members held

fundraisers and provided free labor to construct the department's first station, a two-bay cinderblock facility on land donated by volunteer member Allen Stone. Stone operated a gas station on the property.

Calls for service went to Poff's Garage until the mid-1970s. Poff would rush to the emergency vehicles as Maude Poff quickly phoned the volunteers using a phone-tree approach. Typically, volunteers would alert Mrs. Poff if they were going to be unavailable in advance. There was a Sunday duty team, and this was the only time the Poffs were relieved of the alert responsibilities.

The original station location was used until 1980, when the department was moved to the present-day site. Bent Mountain Volunteer Fire Department No. 8 has used a variety of donated vehicles over the course of its history, including a GMC "egg truck" given by the Coles Egg Farm and equipped with an Oren body. In 1977, the department received a Hahn pumper-tanker purchased by Roanoke County. It could pump one thousand gallons of water per minute. It remained in service until 2000. Today, the station continues to have volunteers supplemented by paid staff during the day.

The latest fire and rescue squad is the Back Creek Volunteer Fire and Rescue Department No. 11, organized in 1987. This department was largely the result of the efforts of the Back Creek Civic League, the Back Creek Extension Homemakers' Club and residents Charlie Lavinder, Bill Joyce and Roger Vest. Several house fires and emergency calls in which long response times contributed to a loss of property and, in one case, a life, created a sense of urgency. By the winter of 1987, sufficient numbers of volunteers had enlisted to receive training and certification that county officials supported the initiative.

In December 1989, the Back Creek Station was completed at its present site and staffed with volunteers, equipment, a Seagrave fire pumper, a brush truck and an advanced life support–equipped ambulance. Lynn Thomas was elected as the department's first volunteer chief, serving in this role until his retirement in 2001. Today, the station has both volunteers and paid staff.

The station was erected on the former Rierson farm across from Back Creek Elementary School. Where the station is located was the Rierson's barn. Dr. Kevin Kelleher recalled that the volunteer firefighters torched the barn for firefighting practice to make way for the station.

Before the barn was burned down, a friend and myself were allowed to scavenge some of the stall wood for projects and it was there that we met Ike Sutphin....He ended up mostly helping us and telling stories, though he did get a couple thicker beams for his woodworking....While

we rummaged wood in the old barn, we ran into a hornets' nest, which Ike, unconcerned, disposed of by crushing between his leather-gloved hands while my friend and I ran for cover. He had many stories of the early days of the [Cave Spring] rescue squad including mountain top rescues and improvised treatments, yet none impressed us as much as the handling of the hornets' nest.

EDUCATION

The first documented school in the Back Creek section comes from a deed recorded in 1842, in which two acres are set aside for establishing a schoolhouse on land adjoining that of Henry Wingart, David Willett and William Ferguson. The parcel was purchased from David Ferguson for $150 and recorded on February 2. Based on information in the deed, Wingart, Ferguson and David Willett were acting as the school's trustees, "unto the said Wingart, Willett, and Ferguson one small lot of land containing 2 acres which he, the said Willett, has laid off for a school house." While it is difficult to determine where, specifically, in the Back Creek section this two-acre parcel would have been, it may have been in the Haran section, as the Willetts and Fergusons were neighbors there at the time of the deed.

A second known schoolhouse in the Back Creek section appeared on two maps produced in the mid-1860s. Both maps show a schoolhouse located near Poages Mill. Other than a simple identification—"school house"—nothing more is known. This may be the same schoolhouse later identified in the early 1870s as School No. 6 in the Cave Spring school district.

In 1870, the Virginia legislature established a system of public education. Prior to that, education was a matter of family means through attending private academies or home schooling. Often, clergy would teach classes for youngsters, but no formal system of public education existed. The Roanoke County school system began on September 9, 1870, with the appointment of a superintendent of public education and the formation of school districts within the county several weeks later.

Southwest Roanoke County was in the Cave Spring School District, and each district was overseen by a district school board that made teacher appointments and provided limited funds. The Cave Spring School Board was established on November 5, 1870, and the members were Jordan Woodrum (chairman), James Watts (clerk) and T.M. Starkey. The Cave Spring School District had a large footprint, consisting of the present-day sections of Red Hill, Garst Mill, Windsor Hills, Oak Grove, Starkey, Cave Spring, Poage's Mill and Bent Mountain.

A school could be established by citizens and recognized within the district if it met certain requirements. There must be a schoolhouse with "all the necessary furniture"; the school must admit all children of a proper age in the vicinity such that enrollment would be at least twenty students and the school session would last five months; the school must employ a teacher with a certificate of qualification recognized by the Roanoke County school superintendent and duly appointed by the district's trustees; the community must have raised an amount to pay at least one-third of the teacher's salary; school must begin before March 1 and end prior to September 1; and the school must be willing to be regulated by the laws of public education. If a proposed school could meet these criteria, then the school district's trustees could formally recognize and financially assist the school by providing funds for the teachers' employment.

The typical schoolhouse in Roanoke County in the early 1870s consisted of an average enrollment of forty-eight students, an average daily attendance of twenty-five students, one teacher and one room. There were few exceptions. Teacher salaries were $30.00 per month for men and $26.83 for women. During this period, half of Roanoke County's population was illiterate.

In 1871, school trustees adopted four basic textbooks to be used, and these provided the basis for the education children received for the next two decades, given there were few other resources available to teachers. The books were *Holmes Readers and Spellers*, *Maury's Geography*, *Davies Arithmetic* and *Harvey's Grammar*. In 1872, the school board adopted a countywide property tax of $0.07.5 per $100.00 value assessment to provide funds for teacher salaries and school construction. Interestingly, in the Cave Spring district, an additional tax was levied: a dog tax of $0.75. According to records, the dog tax in Cave Spring raised almost as much as the property tax!

In 1872, a census showed that the Cave Spring School District consisted of 570 white school-age children and 147 black school-age children, for a

total of 717. This did not mean, however, that all children who were enrolled attended school, as public education was not compulsory.

For the 1872 and 1873 school years, the Cave Spring School District had ten recognized schools: School 1 (Cave Spring, A.M. Jordan was teacher), School 2 (unnamed, Henry Cline was teacher), School 3 (Cave Spring, colored, I.K. Plato was teacher), School 4 (Pine Grove, Charles Cline was teacher), School 5 (near Poage's Mill, M.A. Cauthorn was teacher), School 6 (Poage's Mill, John Turner was teacher), School 7 (Bent Mountain, near King's, John P. Haislep was teacher), School 8 (Bent Mountain, Tazewell Price was teacher), School 9 (Red Hill, Dudley Powers was teacher) and School 10 (Dangerfield, W.A. Henderson was teacher). During the next two decades, these one-room schoolhouses would open and close, depending on enrollments and attendance.

From the 1870s through the early 1920s, the Cave Spring School District had numerous schools. But the records of the district are missing for some years and incomplete for others, making a comprehensive history of education at this time difficult. Thus, we must turn to other, more informal resources to piece together school histories during this time. The focus will be on those schools in the regions that are the subject of this book.

The African Church School served the black population in and around Bent Mountain from 1875 to 1884, being formally known as School No. 14. Its specific location is unknown.

Air Point School (School No. 21) was located at the top of Bent Mountain and operated from 1883 to 1915. A small one-room school building was constructed in 1899 to probably replace an earlier log one.

Back Creek School (School No. 9) began in 1912 when a lot was purchased from Daniel Kittinger and a three-room structure was built for $3,200. During its first year, it had an enrollment of eighty-two students. An auditorium was added in 1927. The school grew such that a principal, Ann Hogan, was appointed in 1931. This school closed in 1937, when the "new" Back Creek Elementary School was built (the present-day BCES) and lower grades went to the new school and upper grades attended Andrew Lewis High School in Salem. When the school closed, the building was used by Dr. A.K. Turner for his medical practice in the community. The building today is a residence, 6874 Landmark Circle.

Bell's School (School No. 20), also known as Huff's School, operated from 1899 to 1906.

Bent Mountain/Mountain Top School was for black schoolchildren and existed from 1874 to 1957. In 1909, the county school superintendent

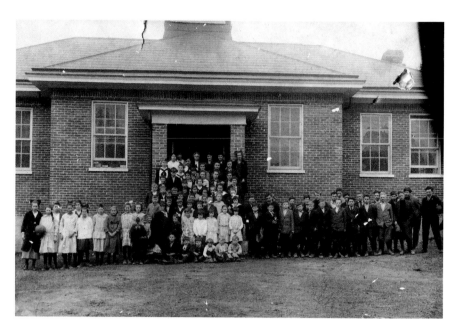

Back Creek School, faculty and students, 1917. The original school was constructed in 1912 and closed in 1937. It served children from elementary through high school. *Courtesy of Molly Koon.*

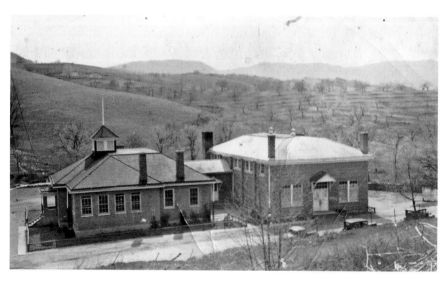

Back Creek School, circa 1930s. Back Creek School is shown here with the original portion (*left*) and the 1927 auditorium addition. *Courtesy of Genevieve Henderson.*

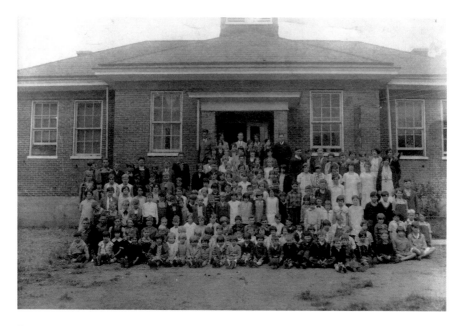

Back Creek School faculty and students, 1929. After the school closed, it was converted to a medical clinic operated by Dr. A.K. Turner. *Courtesy of Molly Koon.*

was petitioned to find a suitable teacher for the school, and Major Frogg was appointed. He served the school for twenty years. He was known for the sign in his classroom that read, "Do you know, or do you think you know?" Referred to initially as School No. 12, the original building was a one-room structure that served the community until 1929, when it was replaced with a larger, multi-room schoolhouse that then became known officially as Mountain Top School. Mountain Top was on land sold to the school board by E.O. Tinsley. Marie Brown shared with me about being a student at the original school. "It had one big room and one small room, and one teacher." According to Brown, students went to the school through the seventh grade. After that, those who continued their educations went either to Lucy Addison High School in Roanoke or to Salem, usually depending on where there were relatives with whom they could board. Mountain Top was constructed using an interesting array of funds. The total cost for the school was $2,963, of which $2,513 was provided by Roanoke County; $250 was raised from within the Bent Mountain community; and the final $200 came from the Rosenwald Fund. The fund was established by the president of Sears, Roebuck & Company as a result of his friendship with Booker T. Washington. Julius Rosenwald became convinced that educating

black children was a critical social and economic cause for the nation, so he provided a fund that made substantial donations to constructing such schools. Mountain Top was one of three "Rosenwald Schools" in Roanoke County. The other two were located in the Hanging Rock and Catawba sections. Water for the school came from a five-foot pipe at the Briggs home across the road, and one washbasin served the entire school. A girls' outhouse was located behind the school, and the boys' was located in front. The school closed in 1957, and upper-grade students were transferred to Carver High School in Salem. After the school closed, it was purchased by the Paige family; for several years, the stage and large blackboard remained in the Paige residence. The school remains as a private residence at 10118 Sling Gap Road.

Bent Mountain School (white) began as School No. 8. The first known Bent Mountain school building was a one-room schoolhouse erected in 1889 for $200, though an earlier school may have existed beginning in 1872. The 1889 schoolhouse was located along what is now Route 221 between present-day Ivy Ridge Road and Old Shilling Road near 10314 Bent Mountain Road. This school was eventually closed due to a new three-room school being built in 1915 at a cost of $40,000 on the present site of what is now the Bent Mountain Community Center. The school expanded with a "new" seven-room brick schoolhouse that was constructed in 1930 for $33,071. That year, sixty-eight students enrolled. The three-room school, however, was used for various purposes even after the brick school had been constructed.

In the early 1940s, the largest of the rooms of the old school was used as a cafeteria. Parents and their children brought food, and the value of what they brought was deducted from the student's lunch fee. Genevieve Henderson, who attended first grade at Bent Mountain in 1941, recalled, "We ate lots of vegetable soup, tomatoes, beans, potatoes, cornbread, cabbage, turnips and apples…things that farmers grew on Bent Mountain. I remember carrying a Karo syrup bucket of milk a few times, with a value of twenty-five cents, which bought my lunch for a full week. The cafeteria closed that year when our last lunch consisted of turnips and oatmeal— guess they had run out of food to cook!" According to Henderson, the school principal and his wife, G.O. and Ann Hogan McGhee, and his mother lived in the other rooms of the building. Once the cafeteria closed, the old school was used as classroom space for high school students; by the late 1940s, the rooms reverted to a cafeteria and school library. The old school was razed in 1989, when the library addition was built. Bent Mountain

Bent Mountain School, circa 1980s. This image shows the school that was built in 1915 and then razed in 1989 for the library addition, having served many purposes. *Courtesy of Dana DeWitt.*

School served both lower and upper grades for over two decades, before the high school component ended in June 1956. After this, upper grades were sent to Cave Spring High School. Seventh-graders began attending Back Creek School in 1967. Ultimately, declining enrollment and fiscal concerns prompted the county school board to close Bent Mountain Elementary School in 2011, and it became a community center.

Bottom Creek School was in the Bent Mountain area and existed from 1892 to 1929. From 1892 to 1914, it was a one-room schoolhouse, but in 1915, a new two-room school was built. According to board records, the school was located on "the west side of road leading from Roanoke to Franklin Court House." It was started due to the efforts of Thomas King, who petitioned for a school in that area. King and his brothers were contracted to build a two-room school for $1,000. Two new wood stoves were shipped to Shawsville to be delivered to the school. New desks were also provided, with one room having small desks and the other large ones. The contract for the school's construction was quite detailed and provides a rare glimpse into how such schools may have looked. The blueprint specified that door locks cost no less than $2 and that three coats of silver-gray Devoe or better paint

May court at Bent Mountain School, 1945. May Days with maypole dances and a May court were popular school activities generations ago. *Courtesy of Dana DeWitt.*

Marble players, Bent Mountain School, 1945. *Left to right*: Hilton King, Herbert Craighead, Namon Conner, Arnold Mills, Melvin Manning, Harold Thompson and Fletcher Wimmer. *Courtesy of Dana DeWitt.*

be used on the interior. A nearby spring provided water, and there were two outhouses. The school was destroyed by fire on January 22, 1929, and the students were sent to Bent Mountain School. Bottom Creek School never reopened. The lot was sold by the county school board in 1931. A somewhat humorous story is told about the King family's "ownership" of the property. Apparently, there was no record of the property on which the school was located ever being formally transferred to the county school board, yet after the school closed, the county approached the Kings about buying back the property. They had been paying taxes on it for years, so they bought back property that was really theirs anyway!

Cave Spring School (School No. 3) was for black children and was open from 1873 to 1884. Its location is unknown.

Cave Spring School (white) was School No. 2 and operated from 1872 to 1925. The original log building was erected in 1856, though the first record of the structure's use as a school was in 1872. It was a two-room schoolhouse and was destroyed by fire in 1925. The lot was sold by the school board in 1927. Its specific location is unknown.

Cotton Hill School, located along Cotton Hill Road, operated from 1884 to 1894. When it closed in 1894, students were sent to the "new" Diamond Hill School.

Bent Mountain School, circa 1950s. The school shown here was originally built in 1930, had a high school component until 1956 and closed in 2011. *Courtesy of Roanoke County.*

Diamond Hill School (1894–1915) was formally known as School No. 16. After the school closed, the building went through a variety of uses before it was sold at auction to Joseph Starkey in 1939 and "presented to the colored people of the community for a church building," according to school board records.

Farland School was in the Starkey section and served black students from 1910 to 1936. The school closed when it was acquired by the state highway department and soon thereafter razed as part of a road project.

Ferguson's School (School No. 5) existed from 1872 to 1915. It was located on what was once called Christley Road but is now known as Mount Chestnut Road. It was also called the "Jim Ferguson School" and located near the Bohon family home place.

Grisso-Gates School (School No. 12) was open from 1884 to 1927 and was located on South Roselawn Road on land donated by William Grisso and a Mr. Gates. One family's history provides an interesting anecdote about one of the school's teachers, Christian Eller. He had attended one year at Bridgewater College and earned his teaching certificate. His first school was Grisso-Gates. A seventh-grade student there was Rebecca Henry. Eller taught at Grisso-Gates for some years and, upon Miss Henry's graduation, he began to court her. Eventually, the two were married in 1896 and moved to Sugar Loaf Mountain, where they farmed and raised ten children. Eller continued to teach, moving to the Oak Grove School, and was instrumental in starting the Oak Grove (Brethren) Church. Before it closed in 1927, there was an effort by parents and other citizens to keep the school open, but the school board closed it and transferred students to Mount Vernon School, which had opened in 1926. Mount Vernon School, located on Brambleton Avenue, was closed in 1981 and is currently the Brambleton Center.

Haran School (School No. 6) was located on the south side of Route 221 near the intersection at Martins Creek Road. The school operated from 1872 to 1928. Initially, the school had been referred to as the "Dink Ferguson School," as it was located on Ferguson's property. Haran School was three different buildings. The first was a log structure (probably called the Ferguson School); then, in 1885, a two-room schoolhouse was built on the same site and later converted to one room in 1918. The effort to erect a new school began in the fall of 1921 through fundraising efforts of the Haran School's community league. In January 1922, the county school board purchased an adjoining lot to the existing schoolhouse property from N.C. and Flora Powell for $5, and it was on this lot that the "new" Haran schoolhouse was erected in 1922. When the school closed in 1928, students

Grisso Gates School, 2017. The schoolhouse is currently a storage building for the residence at 5321 South Roselawn Road. *Author's collection.*

went to the Back Creek School. The school board sold the Haran School and land at an auction in 1929 for $750. The Haran Schoolhouse still stands as a private residence, 7910 Bent Mountain Road. The current owners, the Richards family, have been of great help to me. The "front" of the old school is now the side of the residence that faces Back Creek. Prior to the development of Route 221, the old road ran between the schoolhouse and the creek.

Lamar Martin in an interview in the 1990s talked about his days at Haran School between 1911 and 1918. He said the school was a two-room schoolhouse that went from grades one through seven. From the school went a swinging bridge that went across the creek to John Ferguson's home. (Route 221 had not been constructed.) Martin would be sent across that bridge to fetch water for the school. One of the Ferguson women would insist that the student come in and get some apples before he or she left, as the Fergusons had a large orchard behind the home. After the seventh grade, Martin said that one would ride a horse to get to the Back Creek High School if they continued their education.

King's School (School No. 9), sometimes known as Logan's School, was in the Bent Mountain area and existed from 1872 to 1910. It was "near King's on Bent Mountain," according to school records. When the school closed,

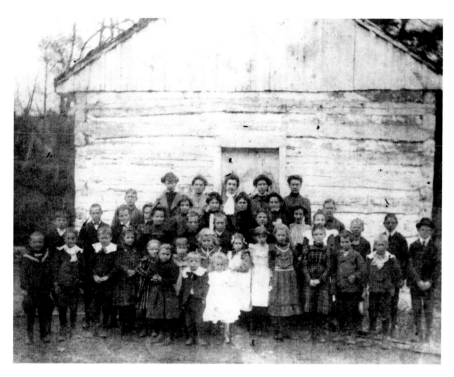

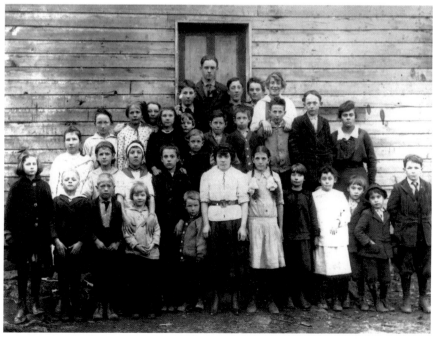

Above: Former Haran School, circa 1980s. The schoolhouse built in 1922 was used until 1928, became a store and then a residence, as it is today. *Courtesy of Lou Emma Richards.*

Opposite, top: Haran School, circa 1880s. This image is believed to show the original 1870s-era log schoolhouse that was replaced in 1885. *Courtesy of the Back Creek Civic League.*

Opposite, bottom: Haran School, 1917. The teacher poses with her students in front of the school built in 1885 that faced Back Creek. The schoolhouse was replaced in 1922. *Author's collection.*

students were transferred to Bottom Creek School. The location of King's School was near present-day 10939 Bottom Creek Road.

Mountain View School was located in the Back Creek section. A note in an 1882 edition of the *Salem Times Register* listed the teacher as J.O. Ronk. Apparently, Ronk conducted weekly debates and spelling matches that attracted numerous students and residents. According to school board records, Mountain View was opened intermittently between 1883 and 1910. Mountain View was the home of Daniel Kittinger, who purchased the property from a Mr. G. Ferguson. The school was in the lower part of the home, having an earthen floor and wood walls. Daniel Kittinger's daughter, Molly, was a teacher at the school for a period of time before she died at an

early age. Interestingly, the Kittingers used their home as a boardinghouse for teachers, most of whom taught at Back Creek High School. Claude Kittinger recalls that his grandmother had such a hard time cooking for her large family and the boarders that a large log was used to feed the cook stove. The log would be stuck through a window and into the stove.

Pine Hill School was located on Twelve O'Clock Knob Road, directly across from Wade Road. The dates of its operation are unknown.

Poage's Mill School (School No. 11) operated from 1883 to 1892, and its location is unknown.

Price School (School No. 7) was located on Bent Mountain. The school (1888–1894) was located on land owned by Tazwell Price and Warfield Price, probably near the Floyd County line. The Prices owned vast amounts of land, and they sold one acre to be used for a school. The location of the school is thought to have been near present-day 10721 Bent Mountain Road.

Rowland (or Roland) School (School No. 17) was in the Back Creek section and opened in 1892 and closed in 1927. This was the "Rowland Ferguson School" but is usually referred to as "Rowland's School" in records, probably to avoid confusion. The school was located on the farm of Rowland Ferguson (the farm was later owned by the Tudor family) on Twelve O'Clock Knob Road. The farmland has since been subdivided. After the school closed, the Ferguson Orchard Company bought the building and lot in 1928 for $115. A humorous story was shared by the late Charlie Lavinder, as told to him by his father, Wiley Lavinder, who was raised near the school. A hound dog hung around the schoolhouse and would come into the building and sleep behind the wood stove during the day. One day, the boys decided to slip a rabbit into the building to see what the dog would do. As class began, a boy took the rabbit from his coat pocket and placed it on the wooden floor. The sleeping dog came alive, barking and searching for the rabbit. Desks and chairs went flying, students dove out of the way and the schoolroom became a total mess, with overturned desks and chairs, books and papers scattered everywhere.

Starkey School (School No. 16) was open from 1895 to 1961. The original schoolhouse was built in 1895 and was a white clapboard A-frame structure housing six grades with one teacher. It was located near the present-day intersection of Merriman Road and Penwood Drive. After two decades, the building was deemed to be in "very poor" condition; the teacher reported that heat was provided by a coal stove and light came only from the windows, some with panes missing. "It is impossible to keep the

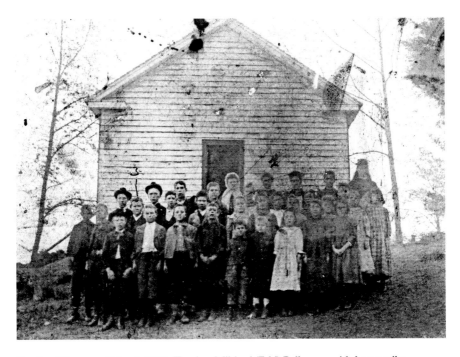

Rowland Ferguson School, 1894. Teacher Mildred (Edd) Bell poses with her pupils; identified are Ocie (1), Icie (2) and Jim (3) Ferguson. *Courtesy of the Back Creek Civic League.*

children comfortable," the teacher, Grace Terry, wrote. The school board replaced School No. 16 with a two-room brick school in 1915 at a cost of $4,000. It was serving fifty students with two teachers at that time. Two wings were added to the school in 1928. In 1949, a brick infill section along the façade between the wings was completed. When the school closed in 1961, students were transferred to Ogden School. The school was used from 1962 through the early 1980s as a senior citizen center. The school was sold by the county in 1986, is adjacent to the Penn Forest Elementary School property and is currently used as a warehouse.

Watts School (School No. 18) existed from 1884 until 1925, though it may have been closed between 1912 and 1915. The school was located on Sugar Camp Road on the farm of Joe Bohon. Students would transfer to Bent Mountain School for upper grades. The school is believed to have been located near present-day 10569 Sugar Camp Creek Road. A small notice appeared in the *Roanoke World News* on January 19, 1921, describing the school. "There is a little school up on Bent Mountain that is known as Watts School. It is a one-room school in a more or less isolated

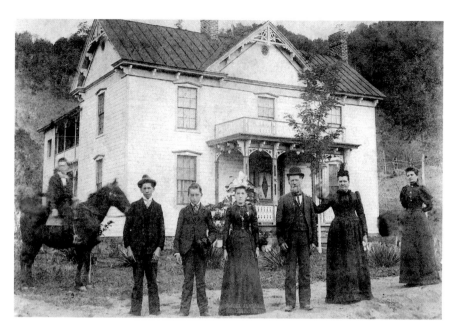

Rowland Ferguson and family, circa 1905. Ferguson (*third from right*) had a schoolhouse on his farm. The house still remains at 5109 Twelve O'Clock Knob Road. *Courtesy of Lorie Murray.*

Starkey School, circa 1980s. The brick school was built in 1915, with additions in 1928 and 1949. It closed as a school in 1961. *Courtesy of Roanoke County.*

neighborhood, and where the children must trudge through snow and ice over a mountain road to get there. Yet that little school, one day last week, when visited by the supervisor, showed an attendance of 35 percent. Miss Alice Muse is the teacher."

Wertz School (School No. 11) opened in 1872 and closed in 1912. This school was located on the Wertz farm on what is now the Poage Valley Road Extension, on the left just before the intersection with Dawnwood Road.

Woodland School (School No. 11, noting the closure of the above school) served students from 1915 to 1925 and was located near "the head waters of Bottom Creek." An interesting notice ran in the March 14, 1921 *Roanoke World News*: "Patrons of Woodland School on Bent Mountain, which was closed some weeks since, because of lack of attendance, are requesting that the school be reopened. The patronage claims that at least 22 students are now pledged up to attend. The school will probably be opened in the near future with Miss Mary Grisso again installed as teacher." After the school closed, the school board sold the lot and schoolhouse in 1927. The first location for the school may have been on land owned by J.B. Willett Jr., as he sold some land for $15 for a school in 1889. The students attending that school made a path through Willett's property that can still be seen and is referred to as School House Road. When the first school was abandoned, local boys used the building to change into their swim trunks before taking a swim in the creek after working in the fields during the summer. The school was apparently relocated in 1915, as the Ferguson family sold the county school board 1.3 acres for a school house that year. When the school closed, the students were transferred to Bent Mountain School, and the school was sold for $225. Based on recollections of older residents, the first school is believed to have been located near 8550 Willett Lane and the second at or near 8305 Poor Mountain Road.

In addition to the schools just named, there were other schools just across the Roanoke County lines that also served students in the Bent Mountain area. There was Funk's School, located in Montgomery County at what is now the Nature Conservancy's Bottom Creek Gorge. The school was housed in the back room of the Funk family's "mansion house." A school was later built on the property. The school closed in 1937, and some of the students transferred to Bent Mountain School. The other school was the Baldwin School in Franklin County, named for Joseph Baldwin, who sold the land on which the school was built. The school, constructed for $800 in 1890 and closed in 1938, was located on Slings Gap Road just beyond the parkway. During the summers, a Brethren congregation used it for

worship. Another Franklin County school—the Adney Gap School—served some children from Bent Mountain. Apparently, there was an agreement among the counties to help educate children who lived near county lines and could attend a closer school outside their particular county of residence. Pippin Hill School was a small Presbyterian mission school just below the Adney Gap School. Miss Harriet Childrey of Richmond taught for many years there. The school had been founded by Dr. Samuel Guerrant, who financially supported the school during his lifetime and left a bequest in his will for the school. When the school closed, the students went to the Adney Gap School, though the building remained in use as a Presbyterian church.

It is hard to imagine what school was like in these one- and two-room houses with numerous students and one teacher. One of the teachers in the Poage's Mill section, Hezekiah Lavinder, stated that his pupils ranged in age from four to twenty-five. Lavinder taught school in the old log structure of Laurel Ridge Church and was teaching there in the 1880s. This may have been the Bell School, but that cannot be determined with certainty.

Around the turn of the century, Roanoke County began the process of consolidating schools for the purpose of improving education and added a

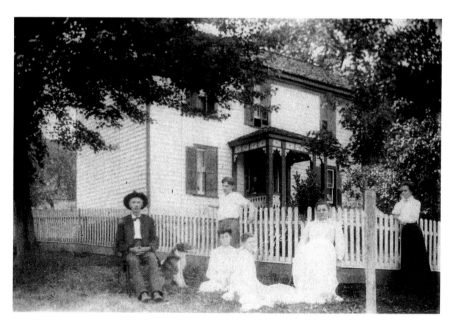

Hezekiah Lavinder and family, circa 1910. Lavinder (*far left*) was an early educator in Back Creek. His home still stands just right of the Bridlewood subdivision entrance. *Courtesy of Laurel Ridge Primitive Baptist Church.*

graded system for student advancement. In Salem, the first high school was created for the county. Teachers began to receive more training and pay.

A report appeared in the October 28, 1920 issue of the *Salem Times-Register and Sentinel* about a tour of the schools in the Back Creek section. The article, "District School Letter No. 5," was part of a series describing the needs of schools in Roanoke County in advance of a few ballot initiatives coming before voters regarding school funding. The portion of the column dedicated to Back Creek schools read as follows:

> *Wednesday morning we had a very pleasant visit at Grisso Gate. Miss Sydney Penn in charge. Several repairs are necessary if this school is to furnish a safe place for the young people there whom we found anxious to have a good year of work. Miss Penn will do her part and the community stands behind her to do theirs.*
>
> *A brisk walk from Grisso and we find ourselves at this two-room school [Cave Spring]. Here are two young, energetic teachers with an enrollment of forty-four. We do not hesitate to say that these boys and girls deserve a more attractive building. Built for a church, the edifice is not suitable for a schoolhouse and the light conditions are unfortunate. Perhaps before long the people will get together and work for a new building so that their children may have the same comfort that those at Deyerle and Oak Grove enjoy. The teachers, Misses Zirckle and Bradley, will help.*
>
> *Thursday we went to Haran. But our good friend of the U.S. Mail was so late that school had been dismissed before our arrival. We located the teacher, Miss Eugenia McCray, at the home of Mr. N.C. Powell and there we spent the night. Miss McCray is enthusiastic about her work and during the evening we discussed the wisdom of getting the people organized in a community league. Mr. and Mrs. Powell were quite as much interested as the teacher and by the fireside we planned to organize a league at the next visit of the Supervisor. Watch for details.*
>
> *An hour was spent at the school in the morning. It is surely a place where there is much need of improvement. But the very need is a challenge to the brave teacher who has purposed to make the session count for the good of the school and the community.*
>
> *It is a pity that any student should miss a day from [Back Creek High School] with a body of teachers as worthy and capable as are the teachers of this fine school. A considerable amount of time was spent here this morning observing the work. Several of the older pupils are still out but are expected in.*

Later that day, a meeting was convened of all the teachers in the Back Creek section. "Every teacher of this group was present. They are Misses McPherson, Via, Draper and Goode, of Back Creek; Miss McCray from Haran; Miss Penn of Grisso Gate; Miss Kessler from Roland Ferguson; and Misses Zirkle and Bradley from Cave Spring. The Supervisor taught classes in reading, English and number work." Other sessions were held and then the teachers organized themselves for "professional cooperation." This column, penned by George Jordan, rural school supervisor for Roanoke County, is helpful in indicating those small schools still functioning in 1920.

The effort to organize community leagues, as referenced in the article, was successful at some schools. Notices of league meetings appeared regularly in newspapers in the early 1920s. Community leagues active in southwest Roanoke County were associated with Haran, Back Creek, Bent Mountain, Bottom Creek, Roland Ferguson, Watts, Starkey, Cave Spring and Grisso-Gates Schools.

The Haran Community League was organized in December 1920 and met at Haran School for the general purpose of "community betterment." Mrs. Alphonso Martin was elected president, and other officers elected were Mrs. John Agee (vice-president), Sparrell Martin (secretary) and Mrs. Nathan Powell (treasurer). Those in attendance also selected committees to carry out the league's work. Committees organized included education, membership and program. The education committee was instructed to purchase wall lamps for the schoolhouse. Following a business session, the meeting moved to "songs and recitations." Lottie McPherson, principal of Back Creek High School, helped to organize the initial meeting. Others who agreed to lead the committee work were Tilden Martin, Joseph Grubb, Mrs. Harold Wright, Omer Simpson, Lucy Tinnell, Eugene McCray and Virginia McCray. The league also organized social events for their community, such as pie suppers and forms of entertainment. At one such gathering in February 1921, some 130 persons gathered at Haran School for music by local talent and an address by Roanoke County supervisor Jordan Woodrum on the subject of Abraham Lincoln. In April of that year, the Haran Community League presented a play, *The Old Hickory Schoolhouse*, a comedy, and in the late summer, the league hosted a lawn party at the school. One ambitious item on the league's agenda—and the main reason for its being organized— was a new schoolhouse. In June 1921, the league's treasury contained more than $250 toward a goal of $500, having secured a loan for $1,000 for the purpose of a new schoolhouse by that September. The *Roanoke World News*, in a brief piece about the league's meeting, observed, "A year ago, the Haran

school, sitting at a bend in the road up Back Creek way, was a disgrace to the neighborhood….There it stood, shabby, paintless, stepless, windowless, a pitiful blot on the beautiful landscape." By fall, Haran had its new school. How long the Haran Community League existed is unknown, but the league was quite active in the 1920s with an ambitious social and civic agenda.

The Grisso-Gates School's community league was started in February 1921. Officers elected at the inaugural meeting were Miss Lutie Bohon (president) Fred Grisso (vice-president) and James Bohon (secretary). Mrs. Ellis Grisso "conducted a short program of the pupils," according to the local newspaper report. Those in attendance were informed about the progress of the Haran School's community league and set about the work of organizing committees. Mrs. Ellis Grisso was appointed chairman of the program committee, J.L. Wertz, chairman of membership and John Henry Grisso, chairman of the building committee.

The next month, the community league voted to join the National Parent-Teacher Association and send delegates to the state PTA convention slated for April 1 at Lee Junior High School in Roanoke. Delegates elected were Miss Lutie Bohon, John Henry Grisso, O.L. Grisso and C.W. Graham.

By April 1920, the Back Creek Community League was holding monthly meetings at the Back Creek School. A notice in the March 22, 1922 edition of the *Roanoke World News* gave an indication of the league's activities and enthusiasm.

> *They had a most enjoyable time out at Ogden School Saturday night when members of the Back Creek Community League produced the comedy "A Poor Married Man." The players made a great hit, it being an all-star cast. Another enjoyable feature was the singing of a group of songs by Judge Woodrum's male quartet. The judge also addressed the company on the value of the work of the Parent-Teachers Association. Miss Gertrude Goade of Starkey gracefully presided at the piano. The audience included patrons of Back Creek, Ogden and Starkey Schools. Illumination by the Delco Lighting Company added much to the enjoyment of the occasion. Nearly $35 was netted by the entertainment.*

The Bent Mountain School's community league started in February 1921. The *Roanoke World News* reported the following in its February 26 edition: "Rural supervisor George A. Jordan organized a community league at the Bent Mountain school on Thursday night. The following officers were elected, Mrs. S.H. Willett, president; Windell Coles, vice-

president; Miss Amelia Harvey, secretary; Miss Evelyn Woodrum, treasurer. The following committees were appointed: School Committee, Mrs. E.O. Tinsley, chairman; Program Committee, Miss Katherine Coles, chairman; Membership Committee, Jasper Lancaster, chairman."

The Bottom Creek School's community league was organized in November 1922. An article in the *Roanoke World News* that month reported the election of the following as officers: T.J. King (president), Mrs. Eugene King (secretary) and Mr. Gearhart (treasurer). Later that same month, the league held a "box social."

Watts School's community league on Bent Mountain was organized in February 1921 by the school's teacher, Alice Muse. In March, the league held a pie supper that raised thirty-six dollars for the European Relief Fund. The following month, the community league reported a pie supper fundraiser that netted twenty dollars for the school.

On April 23, 1921, a Roanoke County Convention of Community Leagues was held in Salem, and there were nineteen community leagues in the county at that time.

By THE 1930s, ROANOKE County public schools began slowly consolidating the old one- and two-room schoolhouses into larger elementary schools. In 1937, the present-day Back Creek Elementary School opened with eight rooms along Route 221 on land purchased from the Rierson family. Additions were made to the school in 1959 and 1970; a complete renovation occurred in 1989, with more alterations in 1994. Kindergarten opened at the school in 1971. Seventh grade was transferred to the Cave Spring Intermediate School in 1970, and sixth grade followed in 1977.

Lorene (Simpson) Preas recalled in 2016 her years attending the newly opened Back Creek Elementary School as a second-grader during the 1937–38 school year.

The May Pole was always a part of the spring ritual at Back Creek Elementary School. I was in the second grade and was one of about ten girls that would dance around the May Pole. My mother made my costume—a plain, sleeveless dress covered with blue ruffled crepe paper. My socks were dyed to match my dress, and we did not wear our shoes while we were dancing and weaving our streamers around the pole. [The ground being wet] *my blue socks faded and I left blue footprints on the ground for several steps. When I took off my socks my feet were blue....Have never forgotten that.*

Genevieve Henderson had fond memories of sports at Back Creek Elementary School in the early 1950s. In 2016, she wrote:

Eddie Barnett was principal at Back Creek Elementary School and loved sports. He opened up the gymnasium at nights for basketball games during the winter months and invited Back Creek teenagers to get involved. It was a great place for us to go have fun and safe place to learn more about playing basketball, and Mr. Barnett was a wonderful coach and had as much fun as the teens he was helping. One special game that many of the girls will remember was when he invited former Back Creek students (now married and many of them mothers) to play a game against the teenagers.

We teenagers laughed at the idea. What chance did he think these older ladies would have playing against us! We showed up for the game that night, after laughing all the way home from Andrew Lewis as to how we would beat the socks off them—after all, we played almost every day and they probably had not held a basketball since their school days.

But the laugh was on us! Those "old ladies" were there in the gym when most of us arrived—all dressed up in their shorts and tops—and making up for the years they had not been playing by making basket after basket. The ones I remember the most were the Morris sisters—Ruth, Lucille, and Iva—and possibly Hortense was there.

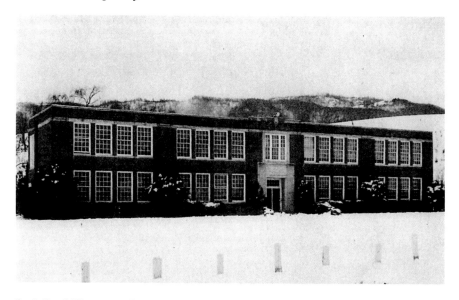

Back Creek Elementary School, 1954. The "new" Back Creek School was built in 1937 for elementary grades. Upper grades went to Andrew Lewis in Salem. *Courtesy of Joyce Turman.*

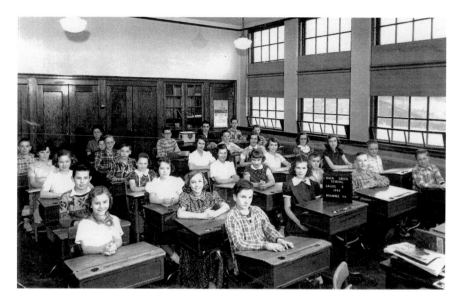

Students at Back Creek School, 1953. This image shows the sixth grade. The school was the center of social and civic life for the section in the 1940s and '50s. *Courtesy of Joyce Turman.*

I don't remember who won the game—it was probably the older ladies—but I do recall that it was the toughest basketball game that I ever played in and they were the roughest players that I ever faced. They must have been outstanding basketball players in their younger days, and Eddie Barnett probably thought it would be a great lesson for us as teenagers and bring our ego down a notch or two.

When Back Creek Elementary School opened in 1937, upper grades were sent to Andrew Lewis High School in Salem. Andrew Lewis was built in the early 1930s and expanded in 1936 to accommodate students from other areas in Roanoke County, including Back Creek. Upper grades from Back Creek continued attending Andrew Lewis until the 1957–58 school year, when only juniors and seniors had the option of attending Andrew Lewis to either complete their education there or attend the newly built Cave Spring High School. When Cave Spring High School opened, it also enrolled the upper grades at Bent Mountain School, thereby ending the high school program at Bent Mountain.

Cave Spring Elementary School was built in 1961; an addition was completed in 1970. In its inaugural year, the school enrolled 514 students. Kindergarten came to the school in 1970.

Cave Spring High School on Brambleton Avenue opened for the 1956–57 school year with Con A. Davis as principal; students had their first day of classes in the new school on September 4 of that year. Davis had formerly been a math teacher at William Fleming High School. The county school board decided the name of the school at a meeting on August 14, just a few weeks prior to the school's opening. There had been numerous suggestions to name the school after area dignitaries, including former Congressman Clifton Woodrum. The board, however, decided a regional title would be more appropriate.

The school was constructed by H.A. Lucas and Sons, with the firm of Frantz and Adkkinson being the architects. In the school's inaugural year, the school band had no instruments, so the "Band-Aid Club" was formed to raise money. Its main event was a community cookout at the Lee Hi Swimming Club, and music was provided by Paul Noble and his orchestra. Principal Davis cooked the hot dogs. To have an accredited library, the new school needed 3,000 volumes, and the Veterans Administration Hospital in Salem donated nearly 2,800 books. The school building cost $800,000, with an additional $100,000 appropriated for equipment and supplies. Due to construction issues, the school opened two weeks later than scheduled,

Selling ice cream at Back Creek School, circa 1950s. Miss Annie Bohon sells ice cream during lunch period. The cooler was just inside the school's front door. *Courtesy of Joyce Turman.*

with nearly 700 students in attendance. The Cave Spring High School PTA was founded on October 2, 1956. The high school operated in that original location for eleven years before the present-day Cave Spring High School opened on Chapparal Drive in 1967 with 1,151 students.

The former high school became Cave Spring Intermediate School in 1967 and Junior High School in 1972. (It should be noted that "intermediate" schools held grades six through eight, "junior high" schools were grades six through nine and the current "middle" schools are grades six through eight.) Jack Spigle was the first principal to serve the intermediate school, which had 903 students in its first year.

A second intermediate school, Hidden Valley, opened in 1972 with 1,166 students, becoming a junior high school in 1976 and later a middle school. It is located on Hidden Valley Road, just off Route 419, and now sits in a Roanoke City neighborhood (the city annexed the area in 1976).

Penn Forest Elementary School on Merriman Road opened in 1972 with 675 students and with May Franklin as principal.

For more than twenty years, the overcrowding at Cave Spring High School was a topic of discussion in the southwest county area. In 1981 and again in 1988, citizen committees reviewed the issue; both times, a recommendation for a second southwest county high school was made. Despite these studies, a bond referendum to build a two-thousand-student high school to replace Cave Spring High School was held in 1995. This referendum passed in the Cave Spring and Windsor Hills districts, but not by a margin to offset the large "no" vote in other parts of the county.

After the defeat of the bond referendum, the school board appointed a blue ribbon committee to assess the future needs of Roanoke County. After a lengthy study, the committee presented a proposed $120 million, three-phase capital improvement plan that included a second south county high school as part of the first phase.

The property selected was located in the Windsor Hills Magisterial District, on a farm previously owned by a Roanoke County artist, Allen Ingles Palmer. The property, known as Woods End, was close to Route 221, near the Canterbury Park and Kingston Court subdivisions. (The school board razed Palmer's home in 2014.)

The school was named by a citizen's committee appointed by the school board. The committee solicited input from the community and considered more than fifty names before making its final recommendation. The final decision was based on aligning the new high school name with its feeder school, Hidden Valley Middle School.

The school colors, navy blue and Vegas gold, and the school team name, the Titans, were selected by the high school steering committee. This committee, made up of parents, teachers and students, helped to organize the opening of the school. The color choice was selected to continue the tradition established at Hidden Valley Middle School. Hidden Valley High School opened in August 2002 and was designed to accommodate 1,100 students. In the first year, the high school had 720 students in grades nine through eleven, as well as 50 teachers, 3 administrators, 4 secretaries, 9 instructional assistants, 6 custodians and 6 cafeteria workers.

SIGNIFICANT SOCIAL CHANGE OCCURRED in the Roanoke County public schools with court-ordered desegregation. The 1962–63 school session was the first in a four-year process of integrating the county schools. Roanoke County had lost an appeal in federal court in the summer of 1962 and was ordered to begin implementing an integration plan that fall. (The last element of desegregation came with the closing of the all-black county high school, G.W. Carver in Salem, in 1966.) Interestingly, Cave Spring High School was already integrating. On September 2, 1961, Marion Elaine Nelson became the first black student to enter the all-white Cave Spring High School. The principal, Con Davis, told local reporters, "Things were so normal, we hardly realized she was here."

One private school, North Cross, is located in southwest Roanoke County. The school was started in 1944 by Mrs. Howard (May) Butts, a former librarian at the Salem Library, in her Salem home. She recruited Margaret (Billy) Northcross (later to become Mrs. Ellis) to teach first grade and 19 students, and she promised to name the school "NorthCross." Mrs. Butts soon saw that her basement was not adequate for the needs of the students. In 1945, a house was purchased at 12 Union Street, and kindergarten and second grade were added. Third grade was added in 1946, with an addition in 1947 that included an auditorium and cafeteria. Financed with tuition and generous subsidies from Mrs. Butts for more than ten years, it was incorporated in 1955. On August 9, 1957, the school was re-incorporated as a nonprofit organization and later became "North Cross" (the last name became two words). At the same time, on Colonial Avenue in Roanoke, Wellington School was organized and offered kindergarten through twelfth grade. On May 1, 1960, Tom Slack, Brounie Trout and Dot Saunders met with North Cross to discuss uniting the two schools. Over the next six months, an agreement was reached, and the schools merged to become North Cross

Country Day School. Eaton School, led by Mrs. D. Kirk (Mary) Hammond, was founded about this same time for students at the junior high level. In January 1961, Eaton School agreed to become part of the new North Cross Country Day School, and thirty-five of its students transferred in September 1961. "Eaton Hall" on today's North Cross campus is in recognition of that history. When the doors of "North Cross School" opened in September 1961, 181 students were greeted by their eleven teachers, with Emerson Johnson as its first headmaster.

ANY HISTORY OF EDUCATION would not be complete without some reference to the public library system. The Roanoke County library system was officially organized on November 6, 1945, in a room of the Roanoke County Junior Woman's Club on Conehurst Drive. In 1958, the library moved to the Roanoke County School Administration building (formerly Comas Cigarette Machine Company) on College Avenue in Salem. In 1967, a million-dollar bond issue for library construction was approved. The headquarters library on Route 419 was dedicated on January 21, 1973. A six-thousand-square-foot expansion and remodel was completed in 1988. It closed on December 16, 2011.

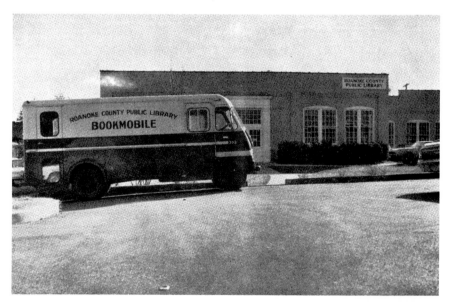

Roanoke County Bookmobile, 1966. Prior to branch libraries, the county had a bookmobile that served rural areas, including Back Creek and Bent Mountain. *Courtesy of Roanoke County.*

South County Library opened with a dedication on January 3, 2012. The groundbreaking was on October 27, 2009. The architects were Peter Bolek and James Shook from the Holzheimer Bolek and Meehan firm of Cleveland, Ohio. The cost was around $15 million ($12 million for the building and the rest for property and grading). Prior to the opening of the headquarters library on Route 419, the southwest section of the county had been served by a bookmobile.

STORES AND BUSINESSES

Numerous mom-and-pop businesses, along with more substantive enterprises, operated in southwest Roanoke County in the twentieth century in addition to the orchards and farms.

BENT MOUNTAIN DRIVE-IN RESTAURANT

In the late 1940s, Merritt Powell's father-in-law, a Mr. Steward, built what was to become the Bent Mountain Drive-In Restaurant along Route 221, just north of the former Pantry Restaurant. By the mid-1950s, operators of the restaurant were Clarence and Betty Jackson, and they initiated curb service. This made the restaurant attractive to young people, with a menu of hamburgers and fries and a jukebox inside. The Jacksons later sold to Larry Smith, who in turn sold to Irvin and Betty Waldron. They operated the restaurant in the 1960s and '70s. The last operator was Robert Furrow.

BENT MOUNTAIN GREENHOUSES

New York native Anthony Maier moved to Bent Mountain in 1954 and started a carnation farm off Slings Gap Road (the greenhouses are still standing) behind the present-day fire station. Maier had been a successful carnation grower in New York. He also developed many new varieties of

the flower. Children from Bent Mountain Elementary School would often take field trips to the greenhouses to see all the flowers being grown. Maier operated Bent Mountain Greenhouses from 1954 to 1975 and, during this time, was instrumental in helping start the local fire department and establish the rural home delivery of newspapers. In 1963, Maier served as president of the American Carnation Society. His greenhouses produced one million carnations annually, and he was credited with developing the Mr. White, Ellen Marie and Dusty varieties. In 2002, his wife, Eleanor Marie, died, and the following year, Maier moved to Tifton, Georgia, to be close to family. He died there in 2007 at age eighty-nine.

Hugh Simpson managed the operation for fifteen years and provided details of the operation. Maier started with two seventy-five-foot by three-hundred-foot greenhouses and later added two glass greenhouses and two plastic ones. The location was chosen because of cool summer temperatures, as carnations need a growing temperature of between fifty and sixty-five degrees. The brand was called "Mountain Air Carnations," and they were cut three times per week, packed in boxes and shipped by truck or Trailway bus to a wholesaler in Lynchburg who served seventy retailers. Carnations were produced nine months during the year, being pulled and replaced in the summer. The business employed a dozen workers in the summer and six to eight in winter months. The greenhouses were heated by oil-fired boilers, which provided steam heat, using about one thousand gallons of oil per day in winter. The operation closed due to increased oil prices and competition from floral importers.

Simpson's wife, Dolores, provided an interesting anecdote. Under their bed was an alarm that would wake them if the greenhouse temperatures dropped below a certain level.

BUCK'S PLACE / YE OLDE ENGLISH INN (POAGES MILL)

Al and Ruth's was a local watering hole that opened around 1950 and remained a bar or restaurant through the 1980s, owned by Buck Mays. Mays operated another bar along Route 221 called Big Bend (presently 8724 Bent Mountain Road). After Al and Ruth's, it became Buck's Place and, by the 1970s, the 221 Steak House. The building was sold, remodeled and opened as Ye Olde English Inn in 1989, an eighty-eight-seat fine-dining restaurant. A small residence on the property was remodeled in 1995. Ye Olde English

Inn closed in 2005, was sold and became the Back Creek Grill, operated by Jim Muscaro and later by Dennis Minnick. The grill closed in 2009. Today, the property (6063 Bent Mountain Road) is vacant.

Bus Lines

From the 1940s into the '70s, Virginia Trailways, a subsidiary of the National Trailways Bus System, operated a bus line from Roanoke to Galax. In 1957, the line was extended to Abingdon when the Tennessee Coach Company connected to the Trailways route. The original Roanoke–Floyd–Galax line was part of a larger Virginia Trailways line that ran from Washington, D.C., to Roanoke, and then from Roanoke to Galax along Route 221. At Galax, the line was taken over by Queen City Trailways, which carried passengers into Tennessee. The Roanoke–Galax line never had more than two rounds, morning and evening. At its peak, however, the line would run two buses for each round. By 1958, the line was cut back to just one round. The line was eventually acquired by the Appalachian Coach Company from Virginia Trailways. Fred Cox rode the bus regularly in the 1960s and early 1970s from Roanoke to Galax as a child and young teenager. He recalls that, during this period, there were no regular stops between Roanoke and Floyd other than riders standing along the highway flagging the bus down, especially at the base of Bent Mountain. Cox says that Garland Gordon ran the bus center in Galax and that a fifteen-minute stop was the Blue Ridge Diner in Floyd. He also remembers that in the early 1970s, the line downsized from a full-length bus to a much smaller bus. The line closed that same decade. Cox relates, "Sometimes I thought the old bus wasn't going to make it up the mountain the way it moved and sounded."

Joyce Turman used to ride the bus in the 1950s, catching it at Fats Reed's store. "If we couldn't hitch a ride to Roanoke when daddy sold produce at the Roanoke city market, we would ride the Trailways bus....Fats sold the tickets and he would put a red flag on the right side of 221 so the bus driver would know he had a rider."

In the 1940s and through the early 1970s, the Roanoke–Starkey bus line operated between Roanoke, Starkey, and Boones Mill. Rides in the 1940s were twenty-five cents one way. The original two-bus line had a garage at 830 West Campbell Avenue in Roanoke in 1945. By 1965, the garage and office had moved to 1005 Salem Avenue, Roanoke, and was operating five buses. C.A. Hubbard was the general manager.

CANNERIES

With the tremendous agricultural industry in southwest Roanoke County, there were numerous canneries for the canning and packing of produce for wholesale shipment. A business directory, *The Industrial and Shippers Guide*, for the Norfolk & Western Railway in 1916 listed the following canneries operating in the Poages Mill section: T.M. Bell, Henry Brothers, J.H. Grisso and Shenandoah Bellspring Company. All of these canneries accessed the N&W Railway for shipments via the Starkey combination station. The cannery operated by L.D. and T.M. Bell produced the Walnut Spring brand of produce. Russ Grisso, grandson of John H. Grisso, recalled that Grisso's cannery was located along what is present-day Ran Lynn Drive, where Ran Lynn Farms, owned by the Draper family, exists (5678 South Roselawn Road). Grisso's cannery ceased operating when owner John Grisso was killed by lightning in 1927. Russ Grisso said that, as a boy, he remembered that the labels used by his grandfather had tomatoes on the front, but he could not recall a brand name.

In the 1930s and '40s, there was a canning factory behind what is now Country Way store; it was Rierson's store at the time. The cannery, owned by Samson Sinclair, mostly canned tomatoes from farmers with whom he had contracts. According to Walter Henry, a steam boiler ran a conveyer belt that was manned by young women who did the canning. Almost adjacent to this cannery was an apple-packing shed owned by Harvey Ferguson. Here, apples were packed in barrels (three bushels equaled a barrel) for shipment.

Packing label, circa 1930. The Luther D. and T.M. Bell cannery produced the Walnut Spring brand, as shown here on their label. *Courtesy of Lou Emma Richards.*

Cave Spring Mercantile Company

In 1838, John Steele began a small mercantile in Cave Spring along with Richard Fowler, a blacksmith. Over the next few decades, Steele and Fowler's store passed through several owners, including Nathaniel Chapman, Thomas Sublette, James Watts and Robert Thaxton. In 1868, Thaxton sold the store to Joseph Berry. Berry operated the store until 1911, when it was assumed by Robert Wyatt, who sold the mercantile to W.D. Robinson for $4,300 in 1913. Robinson then sold the "Cave Spring Mercantile" to W.E. Rasnake in 1916 for $6,000. He owned and operated the store until the 1940s. The store was located on the western side of the intersection of Routes 119 and 221.

In 2003, Rasnake's great-grandson Jim Rasnake wrote about the store from his memories as a boy. He described his great-grandmother as being small with red hair.

> *The store was at an intersection of three roads. The road went west to Salem. It was a two lane crooked road. The north one went to Roanoke (I remember it was called Poor Charlie's Road). The one east was Bent Mountain Road....I remember that behind the store was a creek. The house beside the store was two-story. The house and store were connected, but there was about four feet between them. You could go up about six stairs at the back of the house and through a hallway to the store. The store was very similar to the one the Walton's went to on TV. The flour was in barrels. Lots of jars, few cans. The dry goods were on tables and in counters. The store was always busy. Outside on the west were gas and kerosene pumps. The pumps had glass jars on top. If you wanted gas you turned a crank and gas was pumped up into the jar. You took a hose with a nozzle and opened a valve and dropped the gas into the car. Then you went inside and paid for it.*

Rasnake added that at the rear of the store was a two-story storeroom, with dry goods stored on the second floor and bags of flour, seed and feed on the first floor. According to Jim Rasnake, Worley Rasnake, a grandson and resident of Bent Mountain, ran the store for a few years after his grandmother's death in the 1940s before selling it.

A Works Progress Administration survey of the store and adjoining house was done in 1937. According to the WPA report, the house was used as a store and post office and for a brief time as the medical office for Dr. Joseph A. Gale. "The old store house served as a post office on the old Floyd line,

and almost continuously as a store with the exception of when Dr. Gale used it as an office and in a small way a sort of hospital where he operated on a great many patients....This was once known as the George W. Hartman store. T.C. Sublett seems to have been the most successful merchant who has occupied the old store."

According to deed research done by the WPA, the house (former store) was built in the early 1830s of log. Hartman originally purchased the land in 1818. Dr. Gale used the store from 1871 until 1887 for his medical practice. The store was razed in 1956. During its razing, what some thought were a couple of Civil War–era cannonballs were seen imbedded in the logs. How they came to be lodged in the store's side remains a mystery.

COLES EGG FARM (BENT MOUNTAIN)

Roland H. and John Coles had one of the largest poultry and egg farms in Virginia in the mid-1970s, with a 385,000-layer operation. The Coles farm had been in the family's possession prior to the Civil War. Roland Coles also served as president of the Virginia Poultry Federation during that time. In the 1960s, one of the largest contracts the egg farm had was with the Winn-Dixie grocery store chain. So prominent was the company that, in 1974, executives of Coles Egg Farm were invited to the White House to be among a select group of poultry farmers to meet with President Gerald Ford at a state dinner. In 1981, Coles Egg Farm along with its eight hundred acres in Bent Mountain was sold to Seaboard Foods of Lakewood, New Jersey, and remained Virginia's largest egg producer. In 1988, Seaboard announced it was eliminating sixty positions in an effort to trim costs and reduce operations. In 1989, the company was cited for various environmental infractions and became the largest agricultural cleanup site in the state. By 2009, Seaboard had been acquired by a Japanese firm.

CONNER FRUIT STAND (BENT MOUNTAIN)

Marshal Conner had a fruit stand, the Apple Shed, on the south side of Route 221 near Poff's Garage. He was one of the first persons in the community to haul fruits and vegetables from the South to sell before local produce came in season. The fruit stand was run by Sylvester "Bo" and

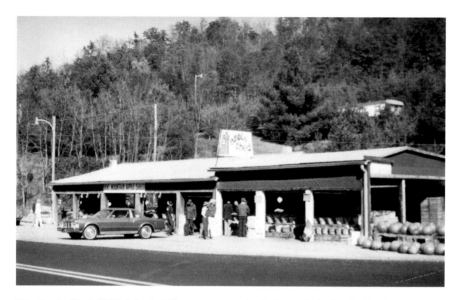

The Apple Shed, 1983. Marshal Conner operated a fruit stand, the Apple Shed, along Route 221 for many years. Later, it was the Bo-Go General Store. *Courtesy of Gladys King.*

Alice Bohon following Conner's death, and the business was renamed Bo-Go General Store. The Bohons operated their store for fourteen years before retiring in 1992.

CONNER STORES (BENT MOUNTAIN)

B.L. "Lump" and Morgan Conner were brothers; both had stores in the Bent Mountain section. One store was located where King's Fruit Stand is today, and this store also had the Airpoint Post Office, where Morgan Conner served as postmaster for twenty-seven years. Conner died in 1966. King's Fruit Stand is operated by Carson King, a nephew of Morgan Conner.

Lump Conner operated a store near the present-day 9500 block of Tinsley Lane. In the 1920s or '30s, Lump Conner operated a small store (no longer exists) just to the south of the present-day Fralin Fruit Stand, according to Lois Overstreet, before opening the one on Tinsley Lane.

Morgan Conner had a son, Clem, who bought a store near the intersection of Countyline Road and Highway 221. Clem was the third owner of this store. The initial owner was Boyd "Boy" Williams, followed by Dewey Alderman. Clem and his wife, Mae, ran the store for forty years. Dana

DeWitt writes, "I remember the store well because we spent every Friday night there drinking Cokes or Dr. Peppers filled with peanuts." Following Clem Conner's death, Mae continued to run the store along with her sister Bea. Mae Conner died in 1995.

FERGUSON BLACKSMITH SHOP AND STORE (POAGES MILL)

Jerd Ferguson came from Strausburg, Virginia, to the Poages Mill section in 1925 and had a blacksmith shop where Jake's Garage is located today along Route 221. He welded iron, shod horses and repaired farm equipment. He and his wife, Lizzie, also had a store on the same site in a log cabin, and they lived in the back of the store.

At the store, Ferguson sold Sinclair brand gasoline from pumps out front. Walter Henry recalled visiting the store on many occasions. "It had a candy counter, pot-bellied stove, and several of us would wait on the school bus in the store during the 1930s." With the advent of automobiles and tractors, Ferguson's blacksmith operation eventually ceased. The Fergusons closed their store in 1942, when the federal government mandated gas rationing, though Jerd and his wife continued to live in the cabin that by then had been sided.

FINNELL & SONS STORE (HARAN)

Broughton Gary Finnell Sr. purchased a house along Route 221 at the foot of Bent Mountain in the early 1940s. A native of Roanoke, Finnell had lived in Detroit, Michigan, where he worked as an accountant at Ford Motor Company and married Edna Schmitt before moving back to the Roanoke Valley. Finnell's son B.G. Jr. also purchased a house and chicken farm near his father's home along Route 221 about that same time. In 1945, the two men decided to build and operate a store, B.G. Finnell & Sons, which is today 7924 Bent Mountain Road. According to Laura Finnell Hall:

The store did car repair and sold gas along with the sale of various small food and candy items. There was a food counter that sold sandwiches, ice cream, shakes, and beer. At night, it was a gathering place for the neighborhood men. The business thrived and at some point, Gladys Bohon

came to work. She lived at the end of Martin's Creek Road and soon became a beloved part of the family and valued employee. The children remember her "softer side" that "took the edge off" BG Sr.'s stern demeanor.

B.G. Finnell Sr.'s youngest son, Bud, was discharged from the army following World War II and joined the family business. While working there, he met Gladys Bohon's daughter Colleen, and the two married and a few years later moved to Indiana. In 1947, B.G. Finnell Jr. built a swimming pool behind the store. Hall writes, "The pool pulled icy water from Back Creek and was a popular gathering spot for the neighborhood and family. BG's children recall the weekly task on Saturday afternoon of draining, cleaning, and refilling the pool...not so much like work but family time and cooling off from the never ending chores of the farm."

In 1949, B.G. Finnell Sr. purchased a 350-acre orchard and packing shed along Applegrove Lane. The orchard had some three thousand apple trees and about a dozen cherry trees. Some apples and cider from the orchard were sold at the store. The orchard operation ended around 1952, as it was no longer profitable. The Finnells also operated a sawmill in the 1950s and constructed homes for family members near the store and pool. B.G. Finnell

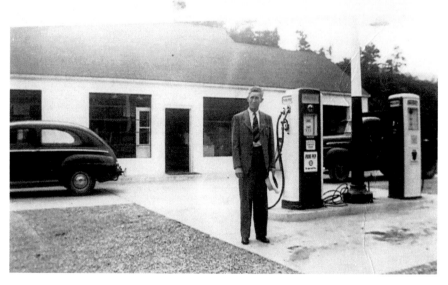

B.G. Finnell Sr. and store, circa 1940s. Finnell's general mercantile and filling station opened in the 1940s and remained in the family until his death in 1962. *Courtesy of Laura Hall.*

Sr. died in 1962, and the store was sold to Merritt Powell and the swimming pool to Bob Ramsey. B.G. Finnell Jr. and his wife, Mary Jane Viar, moved to Smith Mountain Lake in 1968, selling their property at the foot of Bent Mountain. B.G. Finnell Jr. died in 1988.

The store continued to operate under Powell and other owners as a bar and restaurant and more recently as Mountainside Café.

HOLT/BOHON/POWELL STORE (BENT MOUNTAIN)

Colonel Fletcher Holt worked in Bristol, Tennessee, in a clothing store and returned to his home near Bent Mountain in 1922 and soon thereafter began operating a general mercantile. Holt was involved in the community, notably as treasurer of the Bent Mountain Mutual Telephone Company. His store also served as an early post office for the community, with Holt as the postmaster.

In 1944, Holt sold the store to Clyde and Almeda (Poff) Bohon, who later built a brick home on the Calloway Road behind the store and Holt home. Older Bent Mountain residents recall going to the store to watch

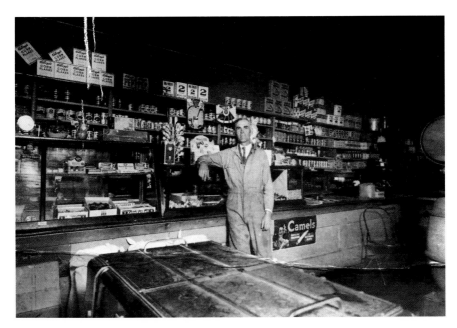

C.F. Holt in his store, circa 1930s. Colonel Fletcher Holt operated a general store from the 1920s until 1944 and also served as Bent Mountain postmaster. *Courtesy of Dana DeWitt.*

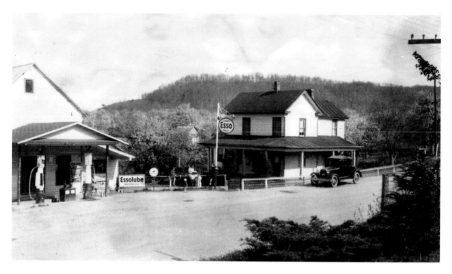

Holt's Store, 1937. This store, acquired by Clyde and Almeda Bohon in 1944, burned in 1957. The store was at the intersection of Route 221 and Callaway Road. *Courtesy of Dana DeWitt.*

television during that medium's infancy. In fact, the Bohons' store was the first to have television on the mountain. The Bohons also had a heating oil business located at the present-day Fralin Produce. The Bohons later sold the store to George and Marie (Bell) Powell. During the Powells' ownership, that store caught fire and burned around 1957. Dana DeWitt recalls that night: "I was young, but I remember Clyde and Almeda were at our house playing canasta with mom and dad. We saw the flames from our window and panic ensued because Almeda's mother lived across from the store and their house sat behind the store. We jumped in the car and found out it was the business."

The Powells rebuilt on a site just a few yards north of the old store. They retired to Florida; the store was then operated by George Dewey Powell and Linda Manning. After them, the store was managed by Rocky Manning and Jack Webb and called "Jack Rock" from a combining of their names. After Manning and Webb, the business was operated by Anthony "Tony" Montuori. The store, last known as the Bent Mountain Convenience Store, burned on January 19, 1994, and was never rebuilt. Presently, the concrete foundation is still visible. Montuori later owned and operated New York Pizza in Vinton until his death in 2011.

Howell's Store (Bent Mountain)

The present-day building that houses the Bent Mountain Bistro (9607 Bent Mountain Road, Bent Mountain) was originally Howell's Store. Proprietor Harvey Howell and his family operated the store in the 1940s. A family member, Glen Howell, worked for the WSLS television station in Roanoke during the early years of broadcasting. While the store sold the usual items for a general mercantile, it also had television sets. Many people from the Bent Mountain community saw their first broadcasts at the store, making it a popular traffic stop.

After Howell, the store was operated by Doug and Lena Lancaster and then Carlton Walters. After Walters, the store was converted to a restaurant and became Hole in the Wall, Grandmother's Restaurant (operated by Whitey Barton), a Mexican restaurant and Bent Mountain Bistro.

Jake's Garage (Poages Mill)

Jake and Mary Likens bought what is now known as "Jake's Garage" in 1960. At first, the couple operated a small fruit stand and then a more developed grocery store by 1962. In 1965, they added the service station with bays for automobiles, selling Union 76 fuel. Likens operated the garage until his retirement, selling the business in July 1997.

In a 1998 *Roanoke Times* article, the reporter described the affection Back Creek residents had for Likens. "The Back Creek section never was incorporated, but if it had been, chances are Jake Likens would have been mayor. Folks who lived at the foot of Bent Mountain gave him the title anyway. He was the man everybody called if they ran out of gas or got stuck in a ditch." According to the newspaper's profile, Likens' garage was a gathering place for a dozen or so men in the area, informally known as the Bridge and Garden Club, on Thursday evenings and Saturday afternoons. Those happened to be the occasions when Likens' wife, Mary, was running errands.

The garage, located at 6422 Bent Mountain Road, still functions as a business today.

King's Store (Bent Mountain)

Located on Patterson Road in the Bottom Creek section, this general store was operated by proprietor Oakley King from the 1930s through the '50s. His great-niece Genevieve Henderson recalls the store. "Not only did he sell the usual groceries found in a country store, but he also had thread, fabric, nuts, and bolts, lots of tin pots and pans hanging around the store, and he had soft drinks and a big display of candy (especially penny candy) and nickel candy bars." Even before electricity, King managed to have ice cream in Dixie cups for sale on the Fourth of July, according to Henderson. "Neighbors would take their butter and eggs and live chickens to the store and trade for needed supplies." King would also take crates of chickens to the Roanoke market to sell for his neighbors and calves to the stockyard for them. "Something I will always remember about going to Uncle Oakley's store," writes Henderson, "was finding his youngest son, Hilton, outside the store shooting marbles—sometimes even in the road since cars came by so seldom in those days. He was the marble champion and went on to become the champion for the area."

Look-Out Lodge and Gift Shop (Air Point)

In the early 1950s, the Lookout Lodge and gift shop were owned and managed by two brothers, Everett and James Glover. The former's nickname was "Old Man of the Mountain." The lodge had two rooms and a cabin. The cabin was purchased later by Reed Dooley. During the Glovers' ownership, they had requested that Roanoke County run a water pipe under 221 to supply the gift shop. The request was denied. During construction on the highway, the Glovers went out at night and dug through the gravel and laid their own pipe. The highway work was completed, the gift shop had water and the county never knew!

Every Sunday morning, the Glovers and friends would have breakfast in the orchard, cooking steaks and enjoying "white" coffee. One man passed out from the coffee, so his friends laid him out in a van. They picked flowers to put around him while he slept it off. When he awakened and was still groggy, he noted being in a van surrounded by flowers and thought he had died and was being carried away in a hearse.

Roanoke Look Out gift shop, 1955. In the 1950s, brothers Everett and James Glover operated a gift shop and lodge where Route 221 crests Bent Mountain. *Courtesy of Frank Stone.*

Look-Out Lodge was purchased in 1958 by Frank Beamer, who sold it to Mr. and Mrs. Frank Stone in 1961. Stone also operated a taxidermy service from the shop. The Stones had the property until 1974, selling to I.B. Crutchlow. Today, it is a residence (9191 Bent Mountain Road).

Metz Garage (Poages Mill)

Beginning in the 1950s, Roy Metz operated a garage at 6521 Bent Mountain Road (presently Sunrise Window Cleaning), servicing automobiles and farm machinery. Following Metz's death, the garage was operated by Garney Conner for many years. Following Conner, the business was bought by K.K. Mills, who ran it is a maintenance shop for his equipment used in strip mining and for clearing rights-of-way for roads. After Mills, the garage was sold to Mike Christley, who had Cave Spring Excavating. Today, the former garage houses Sunrise Window Cleaning. In the 1950s and '60s, Cassell Motors, a used-car lot, operated adjacent to the garage.

The Pantry Restaurant (Bent Mountain)

The Pantry Restaurant on Bent Mountain opened in 1946 and remained a restaurant for half a century. It had closed by 1997, when the property was offered for auction by Woltz and Associates on April 12 of that year. Included in the auction were all the furnishings, dishes and equipment.

A longtime cook at the Pantry Restaurant was Clovis King Cooper. A profile written of her by *Roanoke Times* columnist Ben Beagle in the mid-1970s stated, "She has been in the kitchen there for years and she can cook a chocolate pie that has seized the imaginations of hundreds." Cooper was known for her homemade pies and biscuits, always made from scratch. She arrived daily at 10:00 a.m. and left at 7:00 p.m., preparing a menu of two meats and ten to fifteen vegetables. Cooper died in 1997.

I was shown a menu from the restaurant when it was operated by Mr. and Mrs. "Dusty" Rhodes. Though undated, the menu was quite old. A deluxe hamburger; a foot-long hot dog with mustard, chili and onions; and an egg, tomato and mayonnaise sandwich were each $0.30. All soft drinks were $0.10; homemade pie was $0.25. Country-style steak, French fries and slaw was $0.90. Other items included soups ($0.20), vegetables ($0.15) and a sixteen-ounce T-bone ($3.25).

Peggy's Beauty Shop/Woods Flooring

Peggy Woods opened a beauty shop in the downstairs of her home in the late 1950s. She had a mirror on the wall, a shampoo basin, a styling chair and one hair dryer. By the early 1960s, her sister Judy Martin had begun working alongside her. The two always worked part-time on Thursdays, Fridays and Saturdays. In the mid-1980s, the beauty shop was moved to the upstairs of Woods' home after her husband, Roy, relocated his flooring business. Presently, Peggy is ninety-two and still comes to her shop to shampoo a few ladies' hair.

Roy C. Woods opened an office for his flooring business in his home (6932 Bent Mountain Road) in the mid-1950s. He handled all kinds of flooring along with installation. As the business grew, Woods purchased an old packing shed and converted it into a showroom and office in 1985. Longtime employees included Billy Carroll, son Danny Woods and bookkeeper Alice Stevens. Woods died in 1992; shortly thereafter, the business closed. Etched on his gravestone is a man sanding floors, which was his business logo.

PETERS GROCERY/ORANGE MARKET (CAVE SPRING)

Howard and Hazel Peters operated a general store and gas station, H.S. Peters & Son Grocery, beginning in the early 1940s at the intersection of Brambleton Avenue and Roselawn Road, selling the Pure brand of fuel along with groceries, farm supplies and animal feed. At one end of the store was a barbershop. The Peters sold their store in the 1970s, and it became the Green Market and then, in 1977, the Orange Market. Howard Peters passed away in 2004 and Hazel in 2015. Cave Spring Baptist Church purchased the store in the early 1990s, razing it for expansion of its parking lot.

POAGES MILL SERVICE STATION

The store was built in 1935 using rocks found in Back Creek by William Poage Sr., who also ran the Poage farm. According to Walter Henry, an Italian gentleman helped lay the stones. The story goes that this man also worked on the stone walls along the Blue Ridge Parkway.

Poage and his family ran the store until he died in 1942, and then his wife, Ethel, took over managing the store. The store carried canned goods, bread and other items. There was a refrigerator in the back that contained milk, butter, eggs and probably vegetables. According to the Poages' great-niece Molly Koon:

> Ethel always had cold drinks and it was said the big red Coca-Cola box had the coldest drinks and beer in the county. She sold beer on premise and many an evening she would be in the store with her knitting, a fire in the stove in winter and men from the area sitting with her and enjoying a beer. The store was open all day and into the evening and was definitely a gathering place for Poages Mill residents. Ethel would always go home for dinner, but returned to the store afterwards. It was open Monday through Sunday, closing early on Sunday before church.

The Roanoke newspapers were delivered to the store, and that is where subscribers got the paper. On Sundays, if a subscriber did not get there before church, the Poages would leave the newspapers outside for pickup. Later, subscribers picked up their papers at Jake's Garage. Eventually, newspaper delivery to homes was offered to all county residents. Some in

Poages Mill Service Station, 1987. The rock store along Route 221 functioned as a grocery and service station for more than sixty years. *Courtesy of Joyce Turman.*

the Poages Mill area started home delivery, while others continued to pick up the paper at the garage. Delivery to Jake's was stopped in 1988.

Ethel Poage retired from managing the store in 1973, when the inventory was sold to Walter and Virginia Henry, who operated the store until December 1987. Mrs. Poage continued to help out from 10:00 a.m. until 2:00 p.m., waiting on customers and knitting, so the Henrys could go home for lunch. The inventory was sold to the Christley family, who ran it for several more years. After that, the building was used for various endeavors: a catering business with cooking happening on-site, a landscaping business that also sold Christmas trees for a couple of seasons and, finally, a produce stand. At present, the store is unoccupied.

Koon also wrote:

> *For me personally my mother, Mary Poage Gregson, would help Aunt Ethel in the store during the summer and when she wasn't teaching. That is where she met my father, Carl Gregson, who was boarding at the old Kittinger home on the hill near the school. As kids my brother and I would venture over the old swinging bridge to the store on a hot day or after school and Aunt Ethel would give us one of those cold drinks from the old Coca-Cola box. We would sit under the willow tree next to the store sipping on our*

*drinks and usually a bag of peanuts, then back across the swinging bridge
we would go. Poages Mill was a great place to grow up!*

Dana DeWitt's father, Allen Stone, worked for the American Oil
Company, whose fuel was sold by the Poages. "My dad delivered gas to
Poage's store. When it was time to pay, the proprietor would say: 'Go to the
cash box. You take some and leave me some.'"

POFF'S GARAGE (BENT MOUNTAIN)

The business was built by Clinton Poff and Doug Lancaster and originally
known as Poff and Lancaster Garage. Poff eventually bought out Lancaster's
half of the business, and it became Poff's Garage. Clinton and Maude Poff
ran the garage with the help of Maude's brother Ezra Lancaster. Their son
Lawrence began working in the garage and, in time, took over operations
and passed it along to his son Kevin. Some of the employees who have
worked at the garage over the years were Cline Wimmer, Guy Stump and
Barry Smith. Besides working on vehicles, the Poffs also sold Allis-Chalmers
tractors and had a wrecker service.

Clinton Poff was the first fire chief at Bent Mountain. The fire truck and
ambulance were stored at his garage until such time as the fire station was
built. Fire and rescue calls would ring loudly outside Poff's garage. Dana
DeWitt recalls, "My dad's service station was across 221 (from Poff's). It was
my job to go across the road and see where the call was so dad could prepare
to go on call, too, if mom could stay at the station."

REED'S GARAGE (BENT MOUNTAIN)

In 1915, Cletus Reed opened a garage that both sold and serviced
automobiles. At one time, the garage doubled as a dealership for Studebakers.
The garage, though no longer associated with the Reed family but still using
that name, remains at the original location of 9564 Floyd Highway North,
Copper Hill. Reed was known for his mechanical skill and honest car deals.
One bit of Bent Mountain history associated with Reed was that he received
the first rotary dial telephone call in that section. A director of the Bent
Mountain phone exchange, Reed received a dial call from the Roanoke
County board of supervisors chairman Edwin Terrell in a ceremony crafted

by the Chesapeake and Potomac Telephone Company. Reed died in 1970. After Reed, the business was sold to Amos Janney and presently is owned by Tim Marchon. Among the mechanics who have worked at the garage over the years were William Lancaster, Harris Janney, Dalton Hylton and William Smith.

REED'S STORE (BENT MOUNTAIN)

Elbe Reed operated a store out of what many know to have been the old Bent Mountain post office (10313 Bent Mountain Road). Reed purchased the store and adjoining farm in the 1920s from a Mr. Jenkins, according to Reed's daughter Lois Overstreet. Reed ran the store until he had a heart attack in 1954, at which time the store was operated by Boyd and Lois Overstreet. The store closed in 1957 and became solely occupied by the Bent Mountain Post Office, though postal services had

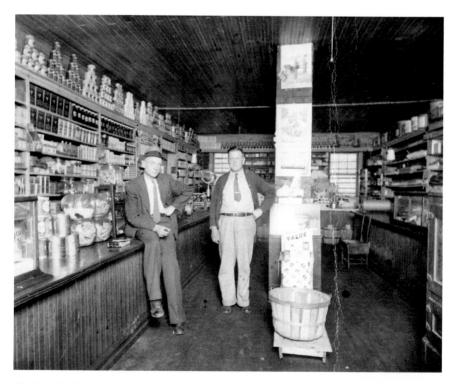

Elbe Reed in his store, circa 1940s. Elbe Reed (*right*) poses with an unidentified salesman in his store, which Reed purchased from a Mr. Jenkins in the 1920s. *Courtesy of Glenn Reed.*

Former Reed Store, January 2017. The Reed Store and later the Bent Mountain Post Office located along Route 221 is being razed in this image. *Courtesy of Dana DeWitt.*

been offered at the store for many years. The store's contents were sold to Noah Thompson, who operated a store a short distance from Reed's along Route 221 (site of present-day Fralin fruit stand). After the store became the post office, Lois Overstreet served for many years as the postmistress there.

Overstreet has many wonderful memories of her father's store. Reed was one of the first to have a radio at Bent Mountain. People would come into the store to listen to it, especially the Grand Old Opry broadcasts during the 1930s. She also recalled that at one time there was a rash of burglaries in the community. Her father decided to sleep in the store. One night, he was awakened by someone trying to get in through the front window. Reed fired his gun, filling the burglar with buckshot. The burglar and his criminal partners fled the scene, and remnants of the shot were still evident in the window decades later. The old wood-frame store was razed in January 2017.

Another interesting footnote is the presence of two post offices so close together. One was at Reed's store and the other just down the road at Holt's store. According to family members, postmaster jobs were political appointments. When a Republican was president, Holt became the Bent

Mountain postmaster, and when a Democrat was president, Reed was given the appointment.

The Bent Mountain Post Office closed at the old store in 1969 and moved to its present-day location in the brick structure built by Allen Stone and still owned by his family.

Reed's Store (Haran)

At the intersection of Route 221 and Martins Creek Road is a store (presently unoccupied) whose history goes back almost a century. R.L. and Ella Gill established the Martins Creek Service Station sometime in the early 1930s. Over the course of the next several years, the store and filling station would be owned and operated by Winoma and Pat Ives, A.J. and Ruth Hambrick, and J.L. and Virginia Thrasher, respectively. The Thrashers ran the business from 1938 until they rented the store and filling station to Marvin "Fats" Reed in 1942. Reed, born and raised at Check in Floyd County, bought the business on January 10, 1945, and changed the name to Marvin Reed General Merchandise. In the deed of sale, Reed not only acquired the real estate but also purchased an air compressor, scales, beverage cooler, cash register, two counters, cigar case, candy case, pie case, stove and a tobacco cutter. The total bill of sale was $4,500. In 1948, he erected an addition that became the Dairy Diner, a small restaurant, for $4,000. As the addition was being erected, Reed lived across the road in the old Haran schoolhouse to eliminate having to travel back and forth to Check. In 1959, he added public restrooms and a walk-in refrigeration box outside of the building. Eventually, Reed moved his living quarters to above the store, where he and his wife had two bedrooms, a kitchen, a living room, a dining room and a large bathroom.

Lou Emma Richards shared the following about the store.

He would have a side of beef in the Walk-In box. There, he would cut nice roasts or steaks. He also had a meat grinder that he used to make hamburgers for the meat case and the restaurant. He had a stove in the back of the store where he kept a large tall pot and made his famous chili, which he stirred with a mattock handle, for the restaurant. He never shared his secret recipe with anyone. His AMOCO gas station was well-stocked with bins of different size nails, garden seed, fishing equipment, can goods, dry

Marvin Reed, 1957. Marvin "Fats" Reed operated his store for thirty-two years, seven days a week, closing only for Christmas. Reed died in 1982. *Courtesy of Lou Emma Richards.*

goods, car oil, fuses and fan belts. If he didn't have something in stock, he would make sure to get it for his customers. He also had a large coal stove that heated the store and also bags of coal for sale. Back in 1958 or '59, it was snowing so bad that he kept the store open all day and night for everyone that got stranded and could not make it up Bent Mountain.

Joyce Turman remembers Reed's store well. "Some of the local men went to catch up on the news at night. I know my dad made trips there several times a week. On weekends, some of the local families showed up for hot dogs, ice cream and visiting....Fats' food was hard to beat, especially his homemade hotdog chili. Doris Wingfield was the main cook/waitress over the years....Doris piled the ice cream on a cone and it only cost 5 cents." Turman also said Reed's store was where men living along Martins Creek Road would gather for hunting. "The main place for coon hunting was Fats Reed's store. It was convenient for them to pick up supplies and a few snacks and drinks to take with them."

Reed ran his store for thirty-two years, seven days a week, 5:30 a.m. to 8:30 p.m., being closed on only one day—Christmas. He did make exceptions for the funerals of family and friends he wanted to attend. He sold the store and retired in May 1973. Reed died in 1982.

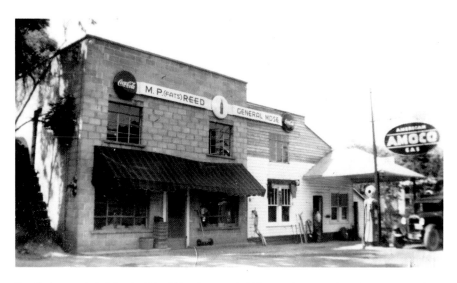

Reed's Store, 1948. Marvin "Fats" Reed expanded his store in 1948. This image shows the new, unpainted addition. Reed bought the store in 1945. *Courtesy of Lou Emma Richards.*

Reed's Store, circa 1950s. M.P. "Fats" Reed General Merchandise expanded to include a restaurant, second-story living quarters and walk-in refrigerator. *Courtesy of Lou Emma Richards.*

From Reed, Rodney and Pauline Ferguson bought the store and changed the name to Ferguson's Grocery. They sold the store in 1988 to David and Charlene Vaughan, who called the business Vaughan's Country Store. They ran the store until they closed it in 1992, and that ended the building being used as a store.

RIERSON'S STORE (POAGES MILL)

Tim Hash, a Rierson descendant, provided the following:

It all began as a swap. The years was 1912. My grandmother, Mary Elizabeth Rierson owned a sow and newborn piglets. A lady, whose name is not known to me, owned a one room sewing and notions shop on the road near where present-day Haran Baptist Church now stands. My grandmother, in exchange for the inventory of the shop, bartered her sow and piglets. At the time, the Riersons lived on Bent Mountain. My grandfather, William Thomas Rierson, was an orchardist and livestock trader.

After a few months, they had an opportunity to partner with another merchant, Mr. Bullock, and moved to where Back Creek School is located today. The store building was rented from the Kittinger Family. The road at that time ran along the creek bed, so the store faced the creek. As was customary back then, there were living quarters for the family in the back of the store. The partnership abruptly ended when my grandparents' partner left town with what cash there was, never to be seen again.

In 1914 the store was renamed W.T. Rierson General Merchandise. Billy, as my grandmother called him, and Mary had no money but still had the store's inventory. In an effort to survive with four children (my mother Ollie was not yet born), they looked for ways to thrive. Although there were few automobiles on Back Creek and Bent Mountain, the combustible engine was here to stay. So, they contracted with Texaco, becoming one of the first gasoline retailers in Roanoke County. Also, at the time Back Creek and Bent Mountain was booming with orchards such that apples were being shipped to other markets. Seeing the need, Bill Rierson as his friends called him, opened a barrel factory. There they made wooden stave barrels suitable for the packing and shipping of apples. Other revenue streams included brokering and speculating on local fruit and vegetables as well as small livestock such as poultry. These things were sold and traded on the Roanoke City Market as well as with other merchants along the 10 mile stretch of road from Back Creek to Roanoke. As eldest son, Maynard became of age, the Riersons would take on contract hauling first by wagon and then by truck from Roanoke to Bent Mountain and all points in between.

About 1926, then owner of the store building, Katherine Kittinger Rierson [Maynard's wife], *sold the real estate to the County for a new school. Back Creek School would move from about ½ mile north to its present-day location. The road which was then called the Roanoke–Floyd*

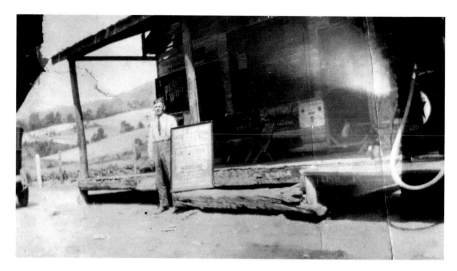

Rierson's Store, circa 1924. W.T. Rierson poses in front of the original store, located where Back Creek Elementary School sits today. *Courtesy of Tim Hash.*

Rierson's Grocery, 1970. The Rierson family operated a store from 1912 until 1977. Today, it is Country Way General Store. *Courtesy of Tim Hash.*

Star Route, was about to change as well. Just down the creek was a two story house with a small orchard and the new road would split the property. Bill and Mary purchased this property, moving their family to their new home on one side of the road and building a new store on the creek side of the road. Over the years, and as electricity came to the area, they would build other buildings and add ventures to their existing business. A canning factory, orchardist supplies and equipment, a drug store, hardware, full-line

grocery with a butcher shop, as well as feed, seed and fertilizers. They also raised fruit, vegetables and livestock to sell.

In 1974, fire nearly destroyed the store, including years of store records. Ollie (Rierson) Hash reopened after only two days and with just a gasoline generator. Ownership remained in the Rierson family until Hash's retirement in 1977. The store, with a deli, remains open today and operates as Country Way.

Old Reno/Toby's Lodge (Cave Spring)

In the 1940s, Mr. and Mrs. Russell Hughes opened Old Reno, a roadhouse, on what is today Crystal Creek Drive but known then as Old Bent Mountain Road. It was later acquired by Robert "Toby" and Nell Saunders and became known as Toby's. It had a reputation as a dance hall and watering hole, being accessed by a swinging bridge. Some patrons who had too much to drink would reportedly start swinging the bridge such that they would tumble into the creek. One large room actually had a tree growing through the middle of it, and the Saunders added a few rooms to make a lodge. The Saunders closed Toby's Lodge in the 1970s. Some of the lodge washed away in the flood of 1985. Today, it is a residence.

ℰↄ **RENO** ℰↄ

Divorce your trouble!

GOOD EATS And REFRESHING
DRINKS

Served With Southern Hospitality

Reasonable Prices

MR. AND MRS. R. S. HUGHES

Phone 53 F 25

ONE MILE FROM STARKEY ON OLD BENT MOUNTAIN ROAD

Reno restaurant card, circa 1940s. Mr. and Mrs. Russell Hughes opened Reno as a roadhouse in the 1940s on what is presently Crystal Creek Drive. *Courtesy of Bob Stauffer.*

Shenandoah Packing Company (Starkey)

The Shenandoah Packing Company was located at Starkey, having been established in 1908 by the Good brothers, natives of Shenandoah County, Virginia. A year later, D. William Good purchased his brother's (D. Saylor Good) share and continued operations. The company packed and canned the Shenandoah brand of tomatoes, apples, beans and sweet potatoes. It is estimated that the company produced more than eleven thousand cases of canned goods annually until its cannery closed in 1928. By 1919, the business was known formally as the Shenandoah Packing and Mercantile Company, having upgraded itself with $2,500 of new canning machinery and opening a dry-goods store at that time.

Starkey Grocery and Hardware

The Starkey Grocery and Hardware was located across from the old Starkey School building and for more than four decades beginning around 1930 was operated by Joe "Pat" and Mabel Doran. In 1942, the Dorans purchased the former chapel of Central Baptist Church and converted it into their store. The location was directly across from the present-day Penn Forest Elementary School, where the Starkey Station retail building is today. In 1970, Doran offered an interesting contest. He had thousands of Coca-Cola bottle caps in a large jar and offered a $900 prize to anyone who could guess the correct number of caps inside. Doran was also known for his Christian convictions, offering customers small crosses and Bibles if they desired. The store closed in the 1980s with the passing of the Dorans and was later razed. The Starkey Station retail building was erected on the site.

David Harris recalls that the Dorans had numerous enterprises at Starkey, including a pawnshop, a used-car lot (Starkey Motors), an ice cream parlor, a shooting gallery, apartments and pony rides. In the 1950s, Harris said the Dorans would hang a bedsheet off the front of the store in the summer and show movies for ten cents. Pat Doran actually worked for the Norfolk & Western Railway, while Mabel tended the store in the daytime.

STARKEY IRON MINES

The Starkey iron ore mines existed at the turn of the last century. The mine tract contained about five hundred acres, though only about twenty acres were in active mining. A description of the tract in 1888 described it as adjoining the lands of Rorer Iron Company, Gideon Turner, Jacob Peters and others and as near the junction of the Rocky Mount and Fincastle Turnpike and Cave Spring Road. That year, T.M. Starkey bought the mines at auction. G.W. Wertz was the foreman of the mines in 1902. The operation, often referred to as the Starkey Mining Company, was eventually sold by Starkey to the Pulaski Iron Company, which closed the mines in 1903 and shipped the tools, carts and other equipment at the Starkey site to its iron ore operations in Allisonia, Virginia. At Starkey, the iron ore was hauled by wagons to Starkey depot. On Google maps, the old surface location of the Starkey mine is at 37.18817 latitude and -79.98558 longitude.

STONE'S UNION 76 (BENT MOUNTAIN)

George Allen Stone built a garage in 1963, initially selling the Pure brand and going by the name Stone's Pure Oil. It was a full-service garage, and Stone worked seven days a week, taking off only on Sunday mornings to attend church. In the late 1970s, Stone sold his business and worked as a mechanic for Seaboard Farms. The store was purchased first by Ronnie

Stone's Union 76 Service Station, 1978. George Allen Stone built his garage in 1963, ran it for more than twenty years and then sold it to Ronnie Wimmer. *Courtesy of Dana DeWitt.*

Wimmer and then by Bill Fralin. In the 1980s, it was known as Bill's Quick Stop. There have been other owners in later years, but the business continues to operate next to the Bent Mountain post office.

While Stone operated the service station, his children worked there, as did Matt Hadacek, David Hadacek, Steve Smith and Don Eldrith.

WDBJ and WSLS Radio Towers

The Roanoke Valley's two early radio stations, WDBJ and WSLS, erected radio towers in southwest county in the 1940s. In those early years, employees actually lived near the towers to ensure maintenance and broadcast quality. The WSLS tower was on Poor Mountain. Worth Barker was the original transmission engineer, and he and his wife lived near the tower before moving close to the Bent Mountain Post Office. The 375-foot WDBJ tower was located on "Bull Run Knob" near Air Point, a half mile off Highway 221. The original transmission engineer for the tower was Roy Melcher. He and his wife lived nearby. Sam Macy, a resident of Bent Mountain at the time, was the assistant engineer. On November 25, 1956, the WDBJ transmitter was moved to Poor Mountain, where numerous television and radio transmission towers are located today.

In addition to the businesses just outlined, there were others.

In the 1930s, Bill and Kate Jones operated a small store out of their home in the former Haran Schoolhouse (now a residence, 7910 Bent Mountain Road).

In the 1950s and early '60s, Mountain Park Motor Court was a small motel that sat along Highway 221 as one headed south up Bent Mountain. The building is a residence today (8711 Bent Mountain Road). The motor court had been built by Jack Kefauver and was operated by the Jennings family in the early to mid-1950s and then by Mr. and Mrs. L.L. Mays in the late '50s and early '60s.

Killian Webster had a small store at what is now 8503 Bent Mountain Road in the 1940s. Webster's store had previously been operated by the Willett family.

Wilson & Company was a meat-processing plant that operated at Starkey from 1910 to 1936.

Noah and Ada Thompson had a general store in the 1940s and '50s at Bent Mountain in the vicinity of today's Fralin Fruit Market (10179 Bent Mountain Road).

Big Bend was a store purchased by Jack Kefauver in the mid-1940s that he remodeled. By the 1950s, the building also had a small restaurant operated by the Jennings family from Glasgow, Virginia, before they opened a truck stop in Salem. After the Jenningses, Big Bend was operated by Buck Mays. Today, it is a residence, 8724 Bent Mountain Road.

Garnand's Store was operating in the 1940s and '50s at the intersection of Starkey Road and Crescent Boulevard. By the 1960s, the store had changed hands and became Crescent Heights Grocery, as it is today.

Charlie Lockett and his wife ran a small store at the intersection of Starkey and Merriman Roads in the 1920s. The store (later residence) was razed many years ago.

Horace Harris opened Harris Body Shop near his home along Route 221 in the mid-1940s, operating it for many years. The auto repair shop was razed, along with the Harris home, with the widening of Route 221 in 2012.

In the late 1930s and early '40s, Jerry Craighead ran a small store from his home near the entrance of the present Nature Conservancy in the Bottom Creek section. The home burned several years ago.

MURDER AND MAYHEM

B efore modern mental health diagnoses, case management and social service support, those suffering from age-related dementia, Alzheimer's disease, psychoses or other mental illnesses had few options. Their families often turned to what were called lunacy commissions for help. These commissions were not made up of mental health experts or even physicians but of three well-respected, court-appointed men, typically justices of the peace, in the community. The commissions would meet with the family, assess the individual in question and make a decision. If the case was severe enough, the commission had the authority to place an individual in a state asylum. For southwest Roanoke County, those placements were at the Southwestern Lunatic Asylum in Marion, which had opened in 1887. The 280-bed facility, overcrowded just a few years after it opened, housed and treated patients as a self-sustaining community with its own kitchen, farm, dairy herd and even cemetery. Patients who could work did. Many who were admitted never left, while others were assessed as "recovered" and returned to their families. A few examples of such incidents follow:

> *Deputy Constable James Peters yesterday brought to the county jail from Cave Spring, C.J. Yates, a white man aged 57 and father of nine children, recently adjudged a lunatic by a commission composed of Justices W.H. Richardson, A.J. Phelps and R.L. Gregory. Application will be made at once for his commitment to the asylum at Marion.*
> —Roanoke Times, *March 9, 1894*

News reached here yesterday that a commission of lunacy had in the early part of the week adjudged J.J. Powell, an aged resident of the Bent Mountain section, a lunatic and that his son, a merchant at Air Point, had him in custody until he could be received into the asylum. The old man having made several unsuccessful attempts to commit suicide was being watched pretty closely, but on Thursday managed to heat a poker red hot, and this he rammed into his mouth, burning himself so dreadfully before help arrived that his death was expected hourly.
—Roanoke Times, *March 31, 1894*

On last Sunday justices H.H. Richardson, A.J. Phelps, and F.M. Willett were called to sit in a case of lunacy of Mrs. M.L., wife of Lewis Arthur, of Back Creek. She was adjudged insane, and taken to Marion, where she will be confined in the Southwestern Lunatic Asylum. [Five months later, Mary Arthur had returned home, according to a local newspaper, "with her mental faculties restored."]
—Salem Times-Register, *September 27, 1895*

A woman named Kate Reynolds, living on Back Creek, was brought to town yesterday and adjudged insane by Justices Miller, Richardson, and Phelps. She was placed in the hands of the sheriff to await a vacancy in the Western State Hospital for the insane in Marion.
—Roanoke Times, *July 7, 1896*

David L. Grisso, son of Daniel Grisso of Back Creek, was brought to town on Monday and examined by a commission in lunacy which adjudged him insane and ordered him committed to the asylum at Marion. This is the second attack for the young man, who spent several months in the asylum five years ago, but was released as cured. It will be remembered that several years ago that this young man was struck on the head with a rock by a boy in his neighborhood, inflicting such injuries as to impair his mind, and he has never been altogether sound mentally since that time.
—Salem Times-Register & Sentinel, *October 31, 1907*

While the Lutherans and Baptists had small orphanages in Salem, sometimes families dealt with unwanted births in their own way. In Roanoke

at the turn of the last century, some newborns were left at hotels, along sidewalks and on front porches. Perhaps it was poverty or the social stigma attached to an unwed mother that was the motive, but newborns were occasionally abandoned in the hope that care would be provided.

About dusk Friday a laborer, in going into a feed room on a farm near Cave Spring, found a willow basket in which, warmly covered up, was a richly dressed female infant about twenty-four hours old. It is understood that a lady in Roanoke will care for the little foundling.
—Roanoke Times, *April 3, 1892*

Mr. Leslie, the blacksmith at Cave Spring, found on his doorstep this morning a young female infant. It was simply wrapped up, but there was nothing about it to indicate who the cruel parents were, or why it was left at his house.
—Salem Times-Register, *October 25, 1895*

Marriages were always a subject of the social columns, especially elopements. Sometimes, the circumstances were related with humor.

At the residence of Mr. George P. Airhart, near Cave Spring, Roanoke County, on Tuesday Rev. J.L. Luck wed Mr. Lee Squires of Middlebrook, Augusta County, and Miss Emma Airhart. It is said that neither of the contracting parties ever saw the other until a few weeks before they were married and then had only seen each other twice; but they had been recommended to each other. They went eastward on the 11:32 train Wednesday morning.
—Staunton Spectator, *June 7, 1881*

On Monday, Daniel Kittinger, a well-to-do Back Creek farmer, brought his pretty seventeen-year-old daughter, Miss Fanny, to Salem to visit the family of William McCauley during commencement, after which he returned home. Monday night, Luther Mcrea, a young man from Back Creek also came to Salem and spent the night with a friend, Thomas Rhodes. Mr. Rhodes said Luther did not sleep much that night, but kept turning, twisting, and sighing, wishing for the morning which he thought would never come. At day he arose and after breakfast sent a horse and buggy up

to Mr. McCauley's. The young lady got in the buggy and drove down the street, where she was met by Mcrea, who was wild with anxiety. Together they drove to the depot, purchased tickets to Bristol, and as soon as No. 1 came they boarded it. At this juncture Mr. McCauley who discovered the flight of Miss Fanny soon after and gave chase, also entered the car and begged and pleaded with the young lady not to run off with Mcrea. However his persuasive powers were unavailing and it is believed that by this time Father Burroughs has pronounced the bonds which made Miss Kittinger the wife of Luther McCrea.

—Roanoke Times, *June 7, 1893*

Mr. George Lloyd, a prominent and well-known farmer of this vicinity [Haran], *had a very severe attack of heart paralysis last week, after appearing before Capt Griffin for the purpose of obtaining a marriage license for Miss Luvenia Puckett and himself. All necessary arrangements were made, all questions answered promptly until he came down to the age. The honorable gentleman failed to give sufficient evidence of her being of age, so he had to leave the papers on the table.*

—Salem Times-Register, *July 3, 1896*

Miss Mary Laughland of Cave Spring and Mr. Frank Elam eloped to Winston-Salem, NC. It was the intention of the couple to be married in the Twin City on their arrival there, and then go to Statesville, NC, the home of the groom where they will reside. The bride's father went to the passenger station with the intention of frustrating the elopement, thinking the couple would go to Bristol. Instead, the young lady heavily veiled and wearing a gray raincoat loaned her by a friend, passed her father and boarded a south bound train for North Carolina.

—*Washington, DC,* Evening Star, *December 1, 1909*

When Prohibition was adopted in Virginia in 1917, it brought a new challenge to law enforcement. Apparently, Starkey, with its train depot, became a distribution point for illegal liquor.

Seven negroes along with two white men named Collins and Miller were arrested about 1 o'clock last Sunday morning by Special Agents King, Stiff, Funk and Dowdy, near Starkey. The officers had a tip whiskey was being

brought in on freight trains so they stopped a train near the Starkey station. Nine men were taken out of two open top cars and along with them four or five sacks containing hot water bottles filled with new corn liquor, an oil can or so and some jugs containing the same fluid.
 —Roanoke World News, *October 11, 1919*

The liquor business in the vicinity of Starkey toll gate is picking up during the last few days according to prohibition officers. Within the last two nights more than fifty gallons of liquor and one Ford automobile have been taken from alleged bootleggers. Last night 20 gallons of liquor was found in an automobile which officers claimed belonged to Acey Perkins of Franklin County and the night before about thirty gallons of the "fire water" was seized near Starkey toll gate along with a new Ford car.
 —Roanoke World News, *May 6, 1920*

Raiding near Starkey about seven miles south of Roanoke, state and federal prohibition agents yesterday cut up two stills, located about a half mile apart, arrested two men, and ruined twelve gallons of corn whiskey and fifteen hundred gallons of mash.
 —Roanoke World News, *December 21, 1921*

One humorous description of an incident with revenue agents occurred at Air Point.

Since they have been engaged in the enforcement of the Prohibition law the local Federal officials have captured whiskey in many sorts of vehicles, like automobiles, trains, buggies and wagons, but not until last night did they capture any in a sleigh. They were in search of blockaders at a point near Air Point…and saw a man coming along in a sleigh. They suspected him of hauling whiskey and started in his direction. He saw them and ran into the woods, leaving his sleigh, a horse that was drawing it, and two ten-gallon kegs of whiskey.
 —Roanoke World News, *April 1, 1922*

There was occasionally the odd and tragic, such as the almost-lost body of a Miss Booth and the untimely deaths of well-known citizens.

The remains of Miss Sarah Booth, daughter of Mr. and Mrs. J.H. Booth of Poages Mill, Roanoke County, arrived here today from the Philadelphia Medical Institute, 71 days after her death. The girl left Virginia with a family which removed to Pittsburg, Pa., was taken sick there, dying in the hospital. No one appearing to claim the body, it was turned over to the state institution for dissection. The parents were informed of the death of the girl, but were not informed of the dissection which had been made of her body. They were unable to find any trace of the body until last week, when it was located in the cold storage department of the Philadelphia Institution. If the Christmas holidays had not suspended studies at the institute, the parents would never have secured the body of their daughter, who was 20 years of age, and a beautiful girl, and might possibly never even have known what became of her. The remains of Miss Booth were interred in the family burying ground this afternoon.

—Newport News Daily Press, *January 31, 1908*

On Monday last, about noon, young Milton Chapman, oldest son of Nathan Chapman of Cave Spring, was instantly killed by being struck with an India-rubber baseball. It seems that at recess the boys at school were in the habit of playing ball, and upon this occasion young Chapman was acting as catcher, and in attempting to catch the ball was hit immediately behind the right ear. Upon being struck he threw his hands up to his head, walked a few steps and sat down, and fell over dead in an instant. He never spoke after being struck. Dr. Gale was soon upon the spot, but when he arrived the young man was beyond medical skill. Young Chapman was about seventeen years of age, and was looked upon as a model young man.

—Salem Times-Register, *February 10, 1877*

On the 3rd instant Mrs. Elisha Argabrite who lived near to what is known as Tyrees Shop on Bent Mountain...accidentally shot and killed herself with 22 caliber pistol. A boy came to Mrs. Argabrite's house, and while he was there found a small pistol. He brought the pistol to Mrs. Argabrite and asked her to show him how the pistol was loaded. She took the pistol in hand, supposing it was empty as she had taken all the cartridges out a few days before....Mrs. Argabrite pulled the trigger to show the boy how it worked. But somebody had, unbeknown to Mrs. Argabrite, loaded the pistol and when she pulled the trigger it fired and ranging towards her stomach

and bowels it proved to be a fatal shot....Drs. White and Huff were immediately called in, but no relief could be had.
—Roanoke Times, August 10, 1897

Ulysses Murray, freight brakeman on the Roanoke and Southern, was caught between two cars at Starkey's depot yesterday and crushed to death. He was twenty-four years of age and leaves a wife and four children.
—Salem Times-Register, January 4, 1901

The Back Creek community was greatly shocked over the tragic death on last Friday morning of James W. Ferguson who met instant death while sawing wood near his home, the pile of wood falling on him, a pole striking him over the eye, crushing his skull. His son, Clyde, and a helper rushed to his rescue removing the wood but to no avail. The deceased was in his forty-second year.
—Roanoke World-News, April 6, 1922

Unusual as it may be for a thunderstorm of any consequence to appear in Virginia during February, the one which struck Cave Spring and Roanoke the eighteenth was declared by older residents to be one of the severest ever known in this community. So far as is known it is the only instance of a death by lightning to occur in Roanoke County in a mid-winter month.

The storm suddenly appeared into the afternoon over the farm of J.H. Grisso, about ten miles from the corporate limits of Roanoke. Mr. Grisso took refuge in a barn where, under the main floors, three horses were stabled. At about 6:15 pm there was a deafening crash when a lightning bolt struck an oak tree, two feet in diameter, on the top of a knoll two hundred yards from the barn.

After the storm, Mr. Grisso was found dead in the barn, his hat having been literally burned from his head; the right shoe split open on one side and all the shoe laces burned out, but there was scarcely a mark on his body. Mrs. Grisso, who had been milking at the spring house, was severely shocked, the bolt tearing a hole in the galvanized bucket she held in her hand. Price Grisso, her son, who had gone into the woodshed to escape from the storm, was shocked. The huge oak tree on the top of the hill where the lightning struck was spilt into a thousand splinters; the radio set in the

residence was torn to pieces; several fence posts were split open although they were situated several hundred yards apart.

Since news of what happened on Mr. Grisso's farm began to be circulated, there have been scores of motorists a day visiting the scene. They continue to go and marvel at the strangeness of the lightning's tragic manifestations.

—Roanoke World News, *March 5, 1927*

Nothing caught the attention of Back Creek and Bent Mountain residents like a murder. Numerous murders occurred and for a variety of reasons, often related to racial prejudice, feuds, infidelity, land disputes and drunken brawls.

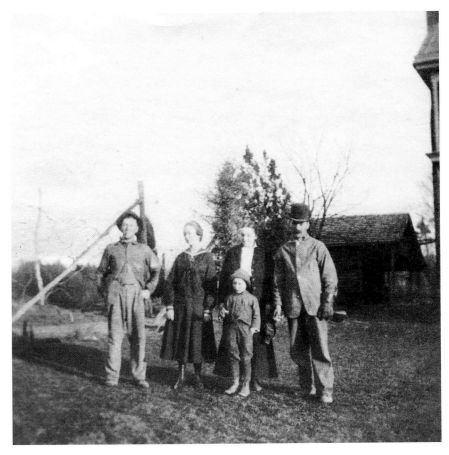

Grisso family, circa 1920. *Left to right*: Ellis, Mary, Susie, Price and John Grisso. John Grisso was killed by a freak lightning storm in 1927. *Author's collection.*

Lightning strike aftermath, 1927. An unidentified man examines the remains of an oak tree splintered by lightning on the Grisso farm. *Author's collection.*

One such account appeared in the business ledger of Elijah Poage. "Mrs. Catherine Martin—one coffin for black man, Stepney, age 52 years old; died from wounds of (seven) buckshot, which said murder was executed by Dennis K. Ferguson on the 16th day of June, 1864, by musket shot while said Stepney was in the corn fields at his plow."

Francis Tinnell killed Elijah Faris in 1867 by beating him with a tree limb, according to another entry in the ledger of Elijah Poage. Poage commented that Faris was a "well-known tyrant" in the section whose "entire life had been one of crime from boyhood to the grave." A jury determined Tinnell acted in self-defense.

Ferdinand Shilling shot and killed Dennis K. Ferguson at Back Creek in April 1872. The *Bristol News* stated they were "two old enemies." Byron Woodrum, son of prominent orchardist Jordan Woodrum, was shot to

death by John J. Huff in September 1878. The two were business partners. Woodrum, following a drunken argument, attacked Huff with a knife and an axe. Huff shot Woodrum, who died thirty hours later. Woodrum's dying request was that Huff not be prosecuted. A jury determined Huff's actions were justified.

In 1886, Benjamin Griffith, having arrived from Texas, sought out his estranged wife, who was living with her sister at Back Creek. When Griffith arrived, two men confronted him on the front porch of the sister's home, and Griffith shot one of the men, Pickett Wertz, through the heart. That same year, Thomas Webber of Bent Mountain went home and discovered a Mr. Collins there with his wife. Webber split Collins's head with an axe.

At Cave Spring in 1887, Charles Shovely called his neighbor George Wimmer to his fence to reportedly show him a bill. As Wimmer leaned in to examine the paper, Shovely pulled a revolver, killing Wimmer at point-blank range.

In March 1889, the Salem newspaper reported that a "difficulty" occurred on the farm of J. Coles Terry at Bent Mountain. Two of Terry's farmhands got in a quarrel, each pulling a knife. One was stabbed in the ribs, and the other was "totally disemboweled" and died the following day.

Two murders, however, stand out. One resulted in one of the last hangings in Salem; the other became immortalized in a folk ballad.

In 1880, Marcus Hawley was convicted of the murder of Zachariah Hays. The trial and swift execution were widely reported in newspapers around the state, including the *Richmond Daily Dispatch* in its November 27 edition.

Salem. Va., November 26. The execution of Marcus De Lafayette Hawley, convicted last month in the Circuit Court of this County of the murder of Zachariah Hays at Back Creek in June of last year, took place here today. Both the murderer and the victim were white men. The execution was conducted privately—the only persons present being the officers of the court, a small guard, a minister of the Gospel, and representatives of the press. The weather was exceedingly disagreeable—cold rain with snow and sleet prevailing, the latter falling steadily during the hanging. HISTORY OF THE ASSASSINATION: The killing of Zachariah Hays was nothing more nor less than a deliberate assassination resulting from a feud of long-standing, having its origin in a suit for the possession of about fifty acres of mountain land claimed by the father of Hawley and by Hays. The latter, some three or four years ago, sold and conveyed the land to the elder Hawley, with a contract that if it was not paid for in a certain lime it should revert

to Hays. Upon the expiration of the time of the contract Hawley had failed to comply with its terms, but remained in possession of the land. The case was then taken to the courts, and after various trials Hays, in the spring of 1879, obtained a judgment in his favor. A writ of possession was issued, and the Hawleys were ejected from the premises into the public road, and Hays took possession. There was much bad feeling, and a great many threats were made on both sides, and the magistrates of that portion of Roanoke County were beset by both Hays and Hawley for peace-warrants against each other, but none were granted. Matters continued in this condition until the 18th of June, 1879, the Hawleys being dispossessed and bitter in their denunciation; but no one thought anything would result from their threats. About sunset of the day mentioned Hays, who had been at work in the field, left for home in the company of two other parties. They had proceeded but a short distance through the woods when a shot was heard and Hays fell wounded. No one saw who fired the shot, nor whence it came. Hays was taken home and upon examination it was found that one shot—a buckshot—only had taken effect, striking him in the neck and lodging in the spine, almost severing the spinal cord, and producing complete paralysis of the whole body from the chest down. Hays lingered a few days and died from this wound. The assassination had occurred in a path leading up the mountain and the party who fired the fatal shot had deliberately chosen this spot where he could stand behind a tall tree (which was used as a blind), and, unobserved, have full view of the path along which his intended victim had to pass. The gun was heavily loaded with shot and slugs, a number of which were subsequently found in the bushes and trees along the line of firing. The well-known bad blood existing between the murdered man and the Hawley family naturally caused suspicion to rest upon the latter, and they were all arrested.

The newspaper reported that the elder Hawley and his four sons, along with a son-in-law, were arrested. Three trials were ultimately conducted, with the father, youngest son and son-in-law discharged. Peter Hawley was sentenced to thirteen years for murder in the second degree; Calvin Hawley was given one year for being an accessory; and Marcus Hawley was convicted of murder in the first degree. Apparently, Marcus had confessed to an aunt, who became a key witness for the prosecution.

A few days before his execution, Hawley married the mother of his two children, Nannie Hawkins. He was also baptized and received into the Episcopal Church in Salem. Hawley never denied killing Hays but

maintained he was acting in self-defense against the many physical threats Hays had made against him. The night before he was hanged, Hawley was visited by his brother, the Episcopal minister and several friends.

At 10:20 a.m. on November 29, Hawley was led from his cell to the outside scaffold at the rear of the courthouse. Asked if he had a final statement, Hawley deferred to the Episcopal minister, who read a statement on Hawley's behalf, invoking Christian sentiment about the afterlife and asking God's blessing upon his friends. The minister, Reverend Goodwin, then prayed, kissed Hawley on the cheek and stepped away.

The prisoner's hands and legs were then positioned, the rope adjusted, the black-cap drawn over his face, and at the giving of the signal, at 10:33 o'clock, Deputy-Sheriff C.B. Stevens sprung the trap. The fall was over eight feet, and death ensued without a struggle, not a single tremor or contraction being perceptible. After fifteen minutes the physicians announced that pulsation had ceased, and at the end of thirty-one minutes the body was taken down and handed over to friends for interment. An examination showed that the neck was dislocated. Hawley was in the 29th year of his age, of fine appearance and figure, and weighed one hundred pounds.
—Richmond Daily Dispatch, *November 27, 1880*

The brutal murder of Freeda Bolt on Bent Mountain in 1929 shocked residents. That a woman would be beaten, left for dead and then, being found alive by her assailant the following day, her murder completed was stunning. Hunters heard what they thought was an animal crying in the woods on the night between the attack and the murder, not knowing it was the moans of a young woman. When her body was discovered, it was initially laid out in the Back Creek Orchard Company's storage room.

The body of Freeda Bolt, 18, of near Willis, Floyd County, who disappeared last Thursday night, was found at ten o'clock last night on Bent Mountain, eighteen miles south of Roanoke.

Discovery of the body was made by Sheriff Hilton, of Floyd, and two deputies who, acting on the reported statements of Buren Harmon, of Floyd County, who has been held since the girl's disappearance, that the body would be found beneath several logs, about thirty yards from the highway, where the highway makes a bend on the mountain.

Sheriff Hilton discovered the body about ten o'clock, and communicated with Roanoke county officers, who departed at eleven o'clock for the scene.

The body, fully clothed, was found in a secluded spot in the woods, and was in a fair state of preservation, Dr. G.A.L. Kolmer, Roanoke county coroner, said at 1:30 o'clock this morning, in a telephonic communication.

A heavy cord had been tied tightly around the victim's neck, but whether or not this had been used for the purpose of strangulation or to drag the body from the road to its hiding place, Dr. Kolmer and Deputy Sheriff J.L. Richardson were unable to say. Only a cursory examination was made this morning before the body was removed to the home of J.D. Willett, half a mile from the scene.

Freeda Bolt, 1928. Bolt's brutal murder at age eighteen in 1929 shocked Bent Mountain residents and became the subject of a folk ballad. *Author's collection.*

Arrangements were being made to remove the body to Salem, where an autopsy will be held today, Dr. Kolmer said. Whether or not Harmon will be turned over to Roanoke county authorities has not been determined, Deputy Sheriff Richardson said, since it has not been established just where the young girl met her death.

The girl, daughter of Mr. and Mrs. J.K. Bolt, who reside about seven miles from Willis, had been boarding in Willis, while attending school. Telling friends she was going to be married, she left her boarding house last Thursday night and, according to her father's report to police here, she was later seen in company with Harmon, apparently headed toward Roanoke.

Harmon was seen in Floyd Friday morning, the father stated, but denied having seen the girl on the previous night. He admitted, it was said, that he had an appointment with her that night, but contended that the meeting never took place.

Since that time, Mr. Bolt had asked the aid of police in the principal cities of the State in helping to locate his daughter. It was at first thought that she probably had come to Roanoke, since Harmon had friends here. Search, however, was extended to Richmond and other cities.

Deputy Sheriff J.L. Richardson, accompanied by Dr. G.A.L. Kolmer, county coroner, and R.T. Hubard, commonwealth's attorney, of Salem, went to the scene, arriving there shortly after midnight.

—Roanoke Times, *December 19, 1929*

Buren Harmon, Bolt's boyfriend, was arrested for the crime a few days later. He had been the last person seen in her company. Pressed by the sheriff as to his activities on the night Bolt went missing, Harmon confessed. The April trial lasted nine days and resulted in Harmon receiving a life sentence. Harmon was spared death, having been diagnosed as "feeble minded." The Salem newspaper reported "there was no show of emotion" when Harmon heard the verdict. Harmon received a pardon after serving eighteen years.

The story of Bolt's murder became a ballad written by D.M. Shank and recorded by the Floyd County Ramblers in 1930 and later by the Carter Family in 1938.

SELECTED BIBLIOGRAPHY

Barnes, Raymond P. *A History of Roanoke*. Radford, VA: Commonwealth Press, 1968.

"Bent Mountain One-Room Schoolhouses, 1872–1956." Pamphlet privately published.

Draper, Anthony L. "Agricultural Change in Roanoke County, Virginia: A Comparative Study of Agricultural Census Documents, Roanoke County, Virginia, 1860 and 1870." Senior honors thesis, College of William and Mary, 1996.

Harris, Nelson. "Mountain Murder Leads to Salem Hanging." *Journal of the Historical Society of Western Virginia* 20, no. 2 (2012): 22–23.

———. "The Surrender of Salem." *Journal of the Historical Society of Western Virginia* 20, no. 2 (2012): 39ff.

"History of Bent Mountain." Files of Roanoke County School Board, undated.

Hutcheson, Charlene D. "Marriage Patterns in Cave Spring and Back Creek, Roanoke County, Virginia, 1770–1850." Files of Virginia Room, Roanoke Main Library, 1995.

Jack, George S. *History of Roanoke County*. Roanoke, VA: Stone Printing, 1912.

Kagey, Deedie. *When Past Is Prologue: A History of Roanoke County*. Roanoke, VA: Roanoke County Sesquicentennial Committee, 1988.

Kegley, F.B. *Kegley's Virginia Frontier: The Beginning of the Southwest, The Roanoke of Colonial Days, 1740–1783*. Roanoke: Southwest Virginia Historical Society, 1938.

Lewes, David W., and Kitty Houston. *Rural Life in the Back Creek Valley: Documentation of the Harris House, Roanoke County, Virginia*. Williamsburg, VA: College of William and Mary, 2004.

Leyburn, James G. *The Scotch-Irish, A Social History*. Chapel Hill: University of North Carolina Press, 1962.

Long, John. "A Horseback Ride on the Back Roads of Roanoke County." *Journal of the Historical Society of Western Virginia* 15, no. 2 (2003).

Moncure, Mrs. Philip St. Leger. "Recollections of Bent Mountain, Virginia." *Journal of the Roanoke Valley Historical Society* (Winter 1967): 30–37.

Motley, Christina M. and Jennifer C. Sexton. *Roanoke County Fire and Rescue: A Reflection of 150 Years*. Roanoke, VA: Roanoke Fire and Rescue Department, 2014.

Peters, Dolores S. "A Short History of the Back Creek Settlement." Roanoke, VA: Privately published, 1974.

Wilson, Bayes, and Norma Jean Peters. "Roanoke County Schools' Legacy." *Journal of the Roanoke Valley Historical Society* 13, no. 1 (1989): 54–62.

Work Projects Administration. *Roanoke: Story of City and County*. Roanoke, VA: Roanoke City School Board, 1942.

INDEX

ABOUT THE AUTHOR

L ocal historian Nelson Harris is a native and former mayor of Roanoke. He has been the pastor of Heights Community Church (formerly Virginia Heights Baptist) since 1999. He is also an adjunct faculty member at Virginia Western Community College. He holds degrees from Radford University (BA) and Southeastern Baptist Theological Seminary (MDiv) and has done postgraduate study at Princeton Theological Seminary and Harvard University. He is a past president of the Historical Society of Western Virginia. As an author, he has been published in various regional magazines, and this is his twelfth book. His previous titles are *The 17th Virginia Cavalry*; *Roanoke in Vintage Postcards*; *Images of Rail: Norfolk & Western Railway*; *Stations and Depots of the Norfolk & Western Railway*; *Salem and Roanoke County in Vintage Postcards*; *Virginia Tech*; *Downtown Roanoke*; *Roanoke Valley: Then and Now*; *Greater Raleigh Court: A History of Wasena, Virginia Heights, Norwich and Raleigh Court*; *Aviation in Roanoke*; and *Hidden History of Roanoke*.

He and his wife, Cathy, live in southwest Roanoke County and have three grown sons, John, Andrew and David.